ENGLISH GOTHIC CHOIR-STALLS
1400–1540

This volume is a companion to *English Gothic Choir-stalls 1200–1400* published in 1987. England continued to be exceptionally well served by its ecclesiastical joiners in the later Middle Ages. This new survey, from its size and scope, highlights once again an under-estimated branch of our medieval artistic patrimony.

English choir-stalls of the later Middle Ages are, like those of the preceding two hundred years, virtually untouched by modern scholarship. The standard work on the subject, by Francis Bond, was published in 1910.

Significant surviving fragments and more or less complete sets of furniture from some twenty monuments have been considered. Most of the important extant sets of choir-stalls from the later Middle Ages in England are located in the North Country, for example Carlisle Cathedral, Cartmel Priory, Whalley Abbey, Ripon Minster, Manchester Cathedral and Beverley Minster. The only significant surviving monuments from the south-east are the royal commissions at St George's Chapel, Windsor, and the Henry VII Chapel, Westminster Abbey. The last two occupy a chapter of their own in the book.

As before, the context of choir furniture is considered – its symbolic importance at the centre of daily worship, its function of accommodating the heterogeneous establishments of the great churches, its siting in the building, its physical enclosure and its decoration. The circumstances of the commissioning of the furniture and the identity, where known, of the carvers is investigated. Any significant developments of joinery techniques and craft organisation are noted.

The study monitors architectural and stylistic development in choir furniture, wherever possible linking one monument with another, and attempts to fit each into an already familiar matrix of artistic activity. The importance of choir-stalls as an institutional symbol of power and affluence, and the honoured and privileged status of the furniture designers and carvers in English medieval society are taken into account. The intervention of royal patronage is discussed, and its promotion of individual artists and styles.

This new research is presented in a series of chapters, each addressing either a single monument or group of such, or an interesting problem. As with its companion volume, this book is not a comprehensive catalogue of all the surviving material, but the bibliography provided is as inclusive as practicable.

In 1978 CHARLES TRACY went as a mature student to the Courtauld Institute to read for a degree in the History of European Art. In 1984 he completed his Ph.D. thesis on English medieval choir-stalls. Since then he has undertaken classes in medieval furniture at various schools and colleges on a free-lance basis. He was commissioned by the Victoria and Albert Museum to prepare a new edition of the *Catalogue of English Medieval Furniture and Woodwork*. This was published in 1987. He prepared many of the woodwork entries and an essay for the Royal Academy 'Age of Chivalry' exhibition catalogue (1987–88). He has published several articles in scholarly journals on miscellaneous woodwork topics. The first volume of his study of English Gothic choir-stalls was published in 1987.

ENGLISH GOTHIC CHOIR-STALLS
1400–1540

Charles Tracy

THE BOYDELL PRESS

First published 1990 by The Boydell Press, Woodbridge

The Boydell Press is an imprint of Boydell & Brewer Ltd
PO Box 9, Woodbridge, Suffolk IP12 3DF
and of Boydell & Brewer Inc.
PO Box 41026, Rochester, NY 14604, USA

ISBN 0 85115 272 4

British Library Cataloguing in Publication Data

Tracy, Charles
English gothic choir-stalls 1400–1540.
1. England. Cathedrals & churches. Choir stalls, history
I. Title
726.5293
ISBN 0–85115–272–4

Library of Congress Cataloging-in-Publication Data

Tracy, Charles, 1938–
 English Gothic choir-stalls, 1400–1540 / Charles Tracy.
 p. cm.
 Companion volume to: English Gothic choir-stalls, 1200–1400.
 Includes bibliographical references and index.
 ISBN 0–85115–272–4 (hardback : acid-free paper)
 1. Choir-stalls, Gothic — England. 2. Choir-stalls — England.
 3. Wood-carving, Gothic — England. 4. Wood-carving — England.
 I. Title.
NA5463.T74 1990
726'.5293—dc20 90-39594

Cover: Henry VII Chapel, Westminster Abbey. Choir-stalls canopywork. Detail.

Printed in Great Britain by
St Edmundsbury Press, Bury St Edmunds, Suffolk

CONTENTS

ACKNOWLEDGEMENTS

It would not be possible to assemble all the information needed for a research project of this sort without the help and cooperation of many people and organisations. It is invidious to mention some providers of assistance but not others, but, as is customary on these occasions, I shall have to ask the many who have granted me small favours to accept my thanks non-specifically.

It has only been possible to publish this book through the generosity of the British Academy; Miss Isobel Thornley's Bequest, University of London; the Marc Fitch Fund; the Prix Minda de Gunzburg and the Twenty-Seven Foundation.

I am grateful for the help and advice of colleagues. Custodians of the monuments have generously given full and free access. They have allowed me also to take photographs to illustrate this book. For permission to use archive material I would like to thank the Keeper of the Muniments, Westminster Abbey, and the Public Record Office, Kew. Several of the photographs used as illustrations are from the collections of the Conway Library, at the Courtauld Institute of Art, and the National Monuments Record for England library. I am grateful to the staff of both for their help. I am indebted to Mr Yogish Sahota of the Westfield College Reprographic Unit for processing and printing my photographs to such a high standard. Finally, my thanks to Dr Richard Barber and the publishers for seeing this project through, and Professor Peter Lasko, who has been as supportive as ever.

LIST OF ILLUSTRATIONS

Chapter VII

LIST OF FIGURES IN THE TEXT

INTRODUCTION

This volume is a sequel to the study of thirteenth and fourteenth-century English choir-stalls published in 1987.[1] England continued to be exceptionally well served by its ecclesiastical joiners in the later Middle Ages. It is to be hoped that this study of the surviving monuments, mainly but not exclusively from greater churches, from its size and scope, will highlight an underestimated branch of our medieval artistic patrimony.

A glance at the historiography of English medieval woodwork[2] confirms that the thirteenth and fourteenth centuries were more neglected by antiquarian scholars than the later Middle Ages. There is simply no equivalent for the earlier period, in terms of archaeological rigour and document-based speculation, of the study by Purvis of the so-called 'Ripon School' of ecclesiastical furniture makers.[3] Perhaps only the fourteenth-century choir-stalls at Winchester have received such intensive archaeological analysis,[4] as was lavished by Whittingham on the later monument at Norwich. Finally, at St George's Chapel, Windsor the characteristic blend of documentary and archaeological insights on the choir-stalls by St John Hope stands for neo-Gothic antiquarianism at its very best.[5]

However good this work in its way, it is still too narrowly based for our purposes. Moreover, several of the monuments treated in this book have never attracted scholarly interest of any kind.[6] The literature on medieval choir-stalls and ecclesiastical woodwork has been discussed elsewhere.[7] Only the works pertaining to the later Middle Ages are given in the bibliography.

As in the previous study, some attention has been devoted to contemporary ecclesiastical joinery on the Continent of Europe. Once again, apart from the constructive similarities of the seating, architecturally and sculpturally, the northern Europeans seem to have gone their own way. Even allowing for the artistic depredations of the Reformation, the French Revolution, the Napoleonic Wars and two world wars in the twentieth century, an English primacy in choir-stall architecture, comparable to that in structural carpentry, can be unmistakably identified.

Significant surviving fragments and more or less complete sets of furniture from some twenty monuments, have had to be taken into account. This is rather less than for the earlier study. In this period there are no greater churches represented from the south-east of England. Most of the major surviving monuments are to be found in the North Country (e.g. Carlisle, Cartmel, Whalley, Ripon, Manchester and Beverley). It will be recalled that in the earlier period the bulk of the new choir-stalls were in the south-east (e.g. Westminster Abbey, Canterbury, Winchester and Chichester cathedrals). Most of the others were situated in the southern half of the country, with only Lincoln, Chester and Nantwich lying above the line from Bristol to the Wash. The only surviving late medieval monuments in the south east of England of outstanding artistic worth are the royal chapels at St George's, Windsor and Westminster Abbey.

[1] Tracy (1987).

[2] This is dealt with in some detail in the introduction of Tracy (1988).

[3] Purvis (1929) and (1935).

[4] I refer to the investigations of W. J. Carpenter-Turner and C. G. Wilson (Mrs Bennett).

[5] Hope (1913).

[6] e.g. Carlisle, St David's, Tong and Sefton.

[7] See Tracy (1987), xxi; Tracy (1988), xxiii–xxvi; and bibliographies in Tracy (1987), (1988) and in this book.

The inclusion of some parochial church choir-stalls reflects the munificence of individual patronage at this time. However, the seemingly haphazard selection of churches (Tong, Gresford, Halsall and Sefton) is due to stylistic rather than historical preoccupations. In the later Middle Ages the number of surviving choir-stalls from collegiate and parochial churches increases considerably. However, very few of them offer anything new in architectural design terms.

The uniqueness of English Gothic choir-stalls is undoubtedly in their canopywork. Whereas the constructive processes and stylistic origins are frequently discussed in both these volumes, the symbolism of such forms has received less attention. The significance of canopywork, needs to be tackled separately within the framework of a broad range of furniture types both ecclesiastical and secular. My principal purpose throughout has been to publish the monuments and to attempt to provide a historical and stylistic context for them. The liturgical functioning of choir-stalls, although touched upon in passing in the first volume, does not get full value here.

As in the first volume the plates represent, amongst other things, a substantial collection of decorative carving motifs for the end of the Middle Ages. In the late Gothic period craftsmen continued to use the tried and tested selection of foliage familiar in the fourteenth century. However, one important newcomer needs to be mentioned. The pomegranate has had a prominent place in artistic decoration and iconography since Classical times. It was adopted by the early Christian church, but seems to have virtually fallen out of use, in this country at least, after the twelfth century. For nearly three hundred years it seems to have been used only rarely in England. However, during that time the fruit was imported into England by the rich, and, in the fourteenth century it was not unknown to English gardeners since Henry Daniel 'was able to grow but not fruit the pomegranate'.[8] Sooner or later, an English three-dimensional art work displaying the species from the thirteenth or fourteenth centuries will probably turn up. At least one contemporary writer, Wyclif, mentions a carved or embroidered representation of the pomegranate. Doubtless, other such references could be instanced.

It is not clear if there was a similar eschewal of pomegranate in northern Continental Europe at the same time. By the early fifteenth century, it was quite commonly represented in Flanders. As a Resurrection symbol, the pomegranate is often held by the Christ Child in panel paintings of the Virgin and Child.[9] Its associations were, however, diverse.[10] To instance a couple of non-heraldic purposes, it was used to represent the unity of the church, and the chastity of the Virgin.

The re-establishment of the pomegranate in the repertory of carved flora in England is usually dated from the second decade of the sixteenth century, being traditionally associated with the union of the English crown with the house of Aragon. Interestingly, during the course of this research, it has become clear that the revival of the motif pre-dated this event by as much as thirty years. It occurs in the datable monuments at St George's Chapel, Windsor (c. 1480) and Ripon Minster (c. 1490), as well as at St David's Cathedral and Tong before 1500. Other fifteenth-century occurrences could be cited and, doubtless, in terms of woodwork generally, the list could be extended. The treatment of the motif is usually rather stylised, the fruit not often showing its seeds. Nonetheless, in all the cases exemplified, the identity of the species is never in doubt. However, I have been careful to differentiate between pomegranate, 'pomegranate'-type and 'stylised' flower. These labels represent estimated degrees of verisimilitude.

A noticeable feature of fifteenth and sixteenth-century ecclesiastical joinery

8 Harvey (1981).

9 Behling (1957), 151–53.
10 James Hall, *Dictionary of Subjects and Symbols in Art*, London, 1979.

is the comparative paucity of documentary evidence in respect of the major monuments, with the important exception of the royal commissions at St George's Chapel, Windsor. This situation is perhaps a reflection of the skewed geographical distribution of the surviving furniture in favour of the north of England. In the fourteenth century the stalls for which building accounts survive, at St George's Chapel, Windsor and St Stephen's Chapel, Westminster, were once again the products of royal patronage. Most of the stalls here considered were made by anonymous master-carpenters. However, occasionally we are provided with a name, or names, as at St George's Chapel, Windsor and even a single-family workshop based on the minster at Ripon.

The project of which this volume forms the second half, like Francis Bond's book before it, is not a corpus of the material. The monuments surveyed were chosen to illustrate their stylistic and historical contributions to the subject. As previously, the research is presented in a series of chapters, each addressing either a single monument or group of such, or an interesting outstanding problem. An attempt is made to define the type of choir-stalls used in England during the later Middle Ages from the typically early fifteenth-century monument at Carlisle Cathedral to the Continental hybrid at the Henry VII Chapel, Westminster Abbey of c.1512, or the classically-decorated but Gothic-designed monument at Sefton Church, Lancs of c.1540. The survival into the fifteenth century at Norwich Cathedral of the Rayonnant-inspired designs familiar from monuments in the south-east of England in the earlier period is briefly considered. The relationship of fitted furniture to its encasing architecture is kept in mind. Craft practices and techniques play an important part in the analysis throughout. A glossary of terms is provided at the end.

A list of the monuments discussed with a brief description is given below:

Monuments Discussed

	Date/s	Type of Establishment	Chapter
Carlisle	c.1410	SC/AU	I
Furniture still *in situ*.			
Cartmel	c.1420–30	P/AU	I
Seating still *in situ*. Canopywork destroyed.			
Whalley	c.1430	A/CI	I
Original seating now to be found at Whalley Parish Church, Blackburn Cathedral and Holme-in-Cliviger Church. Remains of canopywork at Whalley Parish Church.			
St Laurence, Ludlow	c.1415–25	C	II
Furniture still *in situ*. Superstructure 19th c. restoration.			
Wigmore	c.1415	A/AU	II
Fragments of seating, desking and superstructure in Leintwardine Church.			
Chirbury	c.1415	P/AU	II
Fragments in Montgomery Church.			
Ripon	c.1488–94	M/C	III
Furniture still *in situ*.			

	Date/s	Type of Establishment	Chapter
Manchester	c. 1506	C	III

Furniture still *in situ*.

	Date/s	Type of Establishment	Chapter
Jervaulx	c. 1506	A/CI	III

Pair of desk ends at Aysgarth Church.

	Date/s	Type of Establishment	Chapter
Bridlington	c. 1519	P/AU	III

Desk ends and canopy fragments at Leake Church. The Hompton desk end is dated.

	Date/s	Type of Establishment	Chapter
Beverley	c. 1520	M/C	III

Furniture still *in situ*.

	Date/s	Type of Establishment	Chapter
Norwich	c. 1420, 1472–97 & c. 1515	MC/B	IV

An assortment of the different periods still *in situ*.

	Date/s	Type of Establishment	Chapter
St David's	c. 1500	SC	V

Furniture still *in situ*.

	Date/s	Type of Establishment	Chapter
Bristol	c. 1520	A/AU	V

28 seats survive, rearranged by J. L. Pearson, with largely modern canopywork in two straight lines. Now positioned considerably further east than originally.

	Date/s	Type of Establishment	Chapter
Tong	c. 1480	PC	VI

Furniture still *in situ*.

	Date/s	Type of Establishment	Chapter
Gresford	c. 1500	PC	VI

Furniture still *in situ*.

	Date/s	Type of Establishment	Chapter
Halsall	End 15th c.	PC	VI

Fragments of seating and desking in the chancel.

	Date/s	Type of Establishment	Chapter
St George's, Windsor	1478–83	C	VII

Furniture still *in situ*. Important alterations and embellishments by Henry Emlyn, 1787–90.

	Date/s	Type of Establishment	Chapter
Henry VII Chapel, Westminster Abbey	c. 1512	C	VII

Originally 28 back stalls and two royal seats. Furniture has been moved somewhat westwards and pushed back between the arcade piers.

	Date/s	Type of Establishment	Chapter
Sefton	c. 1540	PC	VIII

Furniture, screenwork and nave benching still *in situ*.

Key to types of establishment

A	Abbey
AU	Augustinian Canons
B	Benedictine
C	Collegiate
CI	Cistercian
M	Minster
MC	Monastic Cathedral
P	Priory
PC	Parish Church
SC	Secular Cathedral

Choir-Stalls in the North-West of England in the Early Fifteenth Century

Three important early fifteenth-century choir-stalls in the north-west of England, at Carlisle Cathedral (Pl.1), Cartmel Priory (Pl.2) and Whalley Abbey (Pl.3) will be examined in this chapter. An attempt will be made to see how they are related, to hypothesise a sensible chronology, and to speculate on the circumstances of their patronage.

The choir-stalls at Carlisle Cathedral are most reasonably attributed to Bishop Strickland (1400–19).[1] An attempt to place them in the mid-fourteenth century is not convincing[2] since, although some of the masonry at arcade level in the chancel is about of this date, it is probable that the ritual choir was not sufficiently complete to be usable before Strickland's time.[3] The idea that the canopywork of the stalls is later in date than the seating[4] cannot be seriously sustained.

A major restoration of the buildings at Cartmel Priory was undertaken at the beginning of the fifteenth century.[5] The insertion of stained glass in the choir, datable to *c.*1420–30,[6] helps to fix the manufacture of the stalls. Stylistically, the furniture seems to belong to this time. The monogram incorporating a crown on two of the misericords quite probably refers to the Prior William mentioned in 1418 (Pl.4).[7]

It took over eighty years from the time of their move to a new site, in 1296, for the monks of Whalley to finish building their new church.[8] The provision of choir-stalls took even longer. The initials W.W. on one of the misericords (Pl.5), similar to the monogram at Cartmel, suggests that the choir furniture was made during the abbacy of William of Whalley (1418–34). This supposition is confirmed by an entry for the year 1438 in a fifteenth-century manuscript in the British Library (Harl. Lib. MS. 1830). The induction of a new abbot by the name of John is recorded as having taken place 'in the new choir-stalls'.[9] The record suggests that William's furniture commission took place towards the latter part of his abbacy.

It has been suggested that in the Romanesque building at Carlisle the choir occupied the first two eastern bays of the nave with the screen on the line of the western boundary of the surviving building.[10] The fifteenth-century choir-stalls occupy the first three western bays of the rebuilt fourteenth-century eastern extension. The same arrangement is found at Cartmel, but Whalley followed the earlier practice of using the east end of the nave.

All three sets of furniture consist of back stalls only with a desk in front. The cathedral furniture at Carlisle is by far the most extensive with forty-six seats. As the first bishop of Carlisle, created in 1133, was himself an Augustinian canon, he has always taken pride of place in the choir with a seat on the south

[1] Billings (1840), 3; John A. Cory, 'Carlisle Cathedral', *CWAAS Trans*, I, 1874, 34; R. T. Holtby *et al.*, 'Carlisle Cathedral', London, 1982 edn, 10. Leland records that Bishop Strickland 'fecit magnum campanile in cathedrali ecclesia a medietate ad summum, una cum quatuor magnis campanis in eadem, et stalla perpulchea in choro, et co-opertorium cancellae eiusdem'. See J. Leland, *Collectanea*, ed. T. Hearne, 1774, I, 346.

[2] See Dr Hugh Todd, *A Short History of the Cathedral*, MS in Carlisle Cathedral Library, 287, where he claims to have identified the arms of Robert Ecclesfield, founder of Queen's College, Oxford on the tabernacle work of the stalls.

[3] See Billings (1840), *ibid.*, and Cory (1874) above, 33, who claimed that Strickland's predecessor, Bishop Appleby (1368–95), probably finished the choir including gallery and ceiling.

[4] Holtby (1982) above, 10, and Bond (Stalls), 49 give the stall canopies to Prior Haythwaite (*c.*1430 onwards), as does Pevsner. See Nikolaus Pevsner, BOE, *Cumberland Westmoreland*, London, 1967, 92.

[5] Dickinson (1946), 49–60.

[6] Probably made by John Thornton of Coventry. I am indebted to Mr David O'Connor for this information.

[7] Dickinson favours a later Prior William mentioned in 1441, as a date for the choir-stalls (There were two more Prior Williams recorded at Cartmel, in 1381–96, and 1497–8 and 1501). But if the masonry and stained glass is indeed of the early 15th c., as he claims, there could be no objection to putting the date of the furniture as early as *c.*1420. In the standard text on medieval choir-stalls in Lancashire, Crossley dates the Cartmel furniture to 'about the same date' as that at Whalley *i.e. c.*1430. See Crossley (1919), 22.

[8] O. Ashmore, 'A Guide to Whalley Abbey', Blackburn, 4th edn, 1981, 5–7.

[9] 'in vigilia Omnium Sanctorum intravit conventus de Whalley in nova stalla tempore Johannis Eccles Abbatis'. See Whitaker (3rd edn, 1818), 75.

[10] J. C. Buckler, quoted in Vallance (1947), 36.

[11] See J. C. Dickinson, *The Origins of the Austin Canons and their Introduction into England*, London, 1950, 122 et seqq. For the status of the bishop at Carlisle and his relationship with the chapter see J. Wilson, 'The Priory of Carlisle', VCH, *Cumberland*, II, London, 1905, 131–51.

[12] Ashmore (1981) above, 7.

[13] Cartmel was in the diocese of York.

[14] There is a pair of early sixteenth-century desk ends at Aysgarth Church, N. Yorks, probably from Jervaulx. See Chapter III and Appendix.

[15] If this story were true, why was the seating not more seriously damaged than in fact it is? Is it not more likely that the superstructure was simply removed by the parishioners? It is certainly the view of John Dickinson that the neglect of the chancel during the reign of Henry VIII has been exaggerated.

[16] Tracy (1987), Pl.241.

[17] The foundations on the south side were not inspected. New stone steps have been provided for access.

[18] Also spelt Hathwaite and Huthwaite. The dates of his rule are inexact. His name occurs 27 May 1437 (Durham, Reg. Langley, f. 246), and on 20 July 1447, as Thomas prior of Carlisle (Cumberland County Record Ofice, Mounsey-Hayford Collection, will of Thomas Aglionby). He was also witness to a confirmation of a lease on 11 August 1457. See VCH, *Cumberland*, II, 151.

[19] Holtby (1982) above, 10.

[20] Cory (1874), 34.

[21] Billings (1840), 6.

side, as well as his own throne further east. The prior took the less prestigious position to the north.[11] At Carlisle, notwithstanding, there is no difference in the treatment between these seats and all the other choir-stalls, apart from the usual extra width. The other Augustinian house, at Cartmel, provided seating for only twenty-six. Cistercian Whalley probably had thirty-six stalls, the original establishment of monks, although in 1362 it is recorded that only twenty-six monks resided, even though the permitted number was sixty.[12]

Given the temporal and geographical proximity of the Carlisle and Cartmel monuments their closeness in style is hardly surprising. But the substantiating rider, already mentioned, is that both were Augustinian houses.[13] Whalley is of special interest as it is the only English Cistercian house for which we have any surviving choir-stalls.[14]

The stalls in all three buildings most probably had canopied superstructures. Only the Carlisle canopywork survives intact although without its sculpture. The superstructure of the Cartmel stalls was destroyed whilst the choir was, reportedly, left open to the elements during the sixteenth century.[15] There are slots still extant at the back of the seat capping projections to carry the canopy uprights.

CARLISLE CATHEDRAL

The Carlisle Cathedral stalls are still *in situ* and in a remarkably good state of preservation, except for the regrettable loss of more than one hundred and fifty wooden statues. Some of the latter originally inhabited the image housings on each alternate upright midway between the two zones of the canopywork (Pl.6). Most of them were placed at the upper level in threes under the canopies. In addition the corbels of the central canopy arch springers have been universally removed, as well as columns fronting the uprights at the back of the seat capping projections which at the top fitted into mortises still to be seen inside the cone shaped corbel-capitals. It is fortunate that the wainscoting behind the upper level of the canopy work, so often removed by nineteenth-century restorers, has been retained. All the standards of the seating and canopy supports are original. There is a complete set of desks (Pl.7) and all the misericords have survived.

The furniture is set on a low stone plinth punctuated at intervals by a quatrefoiled ventilation hole. This arrangement was first encountered in England at Lincoln Cathedral c.1370.[16] Its use was almost invariably adopted from the fifteenth century onwards. Most of the original stone foundations appear to be in place.[17] The seating also provides convincing evidence for a lack of disturbance. There are two sections of capping over six metres in length, and four of desking more than five and a half metres long.

It seems that the wooden furnishings of the choir were completed during the priorate of Haythwaite[18] from c.1430. The last-named was probably responsible for erecting the extant wooden pulpitum and projecting loft,[19] a bishop's throne[20] and a series of parclose screens around the east end. However, a modernisation programme in 1764 saw the wholesale removal of surviving screens (apart from Prior Salkeld's early sixteenth-century structure on the north side), high altar, bishop's throne and pulpit.[21] The terminal wing screens of the return stalls were cut off some sixty centimeters above the capitals of the uprights and refashioned when the new entranceway was inserted. The terminal screens at the east end of the lateral stalls are original.

The canopywork was originally painted in conformity to general practice and there are many traces of polychromy to be seen. The plain panelling at the back of the stalls was decorated with scenes from the life of SS Augustine, Cuthbert and Anthony and imaginary portraits of the twelve apostles. This decoration was carried out long after the erection of the furniture during the episcopate of Richard Bell (1478–95).[22]

There can be no doubt that the pulpitum (Pl.8) and tribune above the choir entrance, are later in date than the main body of the choir furniture (Pl.9). The building sequence is very unusual. Yet it is possible that Strickland, who was engaged on the restoration of the north transept destroyed in the 1392 fire,[23] as well as the furnishing of the choir, was compelled to assign the erection of the new pulpitum a low priority. In any case, during the rebuilding of the north transept the centre of the crossing may have been out of commission and the completion of the choir at the west end impractical. The high proportion of restoration work on the extant pulpitum and tribune makes a stylistic interpretation very difficult. The whole of the structural vault, apart from the bosses, the upper zone of the tribune on the east side and the loft to the west, are restoration work. The blind arcades on either side of the entranceway and on the west side of the pulpitum, with their finely articulated mouldings, ogee curves, and use of voluted 'trefoil' leaf crockets, are an archaising reference to the fourteenth-century Decorated style. The restored condition of the loft on the east side suggests that its original decorative embellishment was probably intended to harmonise with the earlier canopy work.

The pulpitum and tribune can be approximately dated to the mid fifteenth century from the coats of arms on its eastern side: those of William Percy, Bishop of Carlisle (1452–60), to the north, and of either Richard Neville, Earl of Salisbury (1428–71), or Ralph Neville, Earl of Westmoreland (1456–1523), to the south.[24]

The inner lower canopies of the return stalls are uncomfortably close to the base of the projecting tribune. Moreover, the uprights supporting them visibly bend outwards. Both phenomena strongly suggest that the loft, for all its stylistic homogeneity with the original woodwork, is a later insertion. The close match of the gablets on the loft with those at the top of the stall canopywork has led a number of earlier writers to assume that the superstructure of the choir-stalls is later than the seating.[25] Allowing for the difference in scale, a comparison of the decorative carving on both components of the furniture leaves us in no doubt that the build was a single campaign. In particular, the squared-off treatment of flowers with four triangular petals and button-like stamen, singly or in groups of three or more, and sometimes characteristically incised or drilled, can be easily recognised throughout. The notion that choir-stall canopywork is later than its accompanying seating surfaces from time to time but is only rarely convincingly demonstrated.

Certainly, the total loss of the statuary on the superstructure has the effect of alienating one part of the furniture from the other. The existence of dowel plugs on the bases of the triangular plinths, and sometimes sawn off pegs still *in situ* on the upper canopies with nail holes behind, is proof of the former existence of this sculpture. One figure from the lower zone survives on the north return stalls (Pl.10). It may well be supposed to represent an Augustinian canon wearing the characteristic skull cap of the order, cassock and scapular. Besides the scrip and rosary hanging from his belt is an object hard to identify but which could be a knife in a sheath. There could have been four such figures at this level at the west end. Two of these must have been sacrificed when the loft was intruded, well before any deliberate acts of iconoclasm. There can be

[22] E. Colledge, 'The Augustine Screen in Carlisle Cathedral', n.d. See also B. Colgrave, 'The St Cuthbert Paintings on the Carlisle Cathedral Stalls', *The Burlington Magazine*, July 1938, LXXIII, 17–21.

[23] Cory (1874) above, 33.

[24] Holtby (1982) above, 10.

[25] See, for instance, Holtby (1982), 10.

little doubt that in the first place the entranceway superstructure was handled differently. Its original form may have been no more than a flat projection of the return stall canopies bridging the gap between the north and south sides.

CARTMEL PRIORY

In compensation for the total loss of the original superstructure, the Cartmel stalls are, at least, still *in situ* and standing on their original foundations, although the floor has been raised by some 30 cm (Pl.2). As at Carlisle, the desks are raised on stone plinths pierced with ventilation holes (Pl.11), and the junction standards are carved from a single block of wood (Pls 12a & b), as instanced[26] at Lincoln c.1370, and the misericords are peg-hinged.

WHALLEY ABBEY

The stalls are said to have been removed from Whalley Abbey in 1537,[27] a year after confiscation by the Crown resulting from the attainder of Abbot John Paslew for involvement in the Pilgrimage of Grace in 1536.[28] Eighteen canopied stalls were placed in the parish church. The earliest record of their arrangement was made by Whitaker in about 1818 (Pl.13).[29] This shows six return and twelve lateral stalls with matching desks and desk ends placed to the west of the medieval choir screen. The number conforms to the existing tally of misericords in the parish church. Later in the nineteenth century, when the choir-stalls were 'restored',[30] four misericords and canopies were added. At present there are twelve stalls on each side but only ten seats on the south.

From the nineteenth-century engraving, we can deduce that a home was found for only half the original number of stalls. Of the other eighteen, the eight seats in Blackburn Parish Church (now Cathedral) are almost certainly part of the Whalley furniture. There are, admittedly, some small inconsistencies at Blackburn in the measurements but this is to be expected. Having made allowances for the restoration work at Blackburn, both sets of woodwork are stylistically very close indeed (Pls 14a & b). The shape of the misericords with pruned shoots either side of the supporter branches is the same. The mouldings of the seat standards, the characteristic handling of the elbows, and the treatment of the angels, are identical. Another four seats at the church of St John, at Holme-in-Cliviger, Lancs, said to have come from Blackburn Parish Church,[31] are also almost certainly from Whalley Abbey.

As is to be expected, much of the extant furniture at Whalley is nineteenth-century, specifically, four misericords; six canopies and vaults; all of the desking; all the desk ends, except two at the east end of the north side; six seat standards; some of the seat rail, capping, and wainscoting; some of the canopy uprights, seat back tracery and canopy vaults; and the wing screens at the east and west ends.[32] When the stalls were restored, it is a great pity that the return seats were placed against the side walls. However, the form of the seat junctions in the western corners was retained at the time of the restoration. On the south side (Pl.15) the capping junction is old, as is also a greater part of the southernmost seat standard. The traces of carving on the surviving seat division were interpreted by the Victorian joiner as a lock of hair, and a fitting companion made. Originally, these junctions would have been carved out of one block of wood, as at Cartmel and Carlisle (Pls 12a & b). The junction on the north side is completely modern. It is possible that the rearrangement of the

[26] Tracy (1987), Pl.167.

[27] Whalley Parish Magazine, 1883, 4. I am indebted to Mrs Joy Davenport for generously sharing her knowledge of Whalley local history.
[28] S. T. Taylor-Taswell, *Whalley Church and Abbey*, Blackburn, 1905, 33.

[29] See Whitaker (3rd edn, 1818), pl. facing 247.

[30] Crossley claims this was in 'about 1844'. See Crossley (1919), 22–23, 25–36.

[31] W. Farrer & J. Brownbill (eds), VCH, *Lancaster*, VI, 486–87. I am greatly indebted to Mrs Davenport for supplying sketches of the Holme-in-Cliviger woodwork. These show beyond a doubt that the fragments were also part of the original ensemble.

[32] The restoration work is itemised in Crossley (1919), 35–36.

stalls may have been made some time before the restoration, otherwise the seat junctions would not have needed to be reinstated. The upper part of the western junctions at wainscoting level is probably reliable on the north side, but the traceried wing-screens, as already mentioned, are wholly fanciful. Probably the greatest loss at Whalley is the upper part of the canopywork. On removal from the abbey, probably for lack of head-room, this crucial component of the furniture was discarded.

It is possible that we know the name of the man who carved the Whalley Abbey stalls. Some Italians, and a certain Eatough, are supposed to be mentioned as carvers in the abbey Coucher Books or Bursar's Accounts for the early fifteenth century.[33] It is recorded that Eatoughs were 'woodmen' at Whalley from the thirteenth to the nineteenth centuries.[34] The mediocre quality of the decorative carving at Whalley provides substantiating evidence for the merely provincial standing of the artist.

If the superstructure at Cartmel and the canopywork at Whalley were still intact, the generalisation could almost certainly be made that the appearance of all three sets of choir-stalls, spanning a period of some twenty years, was remarkably similar. The Carlisle and Whalley furniture typifies the tendency in choir-stall architecture of the later Middle Ages towards dematerialisation, or the merging of individual elements of a design into an impressionistic whole, that can in retrospect be seen to have begun at Lincoln,[35] and taken firm root at Chester,[36] Nantwich[37] and York (Pl.80).[38] There can be no denying that the Carlisle canopywork, even allowing for the loss of its figure sculpture, tends to plainness and a certain mechanical regularity. The tendency during the latter part of the fourteenth century for choir-stalls to become more stylistically and sculpturally homogeneous has been noted elsewhere.[39] The Rayonnant aesthetic, as instanced in the early fourteenth century at Winchester Cathedral,[40] of clearly differentiated and individually sculpted units of design repeated in echelon, was rejected in the later monuments. The individuality of each particular canopy was reduced by the gradual diminution of the characteristic early fourteenth-century love of foliate ornament. The process was marked by the increasing ability to read a monument in either a vertical or horizontal direction, as at Lincoln and Chester.[41] This visual ambiguity was further emphasized at Nantwich where the designer jettisoned the time-honoured deployment of clear-cut horizontal zones,[42] partially conflating one into another in a vertical sense. He went still further by sometimes removing the uprights of the stalls, exploiting to the full the use of tracery on the stall backing, a motif deployed for the first time at Chester.

It could be argued that the achievement of the Nantwich master at the end of the fourteenth century was a once-for-all masterpiece, and a stylistic aberration. It is certainly true that for the most part English choir-stall makers for the remaining life of the Gothic style seem to have adhered to their time-honoured practices. Perhaps the major exception is St George's Chapel, Windsor in the late 1470s, where some of the canopywork approaches Nantwich in originality and effect (Pls 160, 163, 167 & 168).[43] Certainly, the Carlisle canopywork in comparison to Nantwich is distinctly revisionist. The zonal ambiguities at Lincoln and Chester are enhanced, at Carlisle, by means of the quatrefoil frieze which threads its way visibly between the lower canopies and the image housings above (Pls 1 & 6). The canopies are punctuated by this volume-defining device. A similar stratagem is employed at the upper level

[33] Unfortunately, after a thorough search, Mrs Davenport has not been able to track down the supposed reference.
[34] T. D. Whitaker, *An History of the Original Parish of Whalley*, 2 vols, 4th edn, 1872–76, II, 143 and R. N. Whitaker, *Handbook of Whalley*, 1884, 74.

[35] Tracy (1987), Pl.169.
[36] Tracy (1987), Pls 176–77.
[37] Tracy (1987), Pl.189.
[38] The York choir-stalls were probably made c.1425. See Chapter III, Note 46. The Chester stalls are datable to c.1390 and the Nantwich stalls to c.1400.

[39] Tracy (1987).
[40] Tracy (1987), Pls 52, 55 & 59.

[41] Tracy (1987), Pls 169, 176 & 177.

[42] Tracy (1987), Pls 189 & 210.

[43] See Chapter VII.

where, instead of the tracery backing being recessed in the centre for a single statue, as at Lincoln and Chester, it projects forward to support not one but three statue bases.

It can be seen that the Carlisle superstructure can be criticised for a lack of visual differentiation. It is doubtful, even if the original statuary could be restored, that this restless visual matrix would be seen to work any better. Compared to the fourteenth-century monuments discussed, when confronting Carlisle, it is difficult to repress a sense of loss. This is not occasioned by the undoubted comparative blandness of the decorative sculpture. After all, the ornament on the Nantwich canopywork is much less varied than that at Chester. In any case, much of the decorative carving on the Carlisle stalls is not uninteresting.[44]

The undoubted impoverishment is due to shortcomings of design. The omission of the band of blind tracery below the lower canopies, so effectively exploited at Chester and Nantwich, misses a proven opportunity to counteract the restrictive horizontality of the waving quatrefoil frieze between the two zones of the design. One of the most effective devices used in late fourteenth-century choir-stalls was the doubled arch on the lower canopies. The layering effect lent a richness to the lower part of the design by virtue of the additional sculpture. It afforded a hierarchical emphasis as well as providing a visual anchor at this level. It had the additional advantage of projecting the canopy well out, thereby tending to take attention away from the restrictive but necessary uprights below. By ignoring this device the Carlisle master-carpenter has condemned his design to a certain pedestrianism. The deployment of three statue housings at the upper level instead of one imparts a heavy block-like effect to this zone instead of the hierarchical pyramidal elevations at Lincoln and Chester. Finally, when the canopywork is eventually allowed some freedom in a vertical sense, the spires of the upper level are found to be quite unable to hold their own. This is partly due to constraints on the vertical dynamic imposed by the mid-level frieze but, for the most part, it is the inevitable consequence of a weak design.

Another instance of comparative impoverishment to be seen both at Carlisle and Whalley is the use of simple transverse rib vaulting, with the occasional tierceron above the lower canopies, compared to the sophisticated lierne vaulting employed at Lincoln, Chester and Nantwich. Admittedly the Whalley canopy vaults do use independent ribs, but merely to join up the ends of the tiercerons (Pl.79). It will hardly need stressing by this stage that these north-country churches did not have the privilege of a royal workshop to make choir furniture for them. On the other hand, it is perhaps surprising that such comparatively small Augustinian and Cistercian houses should have countenanced even this level of design sophistication.

The stalls at Carlisle, Cartmel and Whalley must have been made over at most a twenty-five year period from c.1410 to c.1435. It is perhaps surprising that they were not the work of the same team, considering the comparative paucity of great religious houses in the north-west of England. On the other hand, we probably tend to regard the Pennines too much as a physical and cultural barrier at this time. The Carlisle master-carver and his assistant could have found employment throughout the north of England. The joiners at Whalley and Cartmel may have been permanently attached to these institutions. When undertaking the making of a new set of choir-stalls they would have visited a geographically convenient building, containing a recently manufactured set, to study the design of the furniture and its decoration. They would also have taken advice from colleagues on appropriate joinery techniques.

44 The variety of cusp terminations on the arches of the lower canopies is not inconsiderable.

6

The structural features which these stalls have in common, such as the carving of the junction standards and the canopy vaults in the solid, probably reflect workshop practices common at this time throughout England. The consistency of choir-stall design throughout the Gothic period is a perennial source of wonder. One structural feature, however, to be found at Carlisle and Cartmel, may well have a Morellian significance. In both buildings on the end stalls a section of the upper part of the standard, has been left in place between the elbow and the top of the incurving upper moulding (Pls 16a & b).[45] This device is presumably intended as a brace to give extra strength to the end standard which had to bear the weight of the terminal wing screen built against it. This joinery technique recalls the 'blocking-in' procedure used in the same way at Winchester Cathedral in the early fourteenth century, and is used in identically the same way at Hereford Cathedral.[46] But this device in these two north-country choir-stalls occurs nowhere else at this time in England. This suggests that there was at least an unusually close consultative relationship between the two workshops. On the other hand the mouldings on the seating, including the shape of the misericords in both places, although of a similar type, are by no means identical (Pls 17 & 4). By the same token, the form and design of bench ends and desking at Carlisle and Cartmel is undeniably close (Pls 7, 11, 18a & 85). Another feature of both sets of stalls which is closely comparable is the strict alternation of foliage and figurative standard elbows.

Many of the ornamental features which these two sets of stalls have in common, such as the ogee terminations at the top of the standard mouldings and the crowned heads on the standard junctions, derive from the common stock inherited from the fourteenth century. A close comparison of the decorative sculpture at Carlisle and Cartmel shows that the two sets of furniture were not carved by the same artists. At Carlisle it is very difficult to differentiate more than one hand. However, it is hard to believe that one craftsman could have carved the entire decorative sculpture single-handed, since work on the misericords would have occupied about four years alone. In this context it is as well to remember the ability of members of a workshop, particularly the apprentices, to adopt a 'house style'. In the foliage decoration at Carlisle a single leaf can be presented in a natural way or squared-up conventionally (Pls 19a–d). In addition, an altogether more stylised squared-up circular format is common (Pls 20a–d). A common conceit on both misericord supporters and seat standard elbows at Carlisle is the leaf wound up into a spiral with new growth pushing through the centre (Pl.82a). The carver at Carlisle likes pellets in various combinations and protuberances.

Perhaps the most obvious difference in the decorative carving at Carlisle and Cartmel is the design of the misericords. It is true that at Cartmel pellets and protuberances are again in evidence, although not so commonly. But the carving, possibly the work of one hand, is distinctly less refined, although equally vigorous. A peculiar characteristic is the treatment of the eyes of the human and animal heads with their drilled pupils (Pls 12a & 83). The foliage is much less naturalistically handled, and the 'squared-up' forms of Carlisle, here, have a rounded profile (Pls 21a–d). The dragon heads and angel elbows, although sharing characteristics with Carlisle's, are clearly by a different hand. Some of the foliage forms are extremely fanciful and betray a degree of provincialism. The pose of the angels on the standards is similar to that at Carlisle with the tips of the wings pushed down. Also the Cartmel artist uses the conceit of new growth pushing through the centre of a naturalistic foliage standard elbow (Pl.82b).

The Whalley superstructure (Pl.3), with its slightly tipped-up canopies and blind tracery below, was probably in its original state aesthetically more

45 At Carlisle these braces have been removed on the return stalls.

46 Tracy (1987), 18 & Pls 56a & b, 57 & 96.

7

47 Crossley illustrates a selection of moulding profiles from Cartmel and Whalley. See Crossley (1919), facing 36 & 37.

successful than Carlisle. The mouldings of its seating, and the shape of its misericords, are nearer to Carlisle than Cartmel and, in common with the other two stall sets, its misericords are peg-hinged.[47] Some of the decorative tympana of the lower canopies at Whalley recall those at Carlisle. They are more broadly treated with foliage designs and sometimes grotesque human faces.

Compared with Carlisle, what the misericords at Whalley lack in sophistication and subtle draughtsmanship, they make up for in clarity and a certain rustic vitality (Pls 5, 24 & 25a, b, e & f). They are all of a piece with the exaggerated out-of-scaleness of the standard elbows (Pls 14a & b). The angel standard elbows resemble quite closely those on the other monuments, except that they conform to the characteristic disc-like profile of the rest (Pls 22a–c). Whalley's surviving desk-ends resemble Cartmel and Carlisle with a centralised tracery design and massive moulded buttress attached (Pls 18a & b, & 85). The surviving poppy head is very remarkable with two pairs of feathered angels one on top of the other (Pl.23). The decorative repertory is broadly comparable with that in the earlier furniture but the quality of the carving is often poor (Pls 25a–f).

Without doubt, however, the most telling comparisons are between Cartmel and Whalley. Both monuments must have been made within no more than fifteen years of each other, and are close geographically. But although the Whalley craftsman shows a knowledge of the earlier monument he is not the Cartmel artist. The main interest at Whalley is the conjunction of subject matter with Cartmel, notably the treatment of the vine for the prior's misericord with an identical form of monogram surmounted by a crown (Pls 4 & 5), the depiction of a three-faced green-man on a misericord (Pls 83 & 84), and another with the 'Pelican in her Piety', and an angel with wings outstretched. The treatment of some hair and beards on misericords and their supporters might suggest that the Whalley artist tried to copy the style of the Cartmel carver also (Pls 25f & 83), although men wore their hair in rolls throughout England at this time. The use of human heads as supporters, particularly heads in profile, recalls the woodwork at Nantwich, Chester and Lincoln.

We have examined the choir furniture in three great fifteenth-century English churches in the remoter western side of the Pennine ridge. The quality of workmanship, at its best at Carlisle Cathedral, is always well below the standard set by the north-country Lancaster Parish Church or Chester Cathedral from the fourteenth century. For various reasons, it seems, Carlisle was not able to attract a first-rate master carpenter. Clearly the man who was hired to do the job did his best to produce an impressive piece of architecture. But suitable models close to hand were wanting. He may also have lacked skilled assistance which could account for the mechanical nature of most of the joinery of the superstructure. The Cartmel Priory and Whalley Abbey operatives were probably estate carpenters. The craftsman at Augustinian Cartmel was *au fait* with the earlier furniture at the sister episcopal church of Carlisle. He seems to have studied the joinery techniques used there closely. The Whalley master evidently knew the furniture at Cartmel, and made direct copies of several of the misericords. Presumably there were no suitable models for him at the neighbouring Cistercian houses at Jervaulx, Fountains, Kirkstall or Sawley. In any case, it is likely that there was no distinction in choir-stall design to be made between the different monastic orders. Had the buildings under discussion been collegiate or parish churches the level of artistic quality could have easily been on a par. The establishments examined, although comparatively large, were far from wealthy. Moreover, the scope of their artistic patronage was probably restricted by their provincial status.

Early Fifteenth-Century Choir-Stalls in Shropshire and Herefordshire

The survival in Ludlow, Leintwardine (from Wigmore Abbey) and Montgomery (from Chirbury Priory) parish churches (Pls 26–28) of early fifteenth-century choir-stalls in fragmentary or altered condition prompts a discussion of ecclesiastical furniture design and decorative carving in these formerly remote marcher counties. The Augustinian furniture at Wigmore and Chirbury is stylistically provincial in comparison with that in the thriving collegiate church of St Laurence, Ludlow. Connections can nonetheless be made. This is hardly surprising when we learn that the Mortimer family, whose ancestral seat was at Ludlow, were generous benefactors of Wigmore. In his will of 1 May 1380 the third Earl of March, Edmund Mortimer, stated his wish to be buried in the abbey choir. He bequeathed the sum of £1000 for building works and a long list of gifts.[1] Chirbury lay some twenty-five miles to the north-west. It formerly contained choir-stalls, closely related both stylistically and architecturally, to those at Wigmore. However, the unequivocal identification of the same workshop of wood carvers and joiners in two different buildings is a rarity in the history of English medieval choir-stalls. Even at Wigmore and Chirbury there can be no absolute certainty in the matter.

A major pre-occupation of this chapter is the dating of these monuments. At Ludlow, contrary to the established view, it will be argued that all the choir seating could be as early as c.1415, whilst only the stall backing relates to the recorded purchase of timber for the choir-stalls in the mid-1440s. There seems to be a total lack of information about the building of the chancel at Chirbury. Moreover, all traces of this part of the priory church have disappeared and there are no relevant records. At Wigmore it is recorded[2] that, when Edmund Mortimer died in 1381, the exterior work had been built to the height of the eaves, but the church still needed a roof. The suggested dating for the Wigmore and Chirbury furniture of c.1415 is based on the supposition that Wigmore Abbey church must have been finished by about that time, and on the late fourteenth-century stylistic resonances in the work. The extent of the furniture in both houses and its accompanying screenwork is unknown. Neither monument seems to have had any substalls. At Chirbury the furniture could hardly have been extensive since the chapter consisted of no more than a prior and five to six canons.[3]

LUDLOW

At Ludlow, the present arrangement consists of thirty-two seats with fourteen lateral and two return stalls each side. The uprights, bottom rail and most of

[1] H. Brakspear, 'Wigmore Abbey', *Arch. Jnl*, XC, 1933, 29.

[2] *Ibid.*

[3] D. Knowles and R. Neville Hadcock, *Medieval Religious Houses. England and Wales*, London, 1971, 154.

the cornice of the stall backing are probably original, as is most of the wainscoting (Pl.29). The decoration of the superstructure, however, is entirely the work of George Gilbert Scott (1859–60), as can be deduced from a lithograph of the choir-stalls looking east published c.1850 (Pl.30).[4] In this, only the minimum of embellishment is indicated. The original canopywork and sculpture is supposed to have been removed in 1548.[5] The stall backing at Ludlow is, exceptionally, most probably of a different campaign to the seating. The wing screens at the east end have been mutilated to accommodate the terminal seat standards each side (Pl.31). Moreover, the irregular spacing of the uprights on the backing belies the possibility that a marriage was originally intended. The intervals closely approximate to the centre-to-centre measurement of the seats below, it is true, but the irregularities betray a lack of coherence. The stalls are fronted by a row of desks each side, mounted on stone plinths with ventilation holes. The decorative carving on the desk ends is closely related to the misericords, and so the desking and seating must have been made at the same time.

The existing wooden choir-cum-rood screen has been heavily restored and remodelled at different times. The choir entrance was widened, probably in the early seventeenth century, thereby reducing the number of return stalls from six to four. The wainscot panels behind the tracery above dado level next to the entrance on the west side have at some time been removed. This was probably in the interests of better visibility west to east, although the backs of the seats on either side of the entrance are now panelled. Surviving tracery heads at the base of the outer bays on the west side of the screen display foliage carving similar to that on the choir-stall desking and misericords (Pl.32). They are probably refugees from a choir screen coeval with the surviving choir-stall seating. At the same time, the vaulting and cornice go with the backing of the stalls in the choir itself.

The whole suite of furniture was probably fitted under the crossing, following the rebuilding of nave and transepts during the latter part of the fourteenth century.[6] Unfortunately, from the mid fourteenth to the mid fifteenth century at Ludlow there is a complete absence of building accounts. Consequently, any attempt at dating the choir-stalls has to be based largely on stylistic criteria. However, we do know that the present central tower replaces a probably early fourteenth-century one, and that it was positioned so as not to disturb the existing screen.[7] It is contended here that the extant stall seating belongs to the late fourteenth-century crossing refurbishment programme, and was subsequently incorporated into the mid fifteenth-century chancel extension. With the three return stalls on either side of the entranceway, as opposed to the existing two, there would have been a grand total of thirty-four seats. The four existing return stalls are of mainly nineteenth-century workmanship, and only the seating junction on the north side is wholly authentic. The floor of the choir has been slightly raised and the return desks and stone plinth almost certainly truncated to allow for a wider choir entranceway (Pl.33). The original foundations were presumably removed during the nineteenth-century reflooring.[8]

In 1447 it is recorded that the Ludlow Palmers' Gild paid 'for one hundred boards of Waynscot' bord'' bought at Bristol with the money of the Gild by the 'licence and grant of the Warden and Council of the same Gild for making new stalls in the high choir of the parish church of St Laurence of Ludlow, of which the price, including carriage, is £5: 6s: 8d'.[9] Since the nineteenth century it has always been held that the existing choir-stalls with most of their misericords were built at that time. However, two scholars suggested that eight misericords, apparently 'signed' with a maker's mark of an uprooted-plant,[10] were earlier

4 I am grateful to Mr David Lloyd for bringing this to my attention.

5 P. Klein, 'The Misericords and Choir-Stalls of Ludlow Parish Church', Ludlow, 1986.

6 For an outline building history see David Lloyd, 'St. Laurence's Church Ludlow. A History and a Guide', Ludlow, 1980, 2–3.

7 Ibid., 10. See also the observations on the fourteenth-century rebuilding at Ludlow in Richard K. Morris, 'Late Decorated Architecture in northern Herefordshire', Woolhope Society, XLIV pt I, 1982, 36–59.

8 Acoustic jars were found inside the quatrefoil openings in the desk plinths.

9 Shropshire Record Office, 356/box 321. Account of Richard Knyghton and Richard Ryall, Stewards of the Palmers' Gild of the Blessed Mary and of St John the Evangelist of Ludlow, in the time of John Parys, then Warden of the same Gild, from Michaelmas 25 Henry VI (1446), for one whole year. I am most grateful to the Shropshire Record Office for their help in providing the translation, useful general information about the Gild accounts quoted below, and the following transcript: Transcript of second entry in Discharge of Account (italics represents reconstituted) – 'Et in Centum mensis vocatis Waynscot' bord' emptis apud Bristoll cum denariis Gilde ex licencia et concessione Custodis et consilii eiusdem Gilde pro novis stallis faciendis in alto choro ecclesie parochiale sancti laurencii de lodelowe quarum precium est cum cariagio v li. vjs. viijd.'. From the surviving five Stewards' annual Account rolls it would seem that outgoings were normally associated with the upkeep of their properties, and the annual celebrations at Whitsuntide. The purchase of the timber in 1446–47 is the only instance of money allocated to subsidising the St Laurence's church fabric. It is unlikely that the Gild paid for the making of the stalls. Their primary interest in the establishment was with the chapel of St John the Evangelist within it.

10 Now positioned, counting from the east; N.3, 5 & 7; S.1, 8, 9, 12 & 13.

than the others.[11] More recently, an attempt has been made to expand this supposedly earlier grouping to sixteen carvings.[12] Accordingly, this group of misericords, dated to c.1425, was part of a new set of stalls arranged eight a side, without any return stalls. The remaining seats belonged to a mid-century refurbishment scheme. This is an ingenious theory, but it is open to criticism. At only sixteen, the number of seats posited must be too few for a collegiate church of this size and importance. In the much smaller churches at Arundel (Fitzalan Chapel), Sussex and Nantwich, Cheshire there were thirty and twenty back stalls respectively. Even Etchingham, Sussex has eighteen stalls. Leland records that at Ludlow there was a college of ten priests to service the needs of St John's Chapel, used by the Palmers' Gild.[13] In addition there would have been regular clergy and chantry priests. We should also bear in mind that there were no substalls at Ludlow to cater for occasional increases in attendance.

It is suggested that, at the time of the recorded acquisition of timber in mid-century, the complete earlier so-called 'set' of sixteen seats was combined and placed on the north side of a new enlarged set of choir-stalls, an additional twelve seats being made and set up on the south.[14] Finally, the insertion of four new return stalls, after the enlargement of the tower piers 'in the 1450s', is seen as the final piece in the jig-saw.[15] It is maintained that at this time the stalls were 'moved eastwards by several feet'[16] to accommodate the return stalls.

It will be argued that the premises of this putative chronology are flawed, and that all the twenty-eight surviving misericords must be of the same date, although probably carved by two different hands. The seat standards on the south side are not substantively different from those on the north, as has been claimed.[17] Small differences in detailing are to be expected in a set of furniture made by two different craftsmen. Any disparities between north and south are not out of the ordinary in these circumstances. They certainly do not justify the adduced caesura of twenty years.

It would be wrong to assume that, because the return stalls are of nineteenth-century date, they were wanting originally. Often in contrast to continental Europe, return seats were a regular feature of English choir-stalls. There is no reason for thinking that Ludlow was an exception. There seems to be no evidence for claiming that the stalls were moved eastwards at any time,[18] although they must have been set on new stone foundations, as the masons' marks on the extant plinths are said to be identical to those on the central tower. Finally, if the seats on the north side are from the early choir-stalls, why are there five misericords with the uprooted-plant 'signature' on the south side? In spite of the wholesale temporary removal of the furniture in the mid-nineteenth century, it would appear that only two of the misericords have been disturbed.[19]

If we subject the carvings themselves to a detailed stylistic analysis we find that they must have always constituted a discrete interrelated corpus. Thomas Wright was the first to suggest that the 'signed' carvings were different (he thought they were superior) to the others.[20] He believed that they were mostly of earlier date. Ever since, the supposed discontinuity in manufacture of the seating has held sway. Wright instanced the dagged borders of the coats in the 'worshipping of the beer-barrel' carving being of the time of Richard II (Pl.34). Later commentators have followed this tradition.[21] Two of the 'signed' misericords (N.5 & S.9) display foliage of late fourteenth-century type such as that on the Lincoln Cathedral choir-stalls of c.1370 (Pls 35a–d). The treatment of the voluted 'trefoil' foliage on N.5 with its sharply-cut dagger-shaped reverse images would not be out of place at any time from the 1320s.

It has been observed that this fourteenth-century type foliage occurs also on

[11] See D. H. S. Cranage, *An architectural account of the Churches of Shropshire*, I, Wellington, 1901, 120; and Thomas Wright, *The History of Ludlow*, Ludlow, 1852, 479.

[12] Klein (1986), above, 2.

[13] W. C. Sparrow, 'The Palmers' Gild of Ludlow', *Shropshire Arch. Soc. Trans*, Ser. 1, I, 336.

[14] It is implied that there were sixteen seats on one side and twelve on the other, with as yet no return stalls.

[15] Klein (1986), above. The central tower was certainly a long time in the building. For this Lloyd adduces the capture of Ludlow by the Lancastrians in 1459, and the possibility of there having been a fire. But there seems to be no reason why the foundations should not have been in place by the late 1440s.

[16] Klein (1986).

[17] Klein (1986).

[18] According to Lloyd, the site of the rood screen in the fifteenth century was the same as before.

[19] Klein (1986), 2.

[20] See Note 10, above.

[21] See, in particular, Cranage (1901) above, 118: 'Some of the misericords may be part of the old stalls which preceded the present ones'; and H. T. Weyman, 'The Church of S. Lawrence', Ludlow, 1931, 8: 'The misericords are of more than one date, some going back to the reign of Richard II, as the style of dress and ornament clearly shows, and most of these bear a distinctive mark. The others must be attributed to the year 1447, when the Palmers' Guild of Ludlow bought at Bristol planks to make new stalls'.

22 Weyman (1931) above.

23 Tracy (1987), Pls 183, 184 & 206.

24 See above, and Klein (1986).

25 Klein (1986), 2.

26 cf. Tracy (1988), Pl.28. The church of St Nicholas, King's Lynn was completed in 1418. See Beloe (1899), 111.
27 Weyman (1931) and Klein (1986). I am grateful to Mr Brian Sprakes for advice on some heraldry matters.

28 Weyman claimed that the choir ceiling and the later choir-stalls were the work of the same hand. See Weyman (1931), 9.

29 RCHM, City of Oxford, 1939, 17 and Klein (1986), 5.

30 Ibid., Pl.69.

carvings which are not 'signed'.[22] A good example is N.11 which displays typical hawthorn foliage (Pl.36). Here the treatment of the crowned head in the centre follows closely a tradition established at Lincoln, Chester, and elsewhere.[23] The foliage carving is very close indeed to that on S.9, an un'signed' carving (Pl.35d). By the same token, the carving of the bishop's face on another 'signed' misericord (N.7), with the drilled eyes, rounded lower eyelid, sharply-cut eyebrows, prominent cheek-bones and aquiline nose, must be by the same artist (Pls 36 & 37).

There can be no doubt that the first hand was responsible for more than simply the 'signed' work. On the basis of the so-called 'signature', and the accompanying foliage, a group of twelve carvings can be assembled as, most probably, the work of the 'uprooted-plant' master (N.3, 5, 7, 9, 11, 12, & S.1, 3, 8, 9, 11, 13). Supposed minor differences in the treatment of the angel elbows on each side of the stalls at Ludlow have been adduced in support of the three-stage building hypothesis.[24] But these variations are certainly not, in my view, substantive enough to carry the argument.

It is not the intention here to effect a definitive stylistic grouping (N.1, for instance, is also most probably by the 'uprooted-plant' master). Suffice it to say, on the basis of the treatment of certain common motifs such as the waving ribbon, also seen on seat standard elbows, and the wings of birds, it is possible to demonstrate that this body of woodwork amounts stylistically and chronologically to a seamless web. Of the two executants, the 'uprooted-plant' master represents an earlier generation with traditional ties to the fourteenth century.

The suggested dating for the early fifteenth-century furniture at Ludlow of c.1425[25] is reasonable, although the hennin featured on a misericord (N.1) (Pl.39a), for example, and the foliage treatment, favours a slightly earlier manufacture. Although too old to have worked himself at Lincoln, the 'uprooted-plant' master at aged sixty could as a young man have been associated, for instance, with the Chester Cathedral choir-stalls (c.1390). The younger of the two men carved in a more robust style (Pl.38). He can, perhaps, be compared to the master-carver at St Nicholas, King's Lynn at about this time.[26]

The dating of an unspecified number of the Ludlow misericords to the mid-1440s has been based largely on their heraldry.[27] However, the suggested backwards adjustment in the dating of these carvings made here need not conflict with any of the heraldic hypotheses presented. The Yorkist symbols of the falcon and rose within a fetterlock (N.13 & S.15), and the Lancastrian gorged antelope (N.6), are as applicable in c.1415 as 1445.

Another reason for the received mid fifteenth-century dating of some of the misericords is the stylistic and iconographical parallels with the choir ceiling that have been adduced.[28] Two of the heraldic images on the ceiling, a rose within a fetterlock and a chained antelope, are also found on the misericords. There are also other closely related images such as the falcon and fetterlock. However, the assumption of a close stylistic parallel, let alone the possibility that both works are by the same hand, is unwarranted.

Parallels have been drawn with the misericords in the collegiate chapel at All Souls, Oxford, consecrated in 1442.[29] There is no close stylistic relationship between the two sets of carvings, but there are several identical motifs employed, such as the falcon and fetterlock, owl, pedlar, king's head, and peacock's feathers. One or two of these appear to be modelled on the Ludlow rendering or to share a common model, such as the dancers (All Souls, N. side (s) vs Ludlow N.1), and the pedlar (All Souls, N. side (r) vs Ludlow S.3).[30] The foliage at All Souls is more conventionalised by comparison with Ludlow in line with the later date. The same is true of the style of dress.

Perhaps the most useful stylistic parallel with the Ludlow misericords is the remains of the choir-stalls from Fotheringay College. At Tansor, Northants a misericord from this establishment displays both the hennin and bunned head-dresses found at Ludlow (N.1 & S.4) (Pls 39a & b). A good example of the hennin with draped veil and *bourrelet* can be seen on the monument to Katherine Mally and Ralph Greene at Lowick, Northants, the contract for which is dated 1418–19.[31] At Tansor there is also a misericord displaying a falcon in the centre with rose and fetterlock supporters, whose design and carving style is pretty close to Ludlow (Pls 40a & b). On the woodwork also from Fotheringay, at Hemington Church, Northants, is a falcon within a fetterlock on a stall end. Another useful stylistic parallel with Ludlow at Fotheringay is the absence of an applied column on the front of the seat standards. This is a feature which one would readily associate with the mature Perpendicular style. In practice, it is rarely encountered on choir-stalls. Fotheringay was another Yorkist stronghold. It provides useful corroborative evidence for an early fifteenth-century date for the Ludlow woodwork. The choir, although probably started in 1411, was slow in building due to the deaths of Henry IV in 1413, and Edward Langley at Agincourt two years later. It must have been completed by 1434 when the contract for the new nave was signed.[32] The choir-stalls were probably made a little later than those at Ludlow, that is *c*.1425.

The archaeological and stylistic evidence suggests that the seating of the Ludlow choir-stalls was made *c*.1415, for a position east of the late fourteenth-century crossing. On completion of the arches of the new central tower, and the refurbishment and extension of the chancel, in the mid 1440s, the existing stalls were placed on new stone foundations. At the same time a new wooden backing was provided, with the timber recorded as having been obtained from Bristol. Unfortunately, the decorative treatment of the choir-stall super-structure cannot be retrieved from what survives. But the specific reference to 'Waynscot' bord'' in the Palmers' Gild accounts most likely refers exclusively to the stall backing since the term referred specifically in the Middle Ages to material for panelling.

LEINTWARDINE (WIGMORE ABBEY)

The desking, seating and superstructure from two runs of six seats at Wigmore Abbey was transferred after the Dissolution to Leintwardine Parish Church, Herefordshire.[33] It is supposedly from the demolished Augustinian Wigmore Abbey, sited some five miles to the south. These fragments are placed on either side of the choir at Leintwardine (Pls 27 & 41). In addition there are some portions of associated screenwork, framed up into a free-standing structure in modern times, situated in the north-east chapel. The original seat rail of the choir-stalls has been replaced and the wainscoting of the superstructure on the north side has been removed. The seats have been severed from a longer continuous row, and only the north-west end is a genuine termination with its special rosette elbow and plain reverse. Here the seat is of average width but the standard is thin and the seat capping stops abruptly, presumably, to allow a wing screen to be butted up beside it. This stall has a special tripartite canopy above, the centre part of which probably housed a sculptured figure (Pl.42). This bay was probably above an official's stall (there is another one built into the screen in the north-east chapel).

[31] F. H. Crossley, *English Church Monuments. 1150–1550*, London, 1921, Pl., p. 34.

[32] P. G. M. Dickinson, *Historic Fotheringay*, Gloucester, 1946, 12.

[33] There is a description of the choir-stalls at Leintwardine in *An Inventory of the Historical Monuments in Herefordshire*, Vol.III, *North-West*, London, 1934, 108 & Pls 130 & 131.

The seat standards on each side have been mounted on modern wooden plinths. Doubtless, the desks would originally have been set on stone bases as at Ludlow (Pl.41). The misericords are metal-hinged. Six of the ten desk panels on the north and two of the twelve on the south sides have been renewed in modern times. As at Ludlow, there is an alternation in the desk front uprights between short members sitting on the top of the plinth, and full length uprights which penetrate the base mouldings. A surviving desk end at the east end on the south side is of the symmetrical type with a simple buttress in front. The cross-shaped poppy head, reminiscent of the Ludlow formula, displays the figure of an abbot with addorsed sheep at his feet (Pl.43).

As at Ludlow the fitting of the uprights on the seat capping seems to be rather haphazard. Unfortunately, there is little foliage carving on the seating with which to compare the desking and superstructure. Nonetheless, the rosette on the elbow of the terminal stall on the north side is very close to one in a spandrel of the desking. The voluted 'trefoil' leaf decoration on another spandrel of the desking is similar in treatment to the same type on the canopywork. Also the way that buds from which the plants are growing are shown in the corners of the desking spandrels can be paralleled on the canopies. A detail of the front buttress mouldings of the desk ends can be found on the buttresses of the miniature canopies.

MONTGOMERY (CHIRBURY PRIORY)

The fragments of choir furniture in Montgomery Parish Church (Pl.28) were transferred after the Dissolution from Chirbury Priory, another Augustinian house, situated two miles away. There is almost a complete set of eight return stalls including the superstructure, unfortunately without panelling and canopywork, and the corner junction on the south side. The skeleton of the wing screens on either side of the choir entranceway has been preserved. The traceried panels at the bottom have survived but the traceried wainscoting above has been removed.

In the following discussion the close relationship between the Wigmore and Chirbury choir-stalls will be considered.[34] A comparison of the superstructure tracery (Pl.44a & b), carved desk panels (Pl.44c–f) and seat standards (Pls 45 & 46) on both sets of furniture shows that the Chirbury woodwork is closely modelled on Wigmore. Apart from the individual traits of the carving style, such as the treatment of the foliage buds and stems in the desk spandrels, and the arrangement of the wings on the angel seat elbows, there is the absence of columns on the front of the seat standards and the general proximity of the moulding profiles throughout.

The stylistic relationship with Ludlow can only be established in a general sense. The shape of the misericords, the treatment of the seat standards, and the handling of the seat junctions provide obvious analogies. The decorative carving at Ludlow is much more sophisticated, but a common debt to the fourteenth century is unquestionable. For instance, the handling at Wigmore and Chirbury of the voluted 'trefoil' leaf on the stall backing with 'plated' stems (Pls 44a & b) is virtually a copy of the type on the Chester Cathedral canopies.[35] We know that Ludlow had structurally the same kind of stall backing with framed wainscoted panels, moulded cornice and wing screens

[34] For more on the monuments' stylistic kinship, see Crossley and Ridgway (1943 et seqq.), V, 205–11.

[35] Tracy (1987), Pl.179. See also the handling of the same motif on the Lincoln Cathedral and St Katherine's-by-the-Tower choir-stall canopies.

(Pl. 30). Scott's imaginative canopywork reconstruction may well have been inspired by the 'officials" canopies at Leintwardine.

I should be inclined to date the Wigmore and Chirbury stalls to the first quarter of the fifteenth century, that is contemporary with the seating at Ludlow.

An attempt was made some years ago to include the woodwork from all three places in a postulated 'Ludlow school'.[36] It should be evident from the foregoing, however, that the stylistic connections between Ludlow, and Wigmore and Chirbury, are only of a general kind, the work at Ludlow being far higher in artistic quality. Moreover it is by no means certain that the Wigmore and Chirbury stalls were made by the same craftsmen. The Ludlow artists do not need even to have been local men. They may well have found employment on other prestigious monuments with Yorkist or metropolitan affinities, such as Fotheringay, throughout England. The Wigmore and Chirbury craftsmen, on the other hand, must have been West Midland denizens of only moderate ability and with modest connections.

[36] Crossley and Ridgway (1943 et seqq.), XI, 64–67. See also Chapter VI.

William Bromflet and the So-Called 'Ripon School' of Ecclesiastical Woodworkers. A Reassessment

1 Francis Bond states: 'It is quite conceivable that some of the same carvers may have worked successively at Ripon (1500), Manchester (1508), and Beverley (1520)'. See Bond (Stalls), 61 *et seqq.*; Crossley (1919), 25; Hudson (1924); For Purvis's articles, and later references to the 'Ripon School', see Purvis (1929 and 1935). See, also, Harvey (1984), 37.

2 The meaning of 'school' in this sense is given as 'Disciples or imitators or followers of philosopher, artist etc., band or succession of persons devoted to some cause or principle or agreeing in typical characteristics' in *Concise Oxford Dictionary*, 1974.

3 Hudson (1924).

4 Purvis (1929), 189.

5 *Ibid.*, 173–77.

6 A loft next to St Wilfrid's Closet. See Purvis (1935), 114.

7 The indenture reads: '. . . Also the said parties are commanded and agreit that incontenent efter that he hays said William fenyschyt his warke at Brydlington that then the said William schalbe gyn wt. the said warke . . .' See *Ibid.*

The 'family likeness' in the late medieval choir-stalls at Ripon and Beverley minsters and Manchester Cathedral (Pls 47–49) had been noticed by several scholars before the pioneering article, published by Purvis in 1929,[1] attached to this corpus of woodwork the epithet 'Ripon School'.[2] Purvis's thesis, a model of antiquarianism, rests on the secure foundations of historical evidence, as well as the beguiling but treacherous comparative analysis of style. He appraised the monuments and associated material with a trained eye, owing to some extent an acknowledged debt to Hudson's earlier monograph on the woodwork in Manchester Cathedral.[3] He convincingly identified the desk ends in three remote Yorkshire parish churches as refugees from the choir-stalls of major dissolved monastic and priory churches.

Purvis's view of art history is unashamedly organic: 'The series of stalls, from Ripon in 1494 to Wensley in 1527, show such marked evolution from the experiments of Ripon through the maturity of Manchester to the comparative degeneration of Beverley and Wensley . . . Before 1490 nothing surviving; then, artists not yet ripe and experienced in their craft; next, the same artists growing mature, bolder, more developed; later, a slight and gradual decline; after 1530 nothing'.[4] Whether or not we would condone such an ingenuous characterisation as this chronological procession of monuments, the perceptive insights, documentary research and hard archaeological data offered are an invaluable legacy of scholarship in themselves.

Over and above the surviving sets of choir-stalls at Ripon, Manchester and Beverley, there are fragments bearing the same stylistic 'signature', attributed to Jervaulx Abbey and Bridlington Priory. These are here the subject of a rigorous reconsideration, the doubtful items being consigned to the Appendix. The extant monuments having been thus passed in review, a contemporary criticism of the historical arguments adduced is proferred.

Purvis discusses the monuments themselves, on the basis not only of a detailed study of their stylistic traits but also the context from which they emerged. Perhaps more significant, however, is the publication of passages from a Ripon document, of about 1520, recording payments to workers, and select quotations from the Paper Book and Fabric Rolls of the minster.[5] In particular an indenture, dated 18 April 1518, enjoins 'William Bronflet of Rypon Carvar'[6] to carry out certain works at the 'Colleg Kyrche off Ripon'[6] as soon as he had finished a job he was engaged upon at Bridlington.[7] This strongly suggests that a William Carver, who was regularly employed by the chapter at Ripon, was

contracted to make the choir-stalls at Bridlington Priory. With this as a basis, the author went on to attribute the earlier choir-stalls at Ripon and Manchester, and the later set at Beverley Minster, to the same workshop on the grounds of style. Finally the inferred corpus is supplemented to include choir-stalls from Jervaulx Abbey and Wensley Parish Church.[8]

As the author points out, the Ripon accounts book is an invaluable, indeed unique, record of a great joinery project in the English Middle Ages. It contains the names of three of the Carver family, William, Christopher and Ranulph, the former, at least, using the alias Brownflet. The name Carver occurs at Ripon for the first time in 1453 in connection with the pulpitum.[9] The man, a Richard Carver, crops up again in 1472–3 in the context of land occupation[10] on the same roll as a Robert Brownflete, chaplain and prebend of Monkton. Purvis suggests that the family name may well have been Bromflet originally, being later changed to indicate the nature of their profession. The last of the fifteenth-century references to the family is John Carver, alluded to in 1478. In the Paper Book a 'John Carver alius dictus Brownfleitt' is recorded as a vicar of the cathedral from 1515 to 1537 at least.[11] Purvis's thesis is that from the mid-fifteenth century, and possibly earlier, the Carver family ran the Ripon Minster carpentry workshop. Moreover, with their experience on the manufacture of a new pulpitum and set of choir-stalls at Ripon over the period 1453–94, their reputation was such that they received a number of important commissions between the turn of the century and the mid 1520s to make ecclesiastical furniture on both sides of the Pennines in a variety of different types of religious house.

It is not surprising that it is William Carver,[12] the younger member of the family, quite possibly the Wakeman of Ripon in 1511 by that name and known to have been working at Bridlington in 1518, who receives most of the limelight in the proposed scenario. However, even before a detailed comparative analysis of the different monuments, such as they are, can be made, it must be said that, on the face of it, the attempt to ascribe the artistic direction of and most of the decorative carving for a related group of ecclesiastical joinery workshops, over the period of some thirty-five years, to one man is unlikely to be sustainable. It is true that Purvis's meaning in this crucial area is not entirely clear, but he does say: 'In the absence of documents to show that this William Carver, of Ripon, actually executed the work at Manchester, at Beverley, and elsewhere – for this is the deduction from the evidence which the author proposes – not a little may be established from a careful comparison of the known examples which show the "family likeness".'[13] At any rate, the admitted deterioration in artistic standards at Beverley and Wensley, whilst conforming to the evolutionist model of a workshop, can hardly be applied with equal conviction to the output of a single man, although this may not have been literally intended. That these monuments conform to a regional period style is undeniable. But an attempt will be made to separate the intimate correspondences from the general ones. The aim will be to discuss the monuments as far as possible in terms of hands. This more rigorous, albeit traditional art historical method, will testify to the redundancy of the epithet 'Ripon School' which can be shown with hindsight to be overly specific.

RIPON MINSTER

The collapse of the southern and eastern sides of Ripon Minster's central tower in 1458 necessitated the partial rebuilding and refurbishment of the late

8 The Wensley stalls lie outside the scope of this paper in terms of context and date. See Appendix.

9 *Memorials of Ripon*, I.

10 *Ibid.*, III, 241.

11 Purvis (1929), 188.

12 The Ripon Minster Fabric Roll of 'about 1520' refers to 'William Carver alias Brownflet'. See Purvis (1935), 114–15.

13 Purvis (1929), 177–78.

[14] Vallance (1947), 167.

[15] *Ibid.*, 168.

[16] Hamilton Thompson accounted for thirty-one, that is: 7 canons, 6 vicars, 6 deacons, 6 thuribulers and 6 choristers. See A. Hamilton Thompson, *Collegiate Church of St Peter and St Wilfrid, Ripon*, VCH, *Yorkshire*, III, 367–72.

[17] It was not possible to inspect the foundations. For the view of the choir mentioned, see C. Thompson, *Book of Ripon*, Chesham, 1978, 30.

[18] *Ibid.* and see also C. Hallett, *The Cathedral Church of Ripon*, London, 1901, 108.

[19] Purvis (1929), 178.

twelfth-century choir. The previous choir-stalls and pulpitum, the building of the latter being recorded in the Fabric Rolls of the early fifteenth century,[14] must have been too badly damaged to be salvaged. The extant stone pulpitum was erected after the rebuilding of the central tower, presumably sometime before the choir-stalls were manufactured.[15] There are two dates inscribed on the choir-stalls: 1489 on a misericord in the south return stalls (S.2), and 1494 on the easternmost desk end at the south-east. It will be argued that the period of manufacture is likely to have been between *c.*1488 and 1494.

The total number of stalls is thirty-four. There are thirteen each side and eight return stalls, the whole fitting into a little over two bays of the choir. An unusual feature in this fifteenth-century north-country context is the existence of substalls, or rather, benches in front of the main stalls complete with their own desks. At the visitation of 1439 the college was said to constitute thirty-two members including the choristers.[16] Although they have been considerably restored over the years, the choir-stalls are still *in situ* and *ensuite* with the coeval pulpitum.

The seating of the choir-stalls is in an unquestionably authentic condition. There are 5·8 metre lengths of unbroken seat capping on the north and south sides. The front desks, albeit heavily restored, appear to form an integral part of the stall foundations. Moreover, in a print of the choir before the George Gilbert Scott restoration of 1862–72, the desks are detectable, although largely hidden by later pewing.[17] The floor level has been raised by about 30cm. The wing screens at the west and east ends have survived more or less intact. The biggest single loss is eighteen of the easternmost canopies of the side stalls. The canopies on the south side were destroyed by the fall of the spire in 1660. Galleries were put in to replace them with matching woodwork on the north side.[18] The polygonal pulpitum loft is unquestionably of the same build as the stall superstructure (Pl.50). The top level of the wing screens at the west end, it should be noted, have been left undecorated. This suggests that the organ loft was planned from the beginning. The details of the decorative carving, such as the treatment of spire crockets and trail frieze, are identical on both return stalls and loft. There can be no doubt that all components of the furniture were designed at the same time. The triple head on the corbel above the entranceway (Pl.51) is drawn in the same way as the head of an angel on a misericord and the corbel head-stop on the backing of the north return stalls (Pl.52). The treatment of a leaf 'capital' on the front of some of the desk end buttresses is identical to many of the stall backing corbel stops. The wainscoting behind the upper tier of canopywork, still in place behind the return stalls, has been removed from behind the lateral stalls.

The differentiation of the officials' stalls is hard to spot at a glance. The seats are considerably wider than the average. The canopywork on the south return stalls receives no special treatment (Pl.53). On the north side, however, the canopies have three faces instead of two, and the canopy above, supported on uprights, consists of a triplet of two-sided gablets instead of the normal three sided canopy seen everywhere else (Pl.54). If there was any differentiation on the canopywork of the officials' seats at the east, all the evidence of it was swept away by the seventeenth-century alterations. The tabernacles at the upper level of the superstructure might be expected to have contained statues. There are, however, no visible plinths as at Carlisle and no sign of mortises on the floor of the second stage. Given the fragility of the traceried panelling of the tabernacles the securing of a statue would in any case be problematical.

Purvis characterises the Ripon stalls as 'experimental' and lacking in experience.[19] He mentions some of the many inconsistencies which will be examined here in some detail. A more or less complete uniformity of design in

England earlier in the Middle Ages as, for instance, in the fifteenth-century St George's Chapel, Windsor, and Lincoln and Chester Cathedrals in the late fourteenth century, was by no means always achieved.[20] No doubt largely because English joiners were so often experimenting, inconsistencies are to be expected. In effect Purvis criticises the irregularities at Ripon with the benefit of hindsight. In the context of what had gone before, they will be seen to be very positive assets, indeed, signs of vigour and innovation. The later achievements of this putative regional 'school' are surely irrelevant standards by which to judge.

Ripon's lack of uniformity presents a formidable archaeological puzzle. As already mentioned, the superficial consistency of the canopywork is beguiling. The decorative carving on the underside of the gablets, for instance, generally consists of standard leaf forms disposed nearly always in pairs (Pl.55). On the north return stall canopies, however, there is a much more varied repertory comprising human and animal motifs (Pl.56).[21] The appearance of eccentric-looking gablets rising from semi-circular instead of pointed arches in the northern corner of the north return stalls (Pl.57) and, in one isolated instance on the south returns, is hard to explain. Nevertheless, if we compare these to the normal gablets, it is perhaps surprising to recognise how similar they are in execution. Moreover once you begin to examine them, it rapidly becomes apparent that no two of them are the same. There are important differences in the type of tracery used behind the stalls. That on the south return stalls is consistently the same. On the north side the three northernmost seats have identical tracery patterns, clearly distinct from that on the south returns, and the official's stall at the south end is different again. The pendant corbels are handled differently on the north and south return stalls also. There are less noticeable but important differences between the stall backing tracery and the pendant corbels of the north and south lateral stalls. The canopy vault plan is the same, with cross, ridge and tierceron ribs, all carved in the solid, on both return and south lateral stalls. The north lateral stalls use a similar plan but incorporate a rose in the apex of the vault.

The seating of both return and lateral stalls is superficially similar. But once again there are significant deviations. In particular the treatment of the standards is strikingly different. The contrast is highlighted at the junction of the north return and north lateral stalls (Pl.58). Whereas the elbows on the lateral stalls turn up at an angle of sixty degrees, those on the return stalls are horizontal. Also the mouldings of the seat capping and canopy and stall backing uprights are clearly disparate at this point. This stylistic disjuncture comes where the work of two different master carvers meets. At the corresponding junction on the south side we find something altogether more serious – a physical mismatch covered up by a carpenter's botch (Pl.59). The problem is identical to the one in the same place at Gloucester Cathedral.[22] The designer has misjudged the width of the choir and made the south return stalls too wide. Instead of the comfortable juxtaposition of seat standards as on the north side, the front of the end division has had to be sliced off and slid behind its companion. The orderly arrangement of the seat capping, uprights and corner return canopies is consequently also denied. It is difficult to understand how a mistake like this can have occurred if the designer was domiciled in Ripon.[23]

The Ripon choir-stalls appear to have been made by three recognisably distinctive master-carvers. Hand A was responsible for the seating and the canopywork of the north return stalls. This man was particularly skilled at undercutting, and his foliage with curling-up leaves is noteworthy. A special trait of his is the placing of an animal – dog or bird for instance – on one of these leaves for use as a misericord supporter (Pl.60). His 'trademark' is the cut

[20] Nothing as architecturally ambitious appears ever to have been attempted in the medium of wooden choir-stalls on the Continent of Europe throughout the Gothic period. For the St George's Chapel, Windsor choir-stalls see Chapter VII.

[21] The figure of a partially clothed man flaunting his private parts occurs in one of the spandrels.

[22] Tracy (1987), 46 & Pl.149.

[23] At Gloucester I have suggested that this was not the case. See *ibid*.

shoot running off the stem of his supporters and elsewhere. Under the gablets of the lower canopies, although on a larger scale than in the seating below, his style can be recognised particularly on the birds and foliage. He probably made the pulpitum loft, the triple face on the vault corbel being recognisably by the same hand as the head corbels beneath the stall backing tracery on the north returns and on the misericord (N.3) of an angel holding a blank shield (Pls 52 & 61). Moreover a rosette on one of the north return stall standards with plain button centre is similar to the motifs on the pulpitum loft.

Hand B, who seems to have been responsible for the entire south side of the seating, works in the tried and tested traditions of the fifteenth century (Pls 62a–f). His carving is crisp and skilful, but conventional and lacking in imagination. In spite of the disjunction of the seating in the south-west corner there is no stylistic break between the south return and south lateral stalls. He uses the traditional English hawthorn and voluted 'trefoil' leaves, as well as the more advanced 'pomegranate'-type (Pl.62b).[24] He may well have played a part in carving the four major desk ends at the cardinal points of the furniture. Two of his stylistic 'trademarks' – the sprouting flower and the crimped leaf – can be seen there, whilst on other desk ends his hawthorn and voluted 'trefoil' foliage can be found. It should be noted that the mouldings on the misericords throughout the south side are the same.

Hand C made the north lateral stalls. His foliage carving is plastic, flat and uniform with little real interest in botanical exactitude (Pls 63a–f). Most of his misericords have the same moulding profile and his supporter stems are easily recognised by their distinctive bevelling and treatment of the side shoots.[25] His handling of the 'pomegranate'-type is distinguished from that of Hand B in his preference of incising over carving. In fact, in his hands the motif is probably more accurately described as 'stylised flower'. He must have also carved some of the desk ends, and it was probably he who invented the characteristic hanging blossom. His misericord of the ape attacked by a lion (N.5) strongly recalls the desk end with the ape on it, whose poppy head incorporates the last-named motif, dubbed by Purvis the 'Aysgarth flower'.[26] He also specialised in the conceit of leaves falling forward, seen often on desk ends and the corbels of the stall backing. But this is not to say that Hand B was not averse to using the device as well.

A tentative chronology is adduced based on the above attributions. This is only a sketch which it may be possible to bring into sharper focus in time. Hand A could well have started somewhat earlier than Hand B. His style is idiosyncratic and craftsmanlike. He was probably a mature artist used to working on his own. The irregularities in his canopywork show that he was more sculptor than architect. The amount of workmanship in the form of animal and human carving in his canopies is not echoed on the south return stalls, or anywhere else at Ripon. It is not unreasonable to suppose that he was the first artist on the job, starting with the pulpitum loft and the north return stalls.

Hand B must have started no more than about a year later (his misericord on the south returns is dated 1489). He provided the continuity between Hands A and C. Hand A must have left the workshop before Hand C arrived, the stylistic disjunction in the north-west corner evidencing a lack of collaboration between them. Hand C shared the task of completing the furniture, including the making of the desks and the desk ends, the major desk ends being dated 1492, with Hand B. This chronological framework is probably reliable at least in outline. The puzzles presented by the different stall backing tracery and vault plans might shed more light on the chronology if they were better understood.

24 The appearance of pomegranate in English art is not normally thought to happen before the marriage of Henry VIII to Catherine of Aragon. See Introduction.

25 This trait is also found on the late fifteenth-century choir-stall refugee fragments now in the Durham Castle chapel. See Appendix.

26 For Purvis's taxonomy of ornament, see Purvis (1929), 200, Appendix C.

MANCHESTER CATHEDRAL

The making of a new set of choir-stalls, accompanying pulpitum and parclose screens was most probably the final stage of the wholesale rebuilding programme initiated at Manchester by James Stanley, warden of the college from 1485–1506.[27] A biographical entry on Stanley in the early seventeenth century *History of the Wardens*[28] states that Warden Stanley 'built the south side of the wood worke in the Quire; ye seates for ye Warden, Fellowes, and Churchmen, being XXX seates on booth sydes, and Mr.Richard Bexwicke that built Jesus Chappell builded the "other syde"'. It has been shown that the heraldry of the carving on the dean's desk end on the south side of the choir unequivocally substantiates the Stanley connection.[29] Moreover the tradition of the Beswicke benefaction is borne out in a plea by the Abbot of Whalley dated 1511 in which he states: 'The said Richard Beswicke was an especial benefactor of the College, having given a suite of vestments, price £45 and more, and having built at his own charge a chapel and one side of the "Queer" of the said College Church, which cost him 300 or 400 marks or more, besides other good deeds'.[30] Beswickes's cipher can be seen on the arms decorating the north-east desk end.[31]

The stalls are on the whole in a remarkably authentic condition (Pls 49 & 212).[32] They are still *in situ* and comprise the original number of six return and twenty-four lateral seats. There were never any substalls. Unfortunately the pulpitum, which was originally made *en suite* with the choir-stalls, now bears little resemblance to its former self.[33] The return stalls, which back on to it, still retain their nineteenth-century glazed instead of wainscoted backs, and the canopywork above has lost the panelling which closed it off, as is still in existence behind the side stalls. Between 1864 and 1872 the pulpitum was removed to the south choir ambulatory. An old photograph of the crossing at this time shows that any canopywork over the entranceway was also taken away.[34] The present canopywork in this position must be entirely George Gilbert Scott's work. The floor of the choir seems to have been raised somewhat above its original level.

Both design and execution of this furniture is remarkably consistent. The use of the Lincoln-type junctions in the western corners (Pl.64), and the conformity of moulding profiles and ornament throughout the seating, hardly suggests a break of any kind in the building programme. A comparison of the carving on the north and south sides suggests that all the decorative carving was done by one man. Certain traits of his style, such as the scalloped handling of some of his leaves, his treatment of human hair, and the way he ties up the ends of the supporter stems with a small leaf (Pls 65a–f), can be seen throughout. Again on the superstructure consistency prevails. On the lower canopies the richness in effect is obtained entirely by architectural means. The fronts of the canopies are 'tipped-up' as at Ripon, by inserting pairs of angled gablets between the uprights which have their own miniature vaults (Pl.66). As at Ripon the figures at the base of the spirelets are post-medieval. At the higher level there are concave spired tabernacles separated by straight-sided buttresses containing niches possibly for a statue (Pl.67). The major innovation at Manchester is the tester above the canopywork, which encloses the design within a prescribed space.

The stalls on either side of the entranceway, of the dean and precentor, are distinguished by being wider than usual (75 to 80cm *vs.* the average *c.*71cm centre to centre measurement). Their canopies, though heavily restored, are also given special treatment (Pl.68). They are based on an octagonal instead of hexagonal plan. Angled three-dimensional spirelets are interpolated between

[27] Hudson (1924), 13–14.

[28] College of Arms, London MS.37 C. See also H. A. Hudson, 'A list of the Wardens of the College of Manchester, with remarks upon an old MS. Catalogue', *Lancs & Cheshire Antiq. Soc. Trans*, XXXIII, 178–191.

[29] See Hudson (1924) above, 18–20.

[30] See *Lancs and Cheshire Recd Soc. Publications*, XXXII, 81–83.

[31] Hudson (1924) above, 21–22.

[32] An engraving in Winkles, *Cathedrals*, from a drawing by T. Worthington, shows the west side of the pulpitum as it was in 1842–47, before the restoration of George Gilbert Scott. In the eighteenth century it had already been fitted up with sash-windows behind the return stalls and seats for the use of the clergy during sermons between the two screens. See Aymer Vallance, 'Roods, Screens, and Lofts in Lancashire', in Fishwick and Ditchfield (eds), *Memorials of Old Lancashire*, 2 vols, London, 1909, 241–50.

[33] For a full description of the Manchester woodwork see Hudson (1924) above, and Crossley (1919), 1–42.

[34] Hudson (1929), Pl.XXIV.

the uprights. The dean's gablets are treated slightly more fussily with machicolation on the roofs of the spires (Pl.69). In both cases, at the upper level the aediculae are provided with machicolated and traceried plinths (Pl.70). The vaulting of the lower canopies is particularly impressive, genuine joinery techniques being used throughout. The vaults above the ordinary seats are of lierne star pattern with a variety of tracery designs in the cells. The dean and precentor's seats, being wider, utilise an enlarged star pattern with a prominent pendant boss in the centre.

The general stylistic homogeneity has already been stressed. Against that should be mentioned a few important differences between the north and the south sides. There is slightly more variety in the canopy-vault cell tracery on the north than the south. More noticeable, perhaps, are the marked differences in the decoration of the tester. On the south side the cusping includes floral terminations and also there is a traceried panel above the spandrels (Pls 71a & b). Moreover in the niche work above the canopies, whereas the treatment of the tracery on the south side is completely uniform, there are three different patterns on the north side – plain Y, cusped lights with quatrefoil above, and the same with vertical elongated quatrefoil above.

All the internal evidence points to the furniture having been made under the direction of one master-carver in a single building programme.[35] Minor differences between the north and south lateral stalls merely suggest that the superstructure on the north side was the final phase of the manufacturing process. The name of Richard Beswicke 'the younger' is mentioned as one of the six 'masters' of the guild that paid for the Jesus Chapel to be erected in 1506.[36] From this we may assume that Beswicke was active as patron of the choir-stalls at the end of Warden Stanley's time at Manchester. The use of Lincoln-type composite corner standards and peg-hinging on the misericords, together with the homogeneity of style in the furniture, makes it very unlikely that there was any substantive break in building operations. One master-carver with an apprentice and carpentry assistance could have completed a set of choir-stalls of this size in about three years. Therefore the traditional dating of c.1506 seems to be perfectly acceptable.

BEVERLEY MINSTER

The misericord of the Treasurer's stall of Beverley Minster (Back Row N.12) is dated 1520.[37] This and three other misericords have inscriptions associating a stall with a particular official connected with the church – chancellor William Wyght, precentor Thomas Donyngton and receiver general/warden of the fabric John Sperke.[38] The constitution of the church was given in Archbishop Arundel's statutes of 1391, comprising a precentor, chancellor, sacrist, seven parsons (berefellarii), nine vicars, seven chantry chaplains, two incense burners, eight choristers, two sacrist clerks and two vergers or bell ringers.[39] The back stalls were occupied by the archbishop and principal members of the foundation.[40] The chantry priests could also use any unoccupied seats in the back row amongst the parsons and vicars.[41]

The stalls, which exactly span the first three bays of the choir, are still in situ (Pl.48). There must have been forty-four back stalls originally, with eighteen lateral and four return stalls each side. In addition there are thirteen substalls each side, making a grand total of seventy. The seating appears to be largely authentic and the seat rail mostly original. The main losses are the tester above the side stalls, most probably the dignitaries' seats on either side of the

[35] On the basis of the subject matter of the misericords Letts found three hands at work at Manchester, and possibly a fourth responsible for the supporters and seat elbows. He seems to have wanted the same artist to have carved the 'Little Red Riding Hood' misericord at Chester Cathedral, the 'Blacksmith Shoeing a Goose' and the 'Friar Fox preaching to the Geese' at Whalley Abbey, 'Punch wheeling Judy in a Wheelbarrow' at Ripon, the 'Sow playing the Bagpipes' at Manchester, and fifteen misericords at Beverley Minster. He repeats the tradition that at Beverley Minster 'a considerable period of time is said to have elapsed between the erection of the stalls on the north and south sides'. See Letts (1886).
[36] Hudson (1924), 23.

[37] It bears the inscription 'The arms of Doctor William Tait, Treasurer of this Church, 1520'. As Wildridge tells us: 'The aureole or fess on the arms is repeated in a small carving on the pendants on the back of the canopy, in addition to the word Tait (spelt Tate)'. See Wildridge (1879), Pl.XXX, 31.
[38] Ibid., 17 (Pl.IV), 21 (Pl.XII) & 39 (Pl.XXXIX).

[39] A. F. Leach (ed.), Memorials of Beverley Minster, II, Surtees Soc., 108, Durham, 1903, 267.

[40] Precentor, treasurer and chancellor ranked below the vicars at Beverley. See J. Bilson, Beverley Minster: Some Stray Notes, Yorks. Arch. Jnl, XXIV, 1917, 226.
[41] Ibid.

entranceway, and the wainscoting behind the top of the canopywork of the lateral stalls. The removal of the tester and wainscoting behind was recorded in 1825: 'Till very lately, a back ran behind the whole length of the tabernacle work, and a canopy, extending in one continued line from east to west overhung the pinnacles. They were both original parts of the work. In the progress of the alterations now going on, the removal of the former became necessary, and the effect has been very good, in exhibiting more clearly the elegant and delicate tabernacle work. Something, however, is still wanting, to relieve the plainness of the back part of the work, which was never intended for exposure; and some persons, perhaps will be disposed to regret the canopy, as an ornament not common in such a situation, and giving the choir a peculiar and distinctive character'.[42] The 'canopy' referred to in the last sentence is unquestionably the discarded tester. The vaulting of the pulpitum entranceway and the traceried organ loft front is part of the Scott restoration after the mid eighteenth-century pulpitum was removed.

The design of this furniture is remarkably consistent throughout. The seating is clearly the product of one building campaign with the same mouldings to be found everywhere. The eastern dignitaries' stalls are extra wide (84cm) but the existing western ones are of standard width. The handling of the junctions in the western corners is identical. Somewhat surprisingly, the combined seat standard formula is not used (Pl.72). The misericord supporters at Beverley are treated similarly to those at Manchester with flowers 'tying-up' the circle (Pls 73a–d). But the foliage carving at Beverley is much less skilled. One standard leaf type only 'ties-up' the joins at the end of the stems and the mouldings of the misericords are completely different. Also the seat standard elbows are uncarved at Beverley apart from the ornament on the sides in the 'spandrels' of the protrusions.

The seat back panelling tracery and all the canopywork is to a standard design (Pls 74 & 75). The only exception is the south-west lower dignitary's canopy, which emulates its peer at Manchester (Pls 76 & 69) (most of the stall back tracery label stops, and all the lower canopy corbels are eighteenth-century replacements). But at Beverley the designer attempts to retain the semi-hexagonal plan of the standard canopies. The result is unexceptionable. The canopy's best feature is the traceried tiered pinnacle which turns into little octagonal battlemented turrets, not unlike the ones on the north-east wing screen at Ripon (Pl.77). All the vaults at Beverley have a lierne pattern of the Manchester type. The vault cells are filled either with tracery or thin plain wood segments. The vaulting is consistently the same throughout the north side except for the dignitary's seat at the west. Even this has the same vault pattern but a different tracery filling (two quatrefoils placed diamond-wise). All the vaults on the south side are of the standard pattern including the western dignitary's canopy. The pattern of the stall backing is the same throughout except for that behind the south-west dignitary's stall.

It seems highly probable that the return stalls were shortened by one seat each side in the eighteenth century to accommodate the impressive entrance-way of the Rococo-Gothick choir screen.[43] It is certainly very unlikely that the most important stalls would have been narrower than the dignitaries' at the east end, as is now the case. If there had been another seat each side as wide as the dignitaries' seats at the east end, only 1·2m would have remained for the entranceway. This might account for the absence of extra seat widths on the remaining return stalls. Both the existing terminal seat standards on the ends of the return stalls are modern.

[42] J. Coltman, A Short History of Beverley Minster, Beverley, 1825, 51–52, quoted in Cobb (1980), 55–56. At the back of the stalls on the north side, on the rail which runs along at the level of the base of the canopies, there is a series of mortises about 1·2m apart. Behind them is a continuous channel presumably to take the former wainscotting. The corner upright, into which this rail is housed, has a large mortise for another rail about 1·9m higher up. This could have carried the backing for the tester. The sections of panel heads attached to the back of the north side of the stalls are probably from the tester.

[43] A reference to the 18th c. work is made in Cobb (1980), 59 & Figs 82, 83.

[44] Purvis (1929), 186–87.

[45] Tracy (1987), Pl.210.

[46] Bond's dating of the York Minster stalls, of *c.*1390, appears to be considerably too early on both archaeological and stylistic grounds. John Harvey considers that the eastern wall of the pulpitum would have been built by 1420, surely a *terminus post quem* for the erection of the choir-stalls. See J. H. Harvey, 'Architectural History from 1291 to 1558', from G. E. Aylmer and R. Cant, A *History of York Minster*, Oxford, 1977, 182. The fabric rolls at York are missing for the period 1424–32. This is the time during which it would be appropriate for the stalls to have been made on stylistic grounds. The York choir-stalls were destroyed in the fire of 1819.

Before attempting to deal with these monuments as a group it will be useful to see how the earliest of them, at Ripon, fits into the context of English ecclesiastical furniture making at the end of the fifteenth century. Purvis saw Ripon as the inevitable product of a tradition of choir-stall making in the north of England stretching back to Lincoln *c.*1370.[44] He interpreted the marked differentiation between the horizontal zones at Ripon (Pl.54) as a tribute to Carlisle (Pl.1). In this he followed Bond who also recognised the formative importance of Nantwich. The idea of raising the fronts of the lower canopies goes back to Nantwich, to which Purvis also pays unspecified tribute.[45] But there, in the upper zone of the canopywork, the deployment of variable levels was taken to a point where the traditional horizontal zoning, a *sine qua non* of the Lincoln and Chester design, was negated. The 'tipping-up' of the lower canopies at Ripon, was again achieved by making the side arches spring from a lower level, as was earlier effected at Carlisle and Whalley (Pls 78 & 79). But Ripon also adopts the conceit first seen at York Minster, *c.*1425, (Pl.80),[46] of raising the fronts of the canopies still further to reveal another upper row of miniature vaulting. In the upper part the use of a single pinnacle as at Lincoln and Chester, and more recently York, is a criticism of Carlisle which uses a tripartite and full-width structure. Ripon uses the traditional concave, rather than convex, traceried niches, most recently used at York, and omits the unsightly multiple exposed plinths found at Carlisle and York.

Ripon's canopywork could hardly be anything other than rich by comparison with utilitarian Carlisle. Purvis's reference to Nantwich in this connection is valid, for the intricacy of the canopywork at Ripon relates back to the fourteenth-century aesthetic. It is true that there is no attempt at Ripon to display a variety of foliage types, as still happens at Nantwich. The interpolation of projecting buttressed gablets across the mid-line of the main canopy faces at Ripon is a refinement of the York solution and, of course, ultimately descended from the doubled lower canopy arches at Lincoln and Chester. The alternative expedient of raising the outer springing line of the outer gable arches, at the point where two adjoining canopies connect, was used a few years earlier at St George's Chapel, Windsor (Pl.81). In that case it is the gablets linking one canopy with another which are 'tipped-up'. This is another legitimate way of preventing too monolithic an appearance in canopywork architecture. At York the entire semi-hexagonal elevation of the lower canopies was simply lifted up to reveal the secondary vaulting cells below. In the process the central gablet was tripled. At Ripon, Manchester and Beverley the uprights of the main gables are angled.

The turning of the major buttresses on to the diagonal at Ripon, an idea noticeably absent at York, may be indirectly related to the somewhat cosmetic expedients to be seen at Carlisle and Whalley. Again the result is visual enrichment, and contributes to the same impressionistic effect adumbrated for the first time at Nantwich. It is noticeable that the canopy vaulting at Ripon, as at Carlisle and Whalley, is composed of quadripartite, tierceron and transverse ribs, often carved in the solid. This is old-fashioned by comparison with Lincoln, Chester and Nantwich, let alone the slightly earlier St George's Chapel, Windsor.

Ripon's major stylistic affinities with its north-country predecessors having been established, it will be useful to substantiate the general picture by examining the detail of ornament and construction. By the middle of the fourteenth century the system of carrying the seating through the junction of return and lateral stalls without a break had been established in England. When the two rows of seats met, a double seat standard was extravagantly carved from a single block of wood. This device obviated the unsatisfactory process of

butting-up neatly two seat standards. The doubled standard provided a focal point by drawing the eye to the sculpture, usually a king's head, on the join. The system was used both at Carlisle and Whalley. It is very surprising that, in spite of the ambitiousness and sophistication of the Ripon canopywork, the practice there was ignored. It is difficult to know why, as it was certainly not due to a lack of expertise. It is striking how disparate are the styles of the three carvers at Ripon. In any case it is clear that the work on the south lateral stalls was a little later than that on the north returns. The use of three master-carvers in a set of choir-stalls is very unusual. In the first place the intention may have been to use Hand A only. But perhaps Hand A was called away or, even, died. Alternatively, Hands A and B may have been jointly commissioned to make the furniture but for some reason Hand C was brought in to replace Hand A after a short time.

It could be argued that from the beginning, due to a lack of funds, it had been intended that the stalls would be built piecemeal. But a design of this sophistication presupposes a scheme which can be expected to have incorporated doubled seat standards in the corners. The absence of them, and the disjunctions in the western corners, must have been due to unknowable disruptions in the building campaign.

Apart from the architecture, there are plenty of characteristics, functional and stylistic, which bind Ripon's choir-stalls closely to their early fifteenth-century predecessors. Foliage comparisons, using Hand B, can be very close particularly to Carlisle and Cartmel (Pls 82a–e). The use of the triple pellet on cusping at Ripon can be paralleled there, and on much other fifteenth-century north-country woodwork. Much more specific is the occurrence of a triple-faced head at Cartmel Priory (Pl.83) and Whalley Abbey (Pl.84) to compare with the one over the entranceway at Ripon. Of course there are differences in style and treatment. In particular the Ripon head is beardless. But the occurrence of the motif in such a prominent position bears out the hypothesis that the designer of these stalls was *au fait* with earlier north-country examples. The shapes and tracery of the desk ends is remarkably similar in all four places and the motif of a roofed buttress top is well established as far back as Carlisle (Pl.85). Ripon follows the system of mounting the furniture on a continuous moulded wooden base, which in turn sits on a stone ventilated plinth. Ripon uses solid canopy vaults, as found at Carlisle and Whalley. Surprisingly the vault plan is of the elementary multiple cross-rib kind with tiercerons. Ripon eschews the lierne pattern used at Lincoln, Chester and Nantwich. Finally the northern seat standard of the north return stalls retains at the front of the moulded incurving section a portion of the original block from which it was carved. This looks very much like the similar retention of a supporting upright left in the solid in the same place at Carlisle and Cartmel. With the exception of the omission of the doubled seat standards, the stylistic affinities at Ripon with the earlier north-country fifteenth-century work points to a continuous prescription of craftsmanship and artistic inspiration.

The most likely model for the Ripon desk end with detached shaft (Pl.86), perhaps the best known motif of the corpus, is the type represented by a fragmentary survival from St Nicholas, King's Lynn, c.1418, now at the Victoria and Albert Museum (Pl.87).[47] However, in every other way the Ripon choir-stalls owe nothing to East Anglia.

The choir-stalls at Jervaulx Abbey seem to have been made at almost the same time as the Manchester furniture. The two desk ends and the screen now at Aysgarth, North Riding carry the rebus of William Heslington (abbot 1475–1510) (Pl.88), and the cipher of an unknown abbot probably also from Jervaulx.[48] The desk ends appear to be a development of the type first seen at

[47] St Nicholas, King's Lynn was completed in 1418. See Beloe (1899), 111; for the V & A Museum bench-end and a related fragment, see Tracy (1988), Cats 164 & 165.

[48] Purvis (1929), 165–67. Both of these motifs are also featured on the pulpitum at Aysgarth. Although the inscription HM cannot be attributed to Jervaulx Abbey, the traditional provenance should probably be allowed to stand. The inscription AS, and the date 1536, on the other screen at Aysgarth, on the north side of the chancel, can be positively related to another Jervaulx abbot, Adam of Sedbergh.

Ripon. The 'house' motif, the roof of which the diagonal buttress is seen to pierce, has been raised up one storey. Below at basement level the plinth of the buttress is lodged. Whether this is an improvement to the design is a moot point. The main panel of the desk end is consequently narrower and shorter, and the whole design becomes a repository of motifs all clamouring at once for our attention. The subsidiary buttress on the front of the design is presumably not an original feature. The scantling of the timber, the mouldings and the general treatment of the carving on these bench ends does not suggest that they were carved by any of the artists who worked at Ripon.

The undoubted detailed stylistic parallels that can be drawn between Manchester and Ripon should not be allowed to obscure the very real differences between the two sets of furniture. The introduction of the tester at Manchester, and the concomitant banishment of the traditional spiring top, was revolutionary. Not only are the spires emasculated, but the whole of the former upper zone is reduced to a subsidiary size (Pl.68). The fifteenth-century tendency to horizontality is again underlined by the use of a prominent and discrete mid-level frieze, and the diagonally placed uprights and spirelets in the lower zone. However, perhaps the second most salient feature of the Manchester superstructure is the almost total reliance for richness of effect upon architectural motifs. Particularly telling is the reintroduction of the formerly popular flying buttress, but this time at the level of the lower canopies. The use of joined, rather than solid, carved canopy vaults in the lower zone at Manchester is another important difference between the two sets of furniture.

In spite of a general similarity in the seating at Ripon and Manchester there is no very close relationship. Indeed, there is no obvious convergence in the seating measurements at Ripon, Manchester and Beverley, especially seat and seat standard widths (apart from the seat standard widths at Manchester and Beverley), and thickness of seat capping (Figure 1). This may come as a surprise since Purvis laid great stress on the degree of standardisation to be found throughout the corpus. He states: 'The main bench-ends have a standard height of 52 in., a width of 15 in., and a thickness of 3·5 in.; the pinnacles are of uniform size, as are the misericord seats and all the members of the construction.'[49] In any case it is dangerous to read too much into measurement statistics for medieval joinery. They always vary somewhat within a single monument in response to the scantling of the material available. On the other hand the general level of consistency between one monument and another is surprisingly high. Only if the measurements in all three sets of furniture could be shown to be really consistent would Purvis's contention that '. . . the Ripon School anticipated with notable completeness modern industrial methods' be borne out.[50] The 'Standardization and methods of mass production' adduced by Purvis[51] implies that the woodwork was all made in a central location, i.e. at Ripon. At least in the case of Bridlington Priory we know this not to have been the case since it is clear from the 1518 indenture that Bromflet was on loan.

It is perhaps ironical that, although the mouldings of the misericords and the seating at Ripon and Manchester are quite similar, the decorative carving has very little relationship indeed. Apart from isolated appearances there of the 'Aysgarth flower', it could be argued that Ripon is more closely connected in terms of ornament with Carlisle than Manchester. None of Purvis's specific decorative motival comparisons between Ripon and Manchester – vine scroll, oak leaves, the so-called 'Ripon amphisboena' on the Manchester Beswicke desk end, or the shield-carrying angel misericords is particularly convincing. He also compares the elephant at Ripon, on a desk end, and at Jervaulx, on the pulpitum frieze. These have no close stylistic relationship. Pellet, 'scollop' and brattish ornament are run-of-the-mill motifs and not stylistically diagnostic.

49 I have not checked the comparative measurements of the desk ends.

50 Purvis (1935), 112.

51 Ibid.

1. *Measurement Data for Ripon, Manchester and Beverley Minster Choir-Stalls.*
(Back stalls. Average measurements in cm.)

	Ripon	Manchester	Beverley	Average	Control*
Width of seat standard	11·0	9·0	9·0	9·6	7·6
Width of seat	67·5	63·0	68·5	66·3	67·4
Seat Height	43·5	41·0	45·5	43·3	43·6
Seat elbow height	69·0	71·0	66·5	68·8	71·1
Height of seat capping	106·0	107·0	105·0	106·0	103·0
Depth of seat	32·5	36·0	34·0	34·1	36·9
Thickness of seat capping	12·0	9·0	11·0	10·6	10·2
Depth of seat standard from elbow to back	34·5	36·0	35·5	35·3	40·5

* Average measurements in the 15th c. choir-stalls at Carlisle, Cartmel and Whalley.

The growth of a small leaf around the outside of some of Hand C's supporters at Ripon may have inspired the ubiquitous conceit at Manchester (Pl.89a). If Hand C at Ripon was the Manchester master, he would hardly have eschewed totally the late Gothic 'banderole' ornament, which he employed so freely on friezes and the seating in the earlier monument. The criticism of the Ripon desk ends seen at Aysgarth is also found at Manchester (Pls 89b & c). The Jervaulx example, however, with its heavy multiple mouldings and its additive design system looks clumsy beside the playfulness and refinement of the Manchester desk ends.

It has been suggested that the rebuilding and refurbishing at Manchester may have been actively encouraged by Warden Stanley's stepmother, Margaret Beaufort, Countess of Richmond and Derby.[52] It was even adduced that the latter's son Henry VII may have made a financial contribution towards the project. Whereas this is a matter for speculation, it is quite possible that the master-carver had seen the furniture at St George's Chapel, Windsor, a royal commission of the last years of Edward IV's reign.[53] There is little sign, however, of any direct influence from the Windsor canopywork, which represented a radical departure from medieval precedent. Moreover, there is no sign of the 'pomegranate'-type at Manchester, widely used at Windsor and even in evidence at Ripon. However, two detailed correspondences are worth mentioning. At Windsor the misericord supporters are often 'tied-up' with a leaf (Pl.90), as they are at Manchester. What is more, the decorative carving has a distant stylistic affinity. Perhaps more significant, however, is the appearance at Manchester of star-pattern lierne vaulting and the pendant boss. In general outline the canopy vaults at Manchester are reminiscent of Windsor, and the question where such an innovation could have sprung from must at any rate be directed towards London. Perhaps the most important parallel with the

[52] Hudson (1929) above, 14.

[53] The accounts for the making of the choir-stalls at St George's Chapel, Windsor belong to the period 1477–84. See Hope (1913), 429–35. See Chapter VII for a full discussion of this monument.

54 In the Report of the king's commission, of 1537, relating to the priory church of Bridlington, is the sentence: 'The stalls of the quear be substancyall and newly made after the right goodly fashyon'. Quoted in Hudson (1929), 95. See also Purvis (1929), 160–63 and Appendix below. The Gaunt desk end has been moved to Leake from Over Silton since 1929. Unfortunately the whereabouts of the benching, seat standard and portion of screen tracery at Over Silton described by Purvis is unknown. They are said to have been sent to York (Information by letter from the vicar of Leake).

55 The rebus of John Hompton, prior of Bridlington 1510–21, and the name of Peter Hardy, subprior in 1518. The Gaunt, or de Gant, family were founders and benefactors of Bridlington Priory.

56 See Note 7, above.

57 For the more distantly related choir-stalls at Wensley (Yorks), Newark, Durham Castle, Hauxwell (Yorks), Barkestone (Leics), and associated screenwork at Wensley (Easby Abbey), Flamborough (Bridlington Priory) and Aysgarth (Jervaulx Abbey), see Appendix.

58 The misericords are probably the most interesting and imaginative component of the furniture.

Windsor choir-stalls is the use at Manchester for the first time on a large scale of a tester.

The three desk ends at Leake church, near Northallerton, are of special importance because they were made for Bridlington Priory about 1518 (Pls 91a–c).[54] Two of them carry the identification of a prior and subprior.[55] Apart from the pulpitum loft at Flamborough, probably also from Bridlington Priory, the Leake refugees are all we have that could be definitively attributed to William Bromflet of Ripon.[56] Possible comparisons with Manchester are consequently very restricted. Nonetheless, even on this narrow basis it is possible to say that the two hands are stylistically closer than any other comparisons from the corpus, if we allow for the extent of mutilation. Much of the traceried plinth, which encases the detached buttresses of the desk ends at Leake, has been lost. Also the little gabled 'houses' above have been almost completely removed. Yet, from the remains it is clear that they were there originally, and that the Bridlington desk ends were closely modelled upon Manchester. Whereas the mouldings on the two sets are not identical, both share the use of wide flat tracery members and a generously wide flat border to the design. Several 'Ripon School' trademarks can be found at Leake, such as the 'Aysgarth' flower, triple pellets, scalloped border and a hanging shield. The Gaunt and Hardy desk ends are topped with canopywork quite similar to that on the north-east wing end at Manchester (Pl.92). But more significantly, there are some very close sculptural correspondences. In particular the poppy head of the Hompton desk end (Pl.93) shares with those at Manchester a close similarity in treatment, and with the Stanley standard the same characteristic of a flower on the end of a long stem emerging from the interstices of an outer covering of foliage, with small flowers on either side of a central ridged spine. The Beswicke desk end at Manchester has vertical 'acanthus' leaves supporting the calyx of the poppy head as found on the Bridlington Hardy bench end. The poses of the fantastic beasts on the upper extension of the buttress in both places have much in common. The carving of the animals with their small lean hairless bodies and prominent leg joints is very close. Bridlington's pulpitum loft (now at Flamborough) recalls both Manchester and Ripon, but only in a general way. However, on the basis of these admittedly limited sculptural comparisons the hypothesis that William Carver worked at Manchester and Bridlington may perhaps be tentatively adduced.

Beverley Minster is the third set of surviving choir-stalls in the corpus.[57] Most previous writers acknowledge that this furniture represents a decline in quality compared to Manchester. It is true that the carving seems to have lost the vigorous three-dimensional quality in evidence since Ripon. Indeed, the resourcefulness in ornament and figure carving displayed on the seating does not compensate for the lacklustre uniformity of the canopywork (Pl.75).[58] In the superstructure, the architectural formulae handed down from Ripon and Manchester seem to be somewhat compromised by repetitiveness and the lack of a proper sense of scale. The proportions of the canopies of the upper stage sit uncomfortably with the tester above. The aediculae of the second tier seem cramped under their spires. The tester is very deep and fussily detailed. Perhaps the factor which most tends to spoil the canopywork at Beverley is the thickness of the tracery and scantling generally. At Manchester the contrast of finely-wrought delicate canopywork against a background of insubstantial web-like tracery is judicious. At Beverley, everything – the buttresses, upper spires and tracery – tends to coarseness. It is as if the canopywork was carved by a stone mason who did not truly understand the possibilities of architecture in wood. The delicacy and insubstantiality of Manchester are exchanged at Beverley for an earthbound commonplaceness.

Perhaps the most valuable contribution that can be made in any reassessment of this body of material is the elucidation of the at times, complicated archaeology. Without a good understanding of it the case for the putative 'school' cannot be properly assessed. In particular, the Ripon Minster furniture is especially difficult to interpret.

No one could deny the general architectural and stylistic similarities shared by the choir-stalls at Ripon, Manchester and Beverley, and the surviving fragments from Jervaulx and Bridlington. However, it is one thing to recognise a stylistic cousinage, but another to attribute the carving and design of the whole group of monuments, as has been attempted, to the same hand. In any case, the suggestion that the Ripon Minster workshop supplied a single craftsman and prescribed the designs for all five choir-stalls, is not borne out by the monuments themselves. The sharing of a repertory of motifs, often on a regional basis, had been common amongst master-carvers since the thirteenth century. Monuments can often look very similar indeed, yet not be designed or carved by the same workshop. A study of the history of ornament shows that there is a world of difference between a motival consonance and a common signature. Where a close comparability is found, as likely as not, it is a later attempted copy by another craftsman, rather than a duplicate by the first artist. In any case, in English medieval woodwork, because of the general paucity of surviving material, individual master-carvers are very rarely encountered more than once. If the choir-stalls at Bridlington Priory are the work of William Bromflet, the Manchester master, we might, indeed, have the basis of a regional 'school'. Yet, however closely the Bridlington bench ends resemble the Manchester furniture, it is impossible to be categorical on the basis of such a meagre survival. Far from the idea that one man could have made the five sets of choir-stalls during the course of a career, it is probable that no fewer than six different master-carvers were involved (three at Ripon, and at least three at Manchester, Jervaulx, Bridlington and Beverley).

In giving the Ripon Minster choir-stalls to William Bromflet it is possible that Purvis was influenced by the entry in the 1518 indenture which stipulates that on the St Wilfrid's Closet '. . . the George to hayff towo heds and thre Armes and on the tone hed a Sallet and of the tother hede a Schaplet . . .'[59] One immediately recalls the mechanical arm which can still be seen on the pulpitum loft at Ripon (Pl. 50). Elsewhere in this document, William Bromflet contracts to '. . . make the Armes of the said Johan at iiii places on the said loft and over scripts of remembrance . . .' The fact that Bromflet was commissioned to make sculpture with mechanical limbs in c. 1518 does not, of course, prove that he was responsible for making the time-beating arm on the minster pulpitum loft. Mechanical limbs on wooden sculpture in the Middle Ages were probably not uncommon.[60]

It can be argued that, although the style was first essayed at Ripon c. 1490, it had by no means reached its canonical form at that point. This is acknowledged by Purvis, and he lays great stress on the fact that the idea of a tester above the canopywork, first seen at Manchester, is implied in the treatment of the tabernacles on the south-east wing screens at Ripon (Pl. 77). However, neither of these occurrences is a convincing rehearsal for the full-scale use of testers above choir-stall tabernacle work. As already mentioned, the Manchester testers, along with the canopy lierne vaults and treatment of misericord supporters, could have been inspired by the St George's Chapel, Windsor choir-stalls (Pl. 94), manufactured some ten years earlier than Ripon. Nobody would deny that the style reached its classic moment at Manchester. Until then, various experiments on similar lines had doubtless been taking place at Ripon and elsewhere. The craftsmen were working in a distinctly north-country

[59] Purvis (1935), 114.

[60] For instance, the wagging tongue on a misericord from the early-fourteenth century Winchester Cathedral choir-stalls.

[61] Tracy (1987), 16–24.

[62] Jervaulx Abbey (Aysgarth Church), Beverley Minster, Newark, Durham Castle, Hauxwell, Easby Abbey (Wensley), Barkestone and Wensley. See Appendix.

[63] On the other hand the choir-stalls at St Mary, Richmond, which are said to have come from Easby Abbey, are stylistically unrelated and indeed inferior to the Ripon-related work.
[64] See Note 2.

[65] Hauxwell, Durham Castle, Barkston and Kirkstall (lost). See Purvis (1929), 199. The author does not mention the Newark stalls.

[66] See Howard's observations on regional 'schools' of woodworking in England in Howard and Crossley (1917), 35–38.

tradition that went back ultimately to Lincoln. It is doubtful that they would have regarded Ripon in particular as the fountain-head of a stylistic revolution.

It is likely that William Bromflet, a denizen of Ripon, was 'lent' by the minster to Manchester and Bridlington to design and carve their choir-stalls. A precedent for this is the 'lending' of the master-carver William Lyngwode to Winchester Cathedral by Bishop Salmon of Norwich in the early fourteenth century.[61] If Bromflet was the master carver at Manchester in c. 1506, he must have been a relatively young man at the time, say 25–30 years old, since he does not seem to have worked on the Ripon choir-stalls c. 1490. During his career he must have been employed a good deal at Ripon itself, but it is not inconceivable that he made choir-stalls elsewhere, which are now lost. If Purvis's conjectures about the minster's carpentry workshop are correct, it is likely that the craftsmen working on the stalls were from the Bromflet (or Carver) family. None the less, the lack of co-ordination in the assembly of the furniture, and the disparity of the carving styles is equivocal.

It cannot be denied that the Ripon choir-stalls must have been influential in north-country woodworking circles. The Manchester and Bridlington furniture apart, the eight instances of monuments unquestionably inspired by either Ripon or Manchester are witness to this.[62] The stylistic similarities are not, of course, restricted to choir-stalls. They include screenwork which, as even today at Manchester, played an integral part in the furnishing ensemble. Before destruction at the Reformation the amount of 'Ripon' inspired woodwork in the north of England must have been very much greater than now.

A weakness of Purvis's thesis is the lack of tangible evidence to support a credible artistic personality for William Bromflet. For all its good design ideas the Ripon Minster furniture lacks the guiding hand of a dominating artistic personality. The Manchester choir-stalls are the artistic high point of the inventory. But, unfortunately, the only evidence that the Lancashire furniture was made by William Bromflet is the comparison with the three desk ends from Bridlington Priory in Leake Church. Even if one accepts a common authorship for Manchester and Bridlington, there can be no sure basis for extending Bromflet's career further, as Purvis tries to do, although the closeness of the screenwork at Easby Abbey to the Manchester woodwork might allow one to speculate that Bromflet worked there too.[63]

The use of the term 'school' conventionally implies the discipleship of a particular artist.[64] In medieval woodwork we rarely know the name of a monument's maker. If we are lucky enough to have one, with disappointing regularity, there is no work with which to associate it. As none of the craftsmen working at Ripon is singled out by name, the use of the epithet could hardly have been adduced on the basis of a documented artist inspiring a revival of ecclesiastical furniture-making. In any case, it seems that Purvis would really have liked to have been able to prove that the entire corpus except for the doubtful category,[65] was the work of Bromflet himself. The label 'Ripon School' was convenient because it did not commit the author unreservedly to the hypothesis of a single artistic career, which could not be proven either by documentation or archaeology. But the label should be used only with care in a medieval context, if it is to retain anything like its proper meaning. In conferring it upon Ripon, the author is on dangerous ground since the minster furniture is a patchwork, as he himself stressed, of experimental character.

The epithet, although romantic, is not historically substantiable. Archaeologically it is misleading. With this corpus of monuments and its satellites, we are dealing with a distinctive regional style comparable with other contemporary bodies of woodwork, for instance in East Anglia, the West Midlands or the West Country.[66] As in other areas of England a distinctive local vocabulary was

created by several first-rate master carpenters interacting upon each other. Hand A at Ripon and the Manchester master were outstanding artists by any standard. This sophisticated trans-Pennine late-medieval tendency was un-equivocally rooted in north-country choir-stall architecture. At the same time it can also be shown to be cognisant of both East Anglian and 'London' woodwork.

The Norwich Cathedral Choir-Stalls and Their Stylistic Context

The ground was prepared for an examination of the stylistic context of the Norwich Cathedral choir-stalls (Pl.95) by the publication in 1948 of Whittingham's masterly archaeological delineation of this complicated monument.[1]

The earliest extant material comprises the return stalls and the first sixteen canopies from the entrance on each side (Pl.96), together with twenty-two misericords.[2] The remnants are only a fragment of the earliest surviving furniture, manufactured during the episcopate of Bishop Wakering (1416–25).[3] The crockets in the shape of birds probably refer to this bishop whose arms were three hawks' lures (Pl.97). Two unidentified heraldic shields were displayed in the spandrels of the original bishop's stall canopy (Pl.104). Moreover, Wakering's predecessor, Richard Courtenay (1413–15), is depicted on a misericord (Pl.98).[4] Bishops may well have been portrayed in earlier English choir-stalls,[5] but they have never been positively identified as at Norwich. The shape of the misericords is of early fifteenth-century type. Finally several of the seat carvings can be associated by their heraldry with particular members of prominent local families.[6] The latter most probably contributed to the cost of the furniture. This must have been one of the first cases in England of lay involvement in the commissioning of choir-stalls. Up to this time, as far as I have been able to ascertain, the financing of a monastic cathedral's choir furniture came from institutional revenues, possibly with assistance from the bishop.

Work of the next period is attached at different points to the remains of Wakering's stalls, the eastern portions of which were burned in the crossing fire of 1463. This campaign was the responsibility of Bishop Goldwell (1472–97). The earlier double-screen canopies were replaced at the east end by a single, rather than two-tiered design, the gables springing from a point considerably higher than those in the earlier work (Pl.99). They are arranged in three unit bays with pierced rather than blind tracery in the spandrels. They are made to link up with the earlier superstructure in a lateral direction by means of the continuation of the former architrave and cresting. When they were fitted, they continued eastwards through the crossing, as the seating still does.[7] The thirty-five misericords and the seating of the second campaign is recognisably different from the earlier work (Pls 100a–d).

In 1509 the stalls were damaged again, in another fire, in the centre of the crossing, after which the same procedure as before was adopted. The surviving stalls were moved up to close the gap, and new work was fitted at the east. According to Whittingham, the fragments from this latest renovation are of Bishop Nykke's time (1501–36). They consist of two misericords (S.29 & 32;

[1] Whittingham (1948). A useful précis of his arguments is provided in Whittingham (1981), 7–11. I am heavily indebted to this painstaking recording work. The later publication incorporates a few minor revisions to the original thesis. His misericord catalogue series is not the same in the two publications. I have used the system from the 1948 article throughout. For a detailed description of this monument Whittingham's account cannot be bettered.

[2] Whittingham believed that there were choir-stalls in the Romanesque choir in the same position as the later ones. The original furniture would have been destroyed in the fire of 1171. Their successors were burned down in the riots of 1272.

[3] Whittingham believed that the probably late twelfth-century stalls were almost certainly damaged by the fall of the spire in 1362. From the heraldry on Wakering's misericords, it seems that legacies were being received from after that time. See Whittingham (1948), 18–19.

[4] Misericord S.6. The initials 'R.C.' identify him.

[5] For instance the ecclesiastic, probably Bishop Woodlock (1305–16), on a misericord in the north return stalls at Winchester Cathedral.

[6] S.3 misericord (arms of Sir Thomas Morley, d.1415); S.4 misericord (image of Sir William Clere of Ormesby, and his wife); S.4 seat standard (shield of Sir Robert Ufford of Wrentham, d.1392); and misericords S.8 (shields of Sir Thomas Hoo, d.1420, and his first wife, d.1400, St Omer of Brundall, and Sir Thomas Erpingham, d.1428); S.9 (shield of Sir Leonard Kerdeston, d.after 1421); S.10 (John Clere, Denise Wichingham and Sir Robert Berney of Wichingham, d.1415); S.11 (shield of Sir James Havile, of Dunston, d.1354); S.12 (shield of Michael de la Pole, 2nd Earl of Suffolk, d.1415); N.7 (shields of Sir William Wingfield of Letheringham, d.1378 and his wife Margaret Boville); N.4 (image of Sir Robert de Illey of Plumstead, d.1398, shield of Sir Thomas Hoo of Brundell impales Felton, shield of Sir Robert de Ufford of Wrentham); N.3 (shields of William de Ufford, Earl of Suffolk, d.1382, John Lestrange of Blackmore, Salop, d.1375. See Whittingham (1948).

[7] In 1851 the superstructure of Goldwell's stalls was dismantled in the crossing area.

Pl. 101)[8] with fleurons carved along the top edge of the seat, and, according to Whittingham, four seat standards and backs. He admits that the mane of the misericord Leo figure 'reverts to wavy 1420 type'.[9] Indeed on stylistic grounds the carving of both misericords conforms more readily to an early fifteenth- rather than sixteenth-century date. In both cases the squared-up voluted 'trefoil' leaf supporters even include the fourteenth-century type sheath of cut shoots at the springing of the foliage spray. Were they salvaged from an earlier, possibly unrelated, set of choir-stalls elsewhere to compensate for the losses of the 1509 fire? A fourth set of choir-stalls, identified by Whittingham who suggested that they may have come from the Lady chapel, is represented by the misericord now in the precentor's stall, together with the seat standards of the dean's stall, and two complete seats now on the north side of the high altar (Pls 102a & b). This material is probably of late fifteenth-century date.

Wakering's stalls numbered seventy,[10] for the prior, subprior and sixty monks, sacrist, precentor, bishop (probably on the south side of the choir entranceway),[11] chancellor and four archdeacons. There were no substalls, the choir-boys sitting on a bench in front. Wakering's desks must have been replaced because the existing back stall desk ends and front desks are of Goldwell's time (Pl. 103).[12] There is much nineteenth-century restoration on the stall canopies, particularly on the south side, and in the upper zone throughout.[13] The superstructure of the return stalls was probably also flat fronted.[14] It has been suggested that the extant projecting gables of the prior's three-sided canopy may have been introduced by Prior Heverland (1436–52) along with the present entranceway (Pl. 95).[15] A drawing of the return stalls of 1830 shows the original canopy gable of the bishop's stall still in position (Pl. 104). It was taller than the others, reaching up to the architrave. In its spandrels heraldic shields can be made out. There are several detailed stylistic inconsistencies in the canopywork. But the restoration content is too high for anything meaningful to be read into them.

The seating of the earlier phase is distinguished by an unusual 'battlemented' frieze along the lower edge of the seat capping (Pl. 100a). Otherwise the seat standards are typical for the period with prominent deeply carved elbows and moulded columns sitting on plinths. The corners are carved in the solid with prominent 'bridge' motifs in the lower 'spandrels', including the perennial crowned head on the north side.[16] The gables of the lower canopies are distinguished by highly elaborate cusping with animal and human heads, and foliage in the spandrels (Pls 105a–f). The ogees are finely drawn with multiple mouldings. The crockets of the gables are typical large-scale, squared-up early fifteenth-century leaf compositions. In the upper zone the band of gables and tracery work stands proud of a wainscoted backing (Pls 96 & 106). The vaults of Wakering's canopies are sophisticated star-plan liernes, with foliated cusping in the cells (Pls 105a & b). The subtlety of the planar 'layering' of the canopywork design is admirable.

The remains of Goldwell's furniture displays a number of interesting stylistic features. The mouldings on the seating consist of uncomplicated combinations of broadly conceived ribs and hollows (Pl. 100b). The style of the carving goes with this comparatively crude articulation. The elbow figures are extremely prominent and characterised by large areas of undecorated surface. The fronts of the seat standards are easily distinguished from the earlier work by the crenellation-like decoration above the capitals of the columns. The seating of the former prior's stall (N.1) is from this campaign. The mouldings of Goldwell's misericords are also easily distinguishable from Wakering's (Pls 98, & 100c & d). As already mentioned, Goldwell's canopies make no attempt to align with Wakering's. Effectively they are a single zone, rather than two, the

[8] Misericords numbered S.26 & S.29 in Whittingham (1981). A date of 1515 is adduced in the 1948 text, but subsequently the estimate is brought forward to 1509.

[9] Whittingham (1948), 22.

[10] Numerals are incised on the backs of the misericords.

[11] Most probably the Romanesque bishop's throne in the eastern apse was out of commission by Wakering's time. At any rate, a loft placed above the high altar sometime in the fifteenth century would have obscured it. See D. H. S. Cranage, 'The "Cathedra" of the Bishop of Norwich, *Norfolk Archaeology*, XXVII, 1941, 429–36.

[12] Whittingham has pointed out that the incised numbering system on the desking is the same as on Goldwell's stalls. See Whittingham (1948), 26.

[13] Undertaken by one Ollett, a craftsman from Mulbarton, in 1833. See Whittingham (1948), 28–29.

[14] The notch for the north side of the original gable to the north of the entranceway can still be seen.

[15] Whittingham (1981), 10.

[16] The southern of the bishop's stall standards may have been adjacent to the entranceway originally. Its obverse face is not cut out to receive a tip-up seat.

top gable stretching up to the bottom of the cornice (Pl.107). The tracery patterns are quite similar to those on the earlier work with prominent use of straight-sided quatrefoils. Also the ogee arch is retained for the main gables. The Perpendicular-type pierced panel tracery in the spandrels, as well as the open-work traceried cusping on the main arches is exceedingly effective (Pl.108a). The canopies are corbelled out from the stall backing on cusped brackets (Pl.99), a technique which was consistent with the intention of paring down the superstructure to a minimum. The pattern used in the replacement vaults of Wakering's lower canopies (Pl.105f) conform to the lierne design of Goldwell's own canopies (Pl.108b). The moulding profiles on the desking, the ornament, and the tracery of the arcading, stylistically confirms the origins of this component in the second campaign (Pl.103). Many of the desk ends are post-medieval, but the four, with extensions and angled buttresses, are authentic. All the substalls are modern.

The architecture of the early fifteenth-century stallwork at Norwich Cathedral represents the apogee of metropolitan-type double-screen furniture in England. Gone are the uncertainties of scale and treatment exemplified in the mid fourteenth-century furniture at Ely Cathedral. The penchant of 'London' designers for the static linear organisation of repetitive miniaturised architectural forms in well defined horizontal planes, as for instance at early fourteenth-century Chichester Cathedral, in contrast to the repeated hierarchical massing of motifs in the vertical at Lincoln and Chester, is faithfully reflected at Norwich. The 'double-screen' design looks back to Ely.[17] The upper zone echoes the frieze-like character of the lower gable echelon, rather than attempting to create a tier of three-dimensional image housings. Norwich applies the lessons of single-screen choir-stall architecture to the double-screen format. A series of highly-decorated gables is subtly emphasized by being projected forward to the level of the front of the seat capping. The shadows cast by the canopy vaults underscore and emphasize the 'facade' of the design. The addition of another zone, and a fussy crenellated cornice as well, is undoubtedly called for. As much as to Ely, the Norwich design looks back to Gloucester,[18] the first two-zone single-screen design. Gloucester and Norwich, with their continuous panelling from seat back to cornice, rising through two horizontal layers, are each in their own way idiosyncratic interpretations of the Perpendicular style.

The close stylistic relationship of Wakering's stalls to metropolitan architecture need not surprise us. The bishop had a career as a great officer of state and at one time or another held the positions of chancellor of the county palatine of Lancaster, master of the *domus conversorum*, and keeper of the chancery rolls.[19] Before his election to the bishopric in 1415, he would have had plenty of opportunity to take notice of the latest artistic developments in the capital. His patronage at Norwich was extensive, and included the completion of a cloister linking his palace to the cathedral, and a new chapter house.[20] He was well known for his generosity and is recorded as having given much jewellery to the cathedral.[21]

In contrast to fifteenth-century stone architecture in the Perpendicular style, English choir-stalls maintain a predisposition for decorative ornament. The lower canopy gables at Norwich indulge the long-established English obsession to the full (Pls 105a–f). This certainly must have been a lavish commission. The fact that by c.1420 English foliage decoration had reached a distinctly conventional phase, with unnaturally squared-up and schematically drawn leaves, contrasting with the unerring botanical recognisability of the first half of

17 Tracy (1987), Pl. 178.

18 Tracy (1987), Pls 145 & 146.

19 DNB, 1899, 3–4.

20 F. Godwin, *De Praesul Angl. etc.*, Canterbury and London, 1743, 438–39.

21 H. Wharton (ed.), *Anglia Sacra*, I, London, 1691, 417.

the fourteenth century, does not prevent the Norwich master-carver from suggesting a bewilderingly wide range of species. At least ten different sorts of leaves are displayed in the succulent giant crockets. The rich cusping and subcusping of the gables is offset by a multiplicity of motifs, including human and animal masks, foliage, some of which is identical to the misericord supporters in the seating below, birds, and even a spoke of three interlocking fishes (Pl.105e, bottom left). In a general way this highly decorative treatment of the gable subarch recalls the marginal illustrations of contemporary illuminated manuscripts. The forward projection of the gables provides the basis for a fine ribbed and cusped star-shaped lierne vault, and another display of cusping and subcusping below. As at Gloucester and elsewhere, in mid fourteenth-century metropolitan work, the ogee arch is retained, along with the finely drawn multiple mouldings, comparable even with the early fourteenth-century woodwork at Winchester Cathedral. Remarkably for their date of manufacture the Norwich stalls retain a stubborn loyalty to the Decorated style. The carving of the seating is also of a high order, with multiple mouldings on the seat capping, under which is the 'billet' frieze (Pl.100a).

Unfortunately, there are no contemporary choir-stalls with canopywork comparable with the first campaign at Norwich. Equivalent decorative carving is not easy to find either. In the late fourteenth-century choir-stalls at St Margaret, King's Lynn there is a 'rose bush' not unlike the one on a misericord at Norwich (Pls 109 & 100c).[22] But perhaps a more substantive reason for adducing the latter church is the presence on the desk fronts of a large number of heraldic shields, displayed in a similar way to the former shields at Norwich above the bishop's stall.

Goldwell was also a prelate of high standing in both church and state. Before his election in 1472 to Norwich he was a prebendary of St Paul's Cathedral, London and had been confidant to Henry IV. Like his predecessor he would have been fully *au fait* with the latest tendencies in artistic matters. He was a considerable patron, at Norwich improving his own palace, restoring the cathedral and chapels, leading the choir roof and having the arms of benefactors painted on the walls and windows.[23] Moreover after he had become bishop, he is said to have 'repaired', if not wholly rebuilt[24] Great Chart Church, in his native Kent, founding a chantry for his family there. Goldwells were lords of the manor.

The canopywork of Goldwell's stalls shares with the earlier monument a strong metropolitan character. The scheme of ogee gables backing transomed Perpendicular tracery goes back at least as far as the chantry chapel of William of Wykeham at Winchester Cathedral, probably completed in 1404 (Pl.110).[25] This was probably designed by William Wynford. It can be seen in the canopy of Prior Rahere's tomb in the monastic church of St Bartholomew the Great, London (Pl.111).[26] The treatment of gable mouldings and the use of pendant corbels there is quite close to the Norwich stalls. The Rahere monument is usually dated c.1500,[27] but it could easily have been made a few years earlier, that is about the same time as Goldwell's stalls. Another essay in the style is the tomb of John Tiptoft, Earl of Worcester, and his two wives, at Ely Cathedral (Pl.112). Tipftoft was beheaded in 1470. The treatment of the tracery at Ely is by no means identical with Norwich but, in this case, the orthodox cusping and subcusping of the gable arches recalls Goldwell's canopies.

The plain treatment of the seat mouldings and the proportions of the elbow carvings are echoed at Salle Church, Norfolk, presumably of about the same date (Pl.113).[28] In both places the abacus of the seat standard column capitals is crenellated. The poppy heads of Goldwell's desking, whilst of typical East Anglian form, are distinguished by a richness of treatment. Different plant

[22] The stalls at St Margaret's were probably made *c.* 1370–80 on the basis of the identification of the misericord subjects. See L. Galley, 'St Margaret's Church, King's Lynn', King's Lynn, 1947, 11.

[23] *DNB*, XXII, 1890, 96–97.

[24] F. Blomefield, *History of Norfolk*, III, 539, & IV, 6.

[25] Wykeham's death date. See Cook, (1947), 90–91.

[26] The canopy was 'added in the fifteenth century'. See G. Worley, *The Priory Church of St Bartholomew-The-Great, Smithfield*, London, 1908, 45–47. It is surely all of a piece with the base, and closely related in style to the Ely Cathedral Tiptoft monument (see below).

[27] For example, see Nikolaus Pevsner, BOE, *London*, I, 1957, 135.

[28] It has been suggested that the chancel was probably built *c.*1450 by John Nekton, Rector 1441–60. See 'The Parish Church of Salle, Norfolk', Norwich, 1938, 16.

species are depicted including rose and hop (Pls 114a & b). Two noticeable Morellian traits are the seam up the middle of the design, recalling the product of a casting mould, and the cusped layered treatment of the lower surface. This conceit is found on bench ends at Fressingfield, Suffolk, which are otherwise quite different in form and treatment. Intriguingly, the desk ends and poppy heads in Goldwell's native Great Chart Church are markedly East Anglian in style (Pls 115a & b). The shape and treatment of the poppy heads is close to the Norwich examples with its plastic carving. Moreover, one poppy head in the Kentish church has the cusped layering at the base as it is found at Norwich. The desk ends from the destroyed church of St John le Poor, Canterbury, now at St Mildred's, are probably by the same workshop (Pl.116). There do not appear to be any other desk ends in Kent remotely similar in form. It is, therefore, highly likely that the Great Chart and Canterbury woodwork is an East Anglian import, the responsibility of Bishop Goldwell.

One of the most interesting features of Goldwell's furniture is the desk ends which, with panelled extensions and angled buttresses seem to parallel the fifteenth-century development of this feature in Yorkshire. However, the Norwich design is modest by comparison with the elaborations at Ripon (Pls 86 & 103).[29] Moreover the buttresses are not physically detached as they were at St Nicholas, King's Lynn (Pl.87). But the forms seem to have been driving independently in the same direction.

Finally, the misericord (Pl.102b), given by Whittingham to the former Lady Chapel, can be paralleled in a non specific way with the seats at Southwold and Wingfield, Suffolk. The woodwork in these churches is of different dates, but the stalls must be of the late fifteenth century.[30]

The paucity of local stylistic parallels for the fifteenth-century campaigns at Norwich may be due to the destruction of so many contemporary monuments. A more likely explanation is that the work was designed and executed by London based craftsmen. It is tempting to draw a comparison of patronage with Ely in the 1330s, where another bishop with good London connections must have influenced the choice of a metropolitan master-carpenter to design a great abbey's stalls, with London craftsmen to execute them. Unfortunately, as at Ely, other works by the same artists cannot be identified. Moreover at Norwich the workshop's activities in the cathedral are quite undocumented.

[29] See Chapter III.

[30] The choir at Wingfield was made collegiate by Sir John Wingfield, d.1360. The desking of the choir-stalls is probably of the early fifteenth century but the rest of the furniture and the screenwork is much later. For a history of Wingfield see S. W. H. Aldwell, *Wingfield: its Church, Castle and College*, Ipswich, 1925.

The Choir-Stalls at St David's and Bristol Cathedrals

These two West-Country monuments are both of early sixteenth-century date. The secular St David's Cathedral furniture must have been made c.1500 during the treasuryship of Owen Pole, 1493–1509 (Pl.117).[1] The date of manufacture of the Augustinian Bristol Priory choir-stalls must be c.1520 during the abbacy of Robert Elyot (1515–26) (Pl.118).[2]

The liturgical choir at St David's is where it has always been, under the crossing tower. There are twenty-eight back stalls surviving, but it is possible that originally there were thirty-six.[3] This would have been a comparatively small choir, although surprisingly, six seats larger than fourteenth-century Exeter Cathedral. However, by comparison with the larger fourteenth-century English cathedral stall sets, at Winchester Cathedral (sixty-six back stalls), Chichester (forty-eight) and Wells (fifty), and fifteenth-century Carlisle (forty-six), the St David's furniture was modest in scale. The surviving furniture precedes at least two previous monuments, the latest having been erected by Bishop Gower in the mid-fourteenth century.[4] At Bristol, before the demolition of the nave in the mid-sixteenth century, the choir probably occupied the area of the crossing.[5] There were either thirty-two or thirty-four back stalls.[6]

ST DAVID'S CATHEDRAL

The furniture at St David's is of typical mid fifteenth-century type. The superstructure is a compromise between the single and double-screen formula, having a parapet in the upper zone cantilevered forward without the aid of front uprights (Pl.119). The contemporary choir-stalls at Norwich Cathedral of Bishop Goldwell's time[7] follow the same principles except that the upper zone is supported by uprights placed on the seat capping projections (Pls 95 & 99). As has been pointed out, the St David's superstructure strongly resembles a type of parish church rood screen, with a lierne vault supporting a loft parapet.[8] Some writers have been critical of both the design and workmanship of the canopywork at St David's.[9] The quality of the carving is unexceptional, it is true, but the design is extremely effective and the whole would have been impressive in its original polychromed state. The desks sit on stone plinths pierced with ventilation holes (Pl.120).

The interpretation of this monument, particularly the superstructure, must be approached with caution on account of the high restoration content.[10] Almost certainly, however, the eastern ends of the lateral stalls have been pushed back

[1] Crossley & Ridgway (1943 et seqq.), 37–38. The more traditional dating was to the episcopate of Bishop Tully, 1460–80, whose arms are displayed on the dean's desk-end. However, a monogram/rebus on the treasurer's desk-end has been recognised as referring to Owen Pole. See W. J. Hemp, 'A "Rebus" in St. David's Cathedral', Arch. Camb., December 1941, XCVI, 202–03. It has been suggested that the presence of Tully's arms on the dean's desk-end must have been to do with his having contributed to the cost of the stalls (Ibid., 203).

[2] Perry (1921), 233–50.

[3] Browne Willis tells us that the chapter at St David's numbered forty-one in total. See Browne Willis, A Survey of the Cathedrals, III, London, 1742, 175.

[4] For a discussion of the 14th c. wooden choir furniture at St David's, see Charles Tracy, 'The St David's Cathedral Bishop's Throne and its Relationship to contemporary fourteenth-century Furniture in England', Arch. Camb., 137, 1988, 113–118.

[5] Vallance (1947), 95–96.

[6] See 'The Ichnography of Bristol Cathedral', in W. Barrett, History and Antiquities of the City of Bristol, Bristol, 1789, facing 292, where thirty-two seats are shown. On the other hand, thirty-three misericords were said to exist in 1861. See R. H. Warren, Arch.Jnl, 1861, 273–74.

[7] See Chapter IV.

[8] Crossley & Ridgway (1943 et seqq.), VIII, 34.

[9] W. B. Jones and E. A. Freeman, The History and Antiquities of Saint David's, London, 1856, 87, and Crossley & Ridgway (1943 et seqq.), VIII, 34.

[10] The late nineteenth-century refurbishment was by George Gilbert Scott. Crossley and Ridgway cite, in particular, 'at least six new carved seats' and seven modern misericords. See Crossley & Ridgway (1943 et seqq.), VIII, 34–35.

about 31cm in modern times to provide a little extra space. From its mouldings, and the signs that its neighbouring seat has been crudely hacked off, the easternmost stall on the south side, unlike its counterpart on the north, can be seen not to have been originally an end seat. Moreover the loft on both sides at the east end continues further east the length of another seat, and is then returned (Pl.121). Also the vaulting underneath has been cut to allow the loft to run its full length. The widening of choirs was resorted to in England in the eighteenth and nineteenth centuries.[11] At the west end, on the other hand, there is unlikely to have been any scope for recession, as the stalls must have always backed on to the north and south-facing flat pier returns. It is tempting to see the present entranceway as wider than the original. However, the traceried wings on either side seem to be medieval even though the flattened arch, and the bayed parapet above, are entirely modern. The wainscoting at the back of the return stalls has not been curtailed, although alterations seem to have been made to the seat capping at the junction of return and lateral seats (Pl.122).

A large proportion of the superstructure is restoration work, including much of the 'stylised flower' frieze on the lower architrave (Pl.123), and most of the upper cornice bosses.[12] The 'stylised flower' motif, which also occurs on a desk end poppy head, was identified as pomegranate by Crossley and Ridgway. It is a motif relatively new to the repertory of English medieval decorative carving.[13] The design of the stall backs must be authentic including the eccentric Y tracery device in the spandrels of the gable heads. The mouldings on this tracery and the daisy-head cusp terminals are comparable with the treatment of the fronts of the desking below. Three of the stalls had shields painted on the wainscoting at some time,[14] and there are traces of red colouring. It is possible that the tracery of the upper portion of the superstructure was always open, being boarded-up in the nineteenth century for warmth. A small section at the south end of the south return stalls is still pierced (Pl.123). The handling of the seat standard elbows is inconsistent in that some are figurative whilst others are moulded (Pl.124). On the other hand the mouldings of the seating seem to be generally all of a piece. The repertory of flora used on the decorative carving at St David's includes hawthorn (Pl.131c), voluted 'trefoil' leaf, rose, vine (Pl.131a), 'stylised flower'/'pomegranate'-type (131b), ivy and oak (Pl.131d).

BRISTOL CATHEDRAL

The frequent appearance of the shield and initials of Robert Elyot, abbot of the monastery from 1515–26, on the choir-stalls has traditionally been cited in the dating of this monument (Pls 125a & b).[15] Twenty-eight seats survive, now rearranged in two straight lines on either side of the choir, considerably further east than they were originally. In 1542, soon after the reconstitution of the abbey as a cathedral, a stone choir screen was introduced from the dissolved Carmelite church in Bristol.[16] In 1859 it was removed on the recommendation of Scott,[17] although a few fragments were retained.[18] The present arrangement, the work of J. L. Pearson, is just the latest in a series of reconfigurations. Bishop Bush, the first of the diocese, is supposed to have conducted a radical remodeling,[19] and, again in 1860, further changes were made under Scott.

A large proportion of the extant furniture is the work of Pearson. The seating is substantially authentic[20] as are nine desk-ends and a further two in the church of St Mary, Olveston (Pls 126a & b).[21] Most of the desk ends in the

11 For instance, at Henry VII Chapel, Westminster Abbey (see Chapter VII, ab), in the late eighteenth century, and at Wells Cathedral in 1848 (see Tracy 1987, 25).

12 Some on the south side are medieval.

13 Early appearances of 'pomegranate'/'stylised flower' occur at Ripon and St George's Chapel, Windsor. See Introduction.

14 The shapes can just be made out on N.1, N.12 and N.14, counting from the west.

15 The only thorough-going study of this furniture is Perry (1921), 233–42.

16 Vallance (1947), 94–96 & Pls 23, 24, 88 & 90.

17 *Ecclesiologist*, XX, 330–32.

18 On the north and south sides of the presbytery.

19 H. J. L. J. Massé, *Bristol, The Cathedral and See, Bell's Cathedral Series*, London, 1901, 233–42.

20 Twenty-eight of the original misericords survive. See Remnant (1969), 45–48.

21 According to Perry 'presented some years since by those in authority at the cathedral'. See Perry (1921) above, 233.

cathedral have been converted into bench ends for the modern substalls. The panels incorporated into the modern back stall desk fronts are mainly of Elyot's time, many displaying the abbot's initials in the spandrels (Pl.125a). At Olveston there are some fourteen bays of parclose panelling with tracery heads, related but different in form to the original panels incorporated into the modern back stall desk fronts in the cathedral (Pls 126b, left and 128, back). They display shields with the arms of the Berkeleys (Pl.127a), Abbot Elyot (Pl.125b) and, unexpectedly, the rebus of the previous abbot, Nailheart or Newland, 1481–1515 (Pl.127b). In front is a row of desking incorporating panelling with tracery heads. The desk ends are identical to those in the cathedral. They are plainer and, from the way the join with the desking is effected, it would seem that they have always carried out their present function (Pl.128).

It is tempting to assume that the whole of the existing stall superstructure in the cathedral, of coved single-screen type, is a modern invention. However, certain important components of the design appear to be original, such as the uprights, the cresting below the coving, the coving bosses and the vine trail and cresting at the very top (Pls 129a & b). A careful archaeological reconstruction by Pearson from surviving material, however fragmentary, cannot be ruled out. Apart from the open stall backs the most obviously 'restored' features are the tracery heads above. Perhaps those now incorporated in the back stall desk fronts (Pls 118 & 125a) come from the original stall backs. The form of the desk fronts can be recovered from the fragments at Olveston (Pl.128). There the parclose panelling (Pls 125b & 128) clearly goes with the rest of the woodwork, but we cannot know quite how it was used. It can hardly have constituted the backs of the original stalls. The benches which are now fixed to the base of this panelling must be a modern addition. At Bristol the blind flamboyant tracery panels which are now incorporated into the modern pulpit (Pls 130a & b), must also be associated with the choir-stalls. Possibly they were part of some terminal wing screens. In general, the decorative carving shows little interest in botanical accuracy.

These two monuments could hardly provide a greater contrast. The St David's furniture emanates definitely from a tradition of regional vernacular workmanship. On the other hand the Bristol choir-stalls, difficult as they are to reconstruct, betray metropolitan origins.

A sure sign of provincial quality in choir-stall making is an evident rationing and perfunctoriness of decoration. The ornament at St David's, on the canopywork and desking is repetitive and uninspired. On the other hand the misericords, seat standard elbows and desk end poppy heads have received the attention of an averagely-skilled master-carver (Pl.131a–d). Provincialism also manifests itself in the eccentric design of the lower zone of blind tracery with the curious triangular sections in the spandrels of the gable heads, and the casual butting of the seat standards in the western junctions.

The stylistic origins of the St David's superstructure in parish church rood screen formulae are apparent in spite of the fact that so few rood lofts survive. An obvious analogy is the loft on the western side of the choir screen at Montgomery parish church (Pl.132).[22] There is no secure date for the Montgomery rood loft but it was probably made at about the same time as the St David's stalls. The applied traceried mid fifteenth-century choir-stall canopywork from the dissolved abbeys of Wigmore and Chirbury (now in Montgomery and Leintwardine parish churches)[23] stands for the design prototype upon which the St David's master-carpenter must have drawn (Pls 44a & b). Moreover the choir-stall seating at Montgomery (Pl.45) is similar to

[22] This was considered on balance to have originated in the church. See F. H. Crossley & M. H. Ridgway, 'Screens, Lofts, and Stalls situated in Wales and Monmouthshire. Part V. Montgomeryshire and Carmarthenshire', *Arch. Camb.*, XCIX, 1946, 210–11.

[23] See Chapter II.

that at St David's with heavily moulded capping, large-scale figurative elbows and plain plinthless seat standard fronts.

As can be expected in a provincial monument, most of the decorative carving at St David's is traditional in form. Motifs of early fifteenth-century type abound on the seating. At the same time the 'stylised flower' in the frieze of the lower canopy architrave, and on the desk end poppy heads, betrays a later date. The western loft at St David's is similar in form to the one at Ripon of c.1490 (Pl.47). Perhaps the most advanced feature on the St David's stalls is the handling of some of the seat elbows, not as conventional figurative bosses, but moulded extensions with decorative carving in the 'spandrels'. This conceit was used in the Henry VII Chapel, Westminster of c.1512 and later at Beverley Minster, c.1520. The use of carved jesters on the St David's choir-stalls coincides approximately with their appearance at Manchester Cathedral.[24]

Although the carving at Bristol is better than at St David's, it is less easy to locate stylistically. In spite of its late date there is still no sign of the Renaissance apart, perhaps, from the shields with frilled edges on a few of the stall fronts and on the superstructure cornice (Pls 129b & 133). The style of the decorative carving, the treatment of misericords and supporters, and the decorative 'spandrels' on the inside of the desk ends is reminiscent of much late fifteenth and early sixteenth-century west-country furniture such as that at Ludlow, Gresford and Tong. The geometric carving in low relief on the desk ends at Bristol is perhaps the most distinctive feature. It is the sort of work that demands more patience than skill, but it is nonetheless effective for that. The misericords are vigorous and it is a pity that so many of them were removed in the nineteenth century for reasons of prudery.[25] The idiosyncratic conceit of using pricked lines, sometimes giving the appearance of panels of leather being sown together, would make the work of this carver easy to recognise elsewhere (Pl.134). The 'eared' poppy heads are also unusual. Unfortunately wood carving displaying these 'trademarks' does not turn up in any other building.

Low relief geometric tracery on the lines of the Bristol work can be seen in rather less competent form in several Somerset churches. Bench ends at Milverton (Pl.135) are an example. Unfortunately, any discussion of the architecture of the Bristol choir-stalls must inevitably be tentative due to the thorough-going nature of the nineteenth-century restoration.

The St David's and Bristol cathedral choir-stalls have little stylistically in common. Although probably made within some twenty years of each other and from 'west country' churches, they are paired here for convenience. Examples of the enduring medieval traditions of regionalism at the close of the Gothic period, they are each worthy of study on their own merits.

[24] Hudson (1924), Pl.XI (4).

[25] They were sent to the South Kensington Museum. See Massé (1901) above, 53. There are no Bristol misericords today at the V & A Museum. Commenting on the subject matter of many of the Bristol misericord carvings, in 1850, George Pryce said: 'As, in all probability, these carvings were executed from designs made by the brethren of the monastery, or, at least, under their immediate supervision, we have in them one of the strongest evidences that the reported scandalous lives of the "religious" in these establishments was no fiction. The men who could perpetrate in durable materials such a proof of the pollution of their hearts and reminiscence of the "horrible crimes" with which they were charged at the Reformation, and inscribe the memorials of their abominations in such a manner as are still witnessed upon these otherwise beautiful carvings were a disgrace to humanity! Happily for common decency and public morals the authorities of the Cathedral have had them so secured that the inspection of them is rendered impossible'. One private-parts-exhibiting misericord supporter has escaped the censoring authorities.

A 'Ludlow' School of Choir-Stall Makers – Fact or Wishful-Thinking?

A putative ecclesiastical joinery workshop based on Ludlow, active during the second half of the fifteenth and the early sixteenth centuries, has been adduced to explain stylistic resemblances between a group of choir-stalls and choir-screens in Shropshire, Cheshire, Lancashire and north-Wales churches.[1] The friendship between Sir Richard Pole, formerly Constable of Ludlow Castle, and Prince Arthur, Lord of Ludlow Castle and the Marches is seen as the basis for a comparison of the woodwork at Ludlow[2] and the garrison church at Conwy. The specific analogy cited is the use of an empty niche on a desk end poppy head. It is true that the Welsh fragments resemble the Shropshire furniture in a general way. However, if they are contemporary with Ludlow they must be a great deal earlier than the time of Sir Richard Pole.

The attempt to link the early fifteenth-century monuments, at Ludlow, Leintwardine and Montgomery, with the early sixteenth-century group of woodwork at Tong, Gresford, Halsall, Astbury, Hughley, Middleton and Aymestry is not convincing either. The poppy heads at Leintwardine (Pl.43) and Tong (Pl.136) are not particularly close. The misericords at Ludlow (Pls 34, 36–38, 39a & 40a), Leintwardine and Montgomery (Pls 137a & b), of typical early fifteenth-century form, are quite different from those at Tong (Pl.138). There is almost certainly an early occurrence on the badly mutilated Annunciation misericord at Leintwardine of the figure of the Crucified Christ, a characteristic piece of English iconography.[3] This feature is certainly found on the Annunciation misericord at Tong, but there are no stylistic connections between the two renderings of the subject. The face of Christ is carved at Tong on the stall backing on the north side, and as a supporter on a misericord at Leintwardine (Pls 139a & b). But, again, there is no artistic kinship. The elongated figure of Gabriel on the Tong Annunciation, compared with the rather stubby figures at Leintwardine, is echoed in the seat standard angel elbows (Pl.140). Although this motif is a constant at Ludlow (Pl.141), Montgomery and Leintwardine (Pls 45 & 46), its handling is completely different from that at Tong, Gresford and Halsall (Pls 142a & b).

Nor do the stalls at Astbury, Cheshire, of c.1500, seem to have any close stylistic relationship with the woodwork at Tong, Halsall and Gresford (Pl.143). The resemblances, as on the mouldings of the seat capping and the mouldings and decoration of the desk ends, is only superficial. The similarities in the choir screens at Astbury and Gresford,[4] with coved canopy at the east and vaulted canopy on the west, are not necessarily proof that the choir-stalls in both churches were made by the same craftsmen. The star-shaped pattern lierne type vault on both screens is very close. But there are several important

[1] Crossley and Ridgway (1943 et seqq.), 64–67. The authors cite Aberconwy, Ludlow, Montgomery, Leintwardine (Herefs), Tong (Salop), Gresford (Clwyd), Halsall (Lancs), Astbury (Cheshire), Hughley (Salop), Middleton (Salop) and Aymestry (Herefs). The idea of a Ludlow workshop was first put forward in Crossley and Ridgway (1943 et seqq.), IV.
[2] See Chapter II for a discussion of the early 15th-century choir-stalls at Ludlow, Leintwardine and Montgomery.

[3] See W. L. Hildburgh, 'An Alabaster Table of the Annunciation with the Crucifix: a Study in English Iconography', Archaeol., LXXIV, 1923–4, 203–32.

[4] For illustrations of the Astbury screen see R. Richards, Old Cheshire Churches, Manchester, Revd Edn 1973, Pls 32, 33 & 34. The dating given is Richards'. See ibid., 27. See F. H. Crossley's elevation drawing of the Gresford choir screen in Howard & Crossley (1917), 239.

5 As was pointed out by Crossley and Ridgway, the meaningful stylistic groupings of choir screens are Astbury and Hughley (Salop) for wainscoting, and Aymestry (Herefs), Gresford and Middleton (Salop) for arch head tracery. See Crossley and Ridgway (1943 et seqq.), XI, 239.

6 A. T. Gayton, 'The College of St Bartholomew, Tong', VCH, Shropshire, London, 1973, 131–33.

7 Bond (Misericords), 217, 226.

8 Probably under the direction of Ewan Christian in 1892.

9 Three of the birds have haloes behind their heads. A fourth carries a fish in its mouth.

10 Dean Jeffery has suggested that the seat below may have had some connection with the Knights Templar, formerly at Weston-under-Lizard.

differences in detail, such as the handling of the tracery in the apex of the arches and the treatment of the panelling at the base of the screens.[5] More significantly, the seat standards of the choir-stalls at Astbury are treated quite differently from those at Tong, Halsall and Gresford, with no angel elbows. Although the seats tip up, they have no misericords, and the panels on the fronts of the desks are decorated with linenfold ornament. None the less, three sets of choir-stalls remain with close stylistic connections. We shall now endeavour to see if they can, indeed, be attributed to the same workshop and, if so, whether the concordances are explicable in terms of patronage.

TONG

The college at Tong was founded in 1410 by Isabel Pembridge, who obtained a license from Henry IV to acquire the advowson from Shrewsbury Abbey. The institution comprised five clergy under a warden, two clerks and thirteen almspeople.[6] Although the building of the church, dedicated to the Virgin and St Bartholomew, is supposed to have been completed by 1430, it will be seen that the extant wooden furnishings of the choir are later than this. It may have been Bond's dating of the stalls to 1410[7] that led to the misguided attempt to link them to the work of an early fourteenth-century Ludlow workshop. The choir-stalls are a fine example of the single-screen collegiate type, consisting of four return and twelve lateral seats (Pl. 144).

The choir screen seems to be coeval with the stalls, with similar foliage carving on the middle rail of the west side to that on the stall cornice. Also the uprights on the west side of the screen have three-quarter round profiles and octagonal bases, like the uprights on the stall backs and the desk fronts. Although the tracery patterns on the arch heads of the choir screen are quite different from those on the stall backing (Pl. 145), that on the lower panels resembles the stall bench fronts quite closely. The stalls have received a fair amount of sympathetic restoration in comparatively recent times.[8] The uprights of the stall backing have been given new bases, and most of the backing cornice has been replaced. The foundations and the flooring have been removed but the furniture is still *in situ*. The desks rest on a wooden plinth, decorated with a quatrefoil frieze. At both ends of the stalls there are panelled wing screens which carry a continuation of the cornice above them. The blind tracery on the stall backing is of a more or less standard design (Pl. 146), except on the fourth panel from the east on the south side. Here, on the lowest level birds appear in the tracery lobes (Pl. 139a). Birds can also be seen on the misericords and stall backing cornice. Presumably, they have Marian significance, along with the pomegranate flower and fruit, tying in with the dedication of the church to the Virgin.[9] At the edge of the special stall back there seem to be lily sprays, whilst in the centre the IHS symbol is flanked by the face of Christ on the east, and an angel holding the Instruments of the Passion on the west side.[10]

As already mentioned, a special feature of the seating at Tong is the use of angel elbows on the seat standards (Pl. 140). The full length figures, feathered or robed, stand on the capitals of the columns, and are of unusual size and prominence. Their deployment is quite different from that commonly found in the late fourteenth and early fifteenth-century choir-stalls like Chester, Nantwich, Carlisle or Whalley. Apart from Gresford and Halsall, with which the Tong figures are closely related, probably the only other instance of full length angels being used as seat elbows is at St Mary, Beverley. The last-named must be much earlier in date, however, and the treatment of the decorative

sculpture there has nothing to do with the work under consideration. The trefoil-shaped poppy heads at Tong with central figures perched on columns (Pl.136), recall Ludlow (Pl.147), as does the shape and treatment of the desk ends (Pls 148a & b), in particular the decoration of the triangular spaces on the obverse with foliage carving. The links with Ludlow, however, cannot be pressed too hard as the monuments are separated in date by well over fifty years.[11] The temptation to compare the handling of the cornices and terminal wing screens in both places should also be resisted as so much of the Ludlow superstructure is nineteenth-century restoration. At Tong the misericord of the Annunciation stands out as the only historiated carving. Its special significance relates, presumably, to the dedication of the church.

GRESFORD

The Gresford stalls are comparable in scale to those at Tong, with four lateral stalls each side and six returns (Pl.149). They were evidently made *en suite* with the choir and parclose screens. The mouldings on the uprights of both screens and choir desks are the same. Also the decorative carving in both parts betrays the same stylistic signature, the motif of the bird in a wreath appearing in both places. The seats are backed by a single open screen of late fifteenth-century type. The curious beasts, lying on top of the western wing screens conform quite closely with some of the animals depicted on the misericords.

Gresford was never a collegiate church. Consequently the building's size, and the quality of its furniture and fittings, have invited speculation. The glass of the east window was given by Thomas Stanley, 1st Earl of Derby in 1500. But whether the whole of the extensive rebuilding of the church was due to the Stanleys, or possibly to its use as a centre of pilgrimage, is not known.[12] The insertion of the east window provides a *terminus ante quem* for the dating of the choir-stalls.

HALSALL

The choir-stalls at Halsall are in only fragmentary condition (Pl.150). There are the remains of some six seats together with substantial portions of desking. On the western desk end on the south side, a poppy head displays the Stanley crest with the eagle and child. Sir Henry Halsall, a patron of the church whose tomb is on the south side of the chancel, and who died in 1523, was married to Margaret, the natural daughter of James Stanley, archdeacon of Chester, and brother to the first Earl of Derby.[13] The benefactor of Gresford church was Margaret's uncle, and of the collegiate church at Manchester, her first cousin.[14]

On the basis of a comparison of the seating, the choir-stalls at Tong, Gresford and Halsall are undeniably close (Pls 140 & 151a & b). The treatment of the angel figures and the columns on the front of the seat standards, and the mouldings of standards and capping, are closely related. As invariably in medieval joinery, there are small differences in the detailed execution. An example is the way that the junctions of lateral and return stalls are handled at Tong and Gresford. In the former where the angle standards are butted together, the tops of an angel's wings are used as a bridging motif. In the latter

[11] For the dating of the Ludlow choir-stalls see Chapter II.

[12] Edward Hubbard, BOW, *Clwyd*, London, 1986, 168–73.

[13] W. H. Bullough, 'A Guide to Halsall and Its Church', 1984.
[14] See Chapter III.

the butting principle is used again but downward-facing fantastic animals are carved on the angled mouldings (Pl.151a). Although there are slight variations in the mouldings of the misericord ledges and the handling of the supporters the treatment of these features in all three churches is remarkably close (Pls 152a, b & c). The stem of the supporters, at Gresford swings down at a sharper angle than that at Halsall and Tong. The quality and design of the Tong carvings is generally superior. The crenellated corbel motif (Pl.153) on a misericord at Tong is reminiscent of the 'reliquary' motif at St George's Chapel, Windsor (Pl.170). The drawing of the tracery on the stall backing at Tong (Pl.146), with its use of ogee arches, and circular and lobed shapes, also distantly recalls the aesthetic of the Windsor decoration. Some of the shallow low relief carving on the misericords at Tong is reminiscent of Windsor (Pls 152a & 188a). Also the way that on the Tong Annunciation misericord the stems of the supporters have flowers growing from them can be compared to the same conceit on the Windsor desk legend frieze.

The Tong seat standard angels are particularly extenuated and elegant. The flying hair of the Tong Annunciation Gabriel recalls an early to mid fifteenth-century convention.[15] By comparison, the Gresford figures are shorter and much less well drawn. Several of them wear typical early Tudor-type caps. Minor but perhaps important differences between Tong and the other two sets of furniture are the multiple mouldings of the seat standard capitals and the chunky plinths beneath (Pl.140).

The desk ends at Tong and Gresford (Pls 148b & 154) are superficially quite close in style, with their similar tracery patterns, intricate edge mouldings and poppy heads, sometimes with figures perched on columns as finials. But the treatment at Tong is noticeably less complicated and the desk ends are distinguished by retaining the typical early fifteenth-century feature of projecting buttresses. The presence of the 'stylised' flower motif at Tong (Pl.152a) suggests that the furniture is unlikely to be much earlier than c.1480. The existence of carving on the inside of the desk ends at Tong and Gresford is not evidence of a close relationship, as has been claimed,[16] since this device can be traced back in English choir-stalls at least as far as Chester Cathedral c.1390. Superficial resemblances apart, Tong and Gresford are not closely related either on grounds of style or date. But above all, in spite of the sophisticated architecture of the choir screen at Gresford, the Tong master-carver was by far the superior. The difference in date must be considerable because of the advanced style of the Gresford choir screen vaulting and, in some cases, the decorative carving.[17] The choir screen loft at Gresford in its vaulting and friezework evokes the spirit of the Manchester Cathedral choir-stalls of c.1506. It cannot have been made earlier than the first decade of the sixteenth century.

When we examine the furniture closely, it will be seen, that the stylistic similarities between Gresford and Halsall are also only superficial. The angels on the seat standards at Halsall are more elegant and better drawn than those at Gresford (Pls 142a & b). The quality of the carving is generally higher at Halsall. It is true that the mouldings on the seating and the shape of the desk ends are quite close (Pls 150 & 154). But they are chunkier at Halsall and some of them, as at Tong, have attached buttresses at the front. In furniture, a possibly unique feature at Halsall, is the use of tracery lights within the desk end mouldings (Pls 150 & 156). The desk fronts at Halsall with their cusped lozenge frieze are again quite distinctive (Pl.157).

On the other hand, Halsall seems to be closely related to Tong. The backwards-leaning relaxed poses on the seat standard angels, with their bulky deeply-creased drapery, round caps and wind-blown hair are distinctly comparable. The desking in both places has the same type of rounded cusped arches as

[15] e.g. on the figure of Gabriel in the reredos of the Henry V Chantry at Westminster Abbey of c.1450.

[16] Crossley and Ridgway (1943 et seqq.), XI, 65.

[17] Cf. the spiky pomegranate and proto-'banderole' on the bench ends.

well as traceried friezes (Pls 145 & 157). The flat mouldings of the desk end tracery decoration, and some of the tracery patterns themselves, are very close (Pls 158a & b). The shield-bearing angel misericords in both places, although clearly not by the same craftsman, have many affinities (Pls 159a & b). 'Pomegranate'-type, *alias* 'stylised flower', ornament is to be found at Halsall, as at Tong.

The Stanley connection established at Halsall would not preclude an early fifteenth-century date for the furniture as the family had been established in Lancashire since the end of the fourteenth century.[18] The Tong and Halsall monuments must have been made at about the same time by craftsmen working in a similar period style. It is clear that the Tong, Gresford and Halsall choir-stalls are not the product of the same workshop, as has been suggested. The coincidences of style are only striking because of the paucity of contemporary extant material generally.

The desire to push both Tong and Halsall back to the mid-fifteenth century on both historical (at Tong) and stylistic grounds should be tempered by the appearance of 'pomegranate'-type ornament in both places. Undeniably both sets of furniture depend respectively upon early fifteenth-century West Midland and Northern traditions. Moreover the drapery style of the seat standard angels is still in the mature International Gothic mode of, for instance, the sculpture in the Henry V Chantry Chapel, Westminster Abbey, of *c.*1450.[19] If the patronage connections at Halsall are somewhat indefinite and only provincial in character, the benefactor at Tong was of the highest credentials. Isabel, the widow of Sir Fulke de Pembrugge (Pembridge) and founder of the college, is supposed to have finished the church before her death in 1446. The collared antelope, lying at her feet on her tomb in the church, indicates that she had earlier been a member of Richard II's court. Her daughter married Sir Richard Vernon of Haddon Hall, her husband's great-nephew.

Even if the master-carpenter at Tong was *au fait* with the latest developments in London, his furniture is most unlikely to date before *c.*1480. This leaves an unexplained gap of some thirty years after the traditional completion of the choir. The earlier fifteenth-century features at Halsall, a monument which must be of late fifteenth-century date, are explained by the remoteness at that period of the place itself.

The hypothesis of a furniture workshop or 'school' based on Ludlow being responsible for a string of monuments in Shropshire, Cheshire, Clwyd and Lancashire from the first decades of the fifteenth to the sixteen centuries can be seen, I believe, to be misguided and without foundation. The only sets of choir-stalls to be quite possibly by the same team are those now at Leintwardine and Montgomery.[20] The remainder of the monuments adduced, at Ludlow itself, Tong, Gresford, Aymestry and Halsall – must have been manufactured by independent if sometimes geographically and temporally related workshops.

As far as can be seen, except in the case of St George's Chapel, Windsor, where some parts of the work were sub-contracted to a London workshop,[21] the fifteenth-century woodworking craft saw no changes to the time-honoured practice of peripatetic teams of carvers and joiners moving from one job to another. Sometimes, as at Ely Cathedral in the fourteenth and Beverley Minster in the fifteenth century, a notable master-carver might be hired to take control of a project. In a few cases the furniture of a smaller religious house, such as Whalley Abbey, or parish church could be made by a village/town or estate carpenter. Goldsmiths, needleworkers and manuscript illuminators, whose workshops had been on the whole permanently based in the large cities, probably since at least the twelfth century, were in a position to propagate the latest fashions, or influence artists in other media, to a far greater extent than

[18] J. Tait, 'Political History to the end of the Reign of Henry VII', VCH, *Lancashire*, London, 1966, 214–15.

[19] Nikolaus Pevsner, BOE, *London I*, London, 1957, 367.

[20] See Chapter II.

[21] See Chapter VII.

the wood carver. The latter could be artistically isolated because of his itinerant way of life, although this did not apply to the best artists. It was only when a team of wood carvers and joiners was called to work in an important centre on a nationally prestigious commission that they achieved, for the time-being at least, the status of a metropolitan 'workshop'. The evidence for such organisations constituting a 'school' of furniture-making, as possibly at St Stephen's Chapel, Lincoln and Chester in the fourteenth century is very rare.

Royal Choir-Stall Commissions in England at the End of the Middle Ages

The second set of choir-stalls at St George's Chapel, Windsor of late fifteenth-century date (Pl.160), and the collegiate furniture instigated by Henry VII at Westminster Abbey (Pls 161 & 213), are the only royal commissions in England to survive from the Middle Ages. Although their archaeology has been discussed in more or less detail by historians and antiquaries,[1] little attempt has been made to set them in their respective stylistic contexts.[2] The problems of stylistic analysis are formidable because for different reasons both monuments exist in an artistic vacuum. The Windsor furniture replaced its predecessor, a monument excellently documented but entirely lost.[3] What is more, when the furniture was made, as far as we know, apart from St Stephen's Chapel, Westminster, there had been no important choir-stalls erected in the south of England for well over one hundred years.[4]

The Windsor furniture is recorded as having been manufactured by English craftsmen. Moreover it can be shown stylistically to be largely a native product. The Henry VII Chapel, Westminster, choir-stalls, on the other hand, seem to have been made by Flemish craftsmen working under English supervision. The Westminster executants may well have had second-generation 'denizened' status. The style of the decorative carving in London points unmistakably to the Low Countries for a stylistic ambience. Unfortunately, many Netherlandish choir-stalls were destroyed during the Napoleonic era. The paucity of extant contemporary choir-stalls in the Netherlands, and the complete absence of canopywork of the Westminster kind, presumably accounts for the unwilling-ness of earlier writers to assign the Westminster woodwork a definitive artistic status.

The manufacture of the fifteenth-century choir-stalls at Windsor is recorded in detailed accounts.[5] The building campaign seems to have taken about five years, from 1478–83. Although the Flemings, Dirike Vangrove and Giles van Castell, are specifically mentioned in connection with carvings made for the rood, it seems that all the craftsmen involved were English by name. A William Berkeley was the master-carver, and the other artists mentioned are Robert Ellis and John Filles in connection with canopywork, and William Ipswich, Hugh Gregory, and William Crue for making and carving ten great gablets. From the accounts it is possible to reconstruct the outline of the building programme and the cost. From the sequence of events Hope considered that the north side was started before the south.[6] All the seating seems to have been made in the lodge at Windsor but most of the canopies were apparently sub-contracted to Ellis and Filles in London.[7] The different parts of the structure, not yet erected, were accumulated in a 'dead store' for future use. The procedures recorded confirm

[1] For Windsor see, in particular, Hope (1913), II, 429–36; and Colvin (1963), II, 884. For the Henry VII Chapel, Westminster Abbey see Jocelyn Perkins, *Westminster Abbey. Its Worship and Ornaments*, London, 1938, II, 170–77, and Colvin (1963) above, III, 218.

[2] The opinions of James & Purvis will be discussed below.

[3] The 14th century choir–stalls at St George's Chapel, Windsor were made between 1350 and 1353. See Colvin, II, 872 and John H. Harvey, 'The Architects of St George's Chapel: I. The Thirteenth and Four-teenth Centuries', *Report of the Society of the Friends of St George's Chapel, Windsor Castle*, IV, No.2, 1961, 52–55.

[4] The Gloucester Abbey stalls were made in c.1350. See Tracy (1987) 44–48. The St Stephen's Chapel furniture was erected over the period 1351–c.1362, see Tracy (1987), 49, 50, 53, 54, 55.

[5] Hope (1913) above.

[6] Hope (1913), 431.

[7] Ellis and Filles were paid £40 for six 'tabernacles' in the 1477–78 to 1478–79 accounts, and again in the 1482–83 to 1483–84 accounts. See Hope (1913), 430 & 432. Both names seem to be of English origin.

the supposition that the part which was to receive the most decoration – the seating – was under the control of the master-carver, who seems to have shared the work with his assistant. As the canopywork was purely architectural, it was, presumably, not considered necessary to ensure a close decorative continuity with the seating. Under these circumstances, part, at least, of its manufacture and carving was delegated to an outside workshop.

Constructionally, the choir-stalls in the Henry VII Chapel, Westminster Abbey are of traditional medieval English Gothic design. The decorative carving draws almost exclusively upon the repertory of north European late-Gothic Flamboyant. The canopywork makes liberal use of geometric tracery, ogee arches and elaborate cusping. Disappointingly for an English royal commission, the building accounts are lost. It was probably completed by 1512, well after Henry VII's death.[8] The Flemish resonances in the design could easily be accounted for by the well recorded presence of Netherlandish craftsmen in England at this time.[9] As already mentioned, two Flemings were employed at Windsor in the late 1470s, although not apparently on the choir-stalls. In 1505–06 a 'Ducheman Smyth' was working on the bronze screen for the king's tomb in the Henry VII's Chapel.[10] Moreover, at about the same time that the stalls at Westminster were finished, it has been pointed out that there were joiners working at the Savoy Hospital with distinctively Flemish names, such as John Duche, John Vanclyffe, Henry Vanshanhale, Garrard Wesell and Meneard de Freseland.[11]

ST GEORGE'S CHAPEL, WINDSOR

This furniture has been meticulously described.[12] It is not necessary, therefore, to produce a detailed catalogue of features. St John Hope's contention that there were originally fifty back stalls (eight returns and forty-two lateral stalls), and two blocks of substalls each side with ten seats in each, is entirely reasonable (Figure 2). Originally, the stalls occupied only the first four and a half bays east of the pulpitum, with the *ostia chori* adjoining to the east.

In 1683, when the choir was fitted up with box pews, the chapter ordered that 'Likewise 2 Elbow seats one for the Virger and other for the Sexton in wayting' be made. These seats were interpolated at the west end of the sub-lateral stalls by inserting a new piece of seat capping, backing, rail, a new standard and permanent ledge seat (Pl. 162). The foliage decoration at the west end of the back stall desk-front psalm legend-frieze is continued across the back of the new seat, and the cross of St George, with the Garter surrounded by scrollwork in a Baroque style, placed on the seat back. The wholesale removal of both blocks of substalls one seat's width to the west facilitated good access, but also exposed the western most seat to view. No doubt this is why each was given such careful decorative treatment. The easternmost substall each side had to be sacrificed for these new seats, giving rise to the loss of the last part of the psalm legend on the back stall desk fronts. Hope, rightly, notes that such a reorganisation of the furniture was a drastic step.

The engraving by Wenceslas Hollar of the 'Prospect of the Cancell from the east' of c. 1672[13] gives a good idea of the original arrangement of the choir furniture (Pl. 163). The return stall desking with entranceway in the centre, alternating superstructure canopy forms for canons and knights, which applied to the lateral stalls also, choristers' seating and, most importantly, the proper siting of the return stalls themselves are plainly visible. Hollar's drawing shows

8 See Christopher Wilson, 'Henry VII's Chapel', from Christopher Wilson *et al.*, *The New Bell's Cathedral Guides, Westminster Abbey*, London, 1986, 70. Pevsner dated the stalls to *c.*1520, which is too late. See Nikolaus Pevsner, BOE, *London I*, London, 3rd edn 1973, 438.

9 See, for example, Stone (1955), 225–33.

10 Colvin, III, 218.

11 *Ibid.*

12 Hope (1913).

13 Reproduced in Ashmole (1672), 145. Curiously Hollar's plan shows 25 lateral and 4 return stalls each side, making a total of 58. He also shows 44 substalls. In spite of the substantial increase in the number of stalls above the level of Hope's estimate, Hollar manages to fit the entire monument within the first four bays of the choir. However, as John Britton remarked *à propos* the Hollar engravings in Ashmole's work: 'none of them can be relied upon for accuracy'. See John Britton, *Architectural Antiquities*, London, 1807–26, III, 28, note.

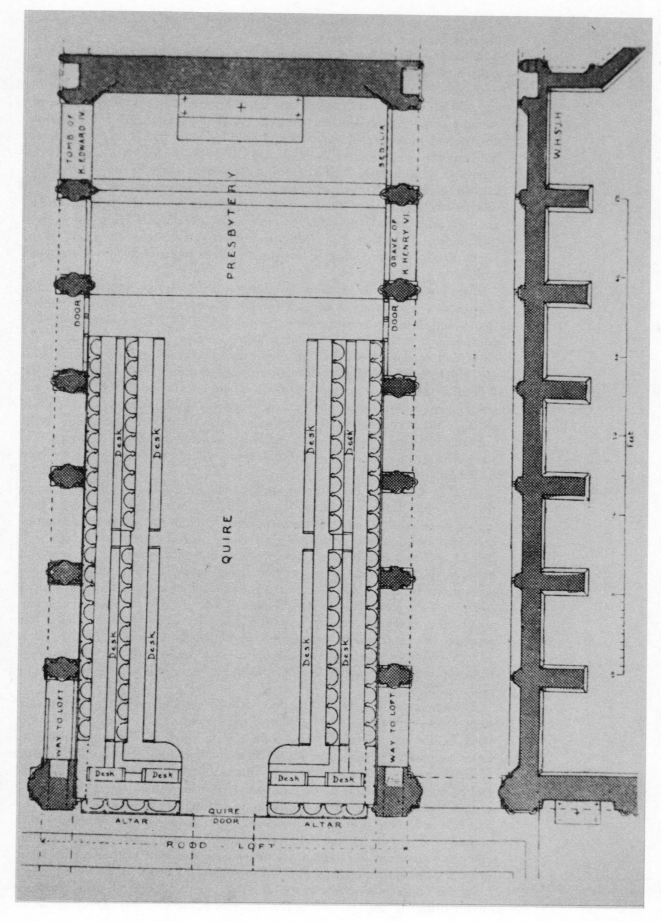

2. *Reconstruction plan of choir-stalls at St George's Chapel, Windsor* (Hope (1913), 435, Fig.35)

49

no sign of the two substalls referred to above, which were most probably inserted some ten years later.

When the chapel was presented with a new organ by George III, the return stalls were moved westwards almost 27cm to accommodate the new Coade-stone screen. At the same time, the westernmost strip of images on the flat screenwork between the return and lateral stalls was cut away. Even this measure could not prevent the western end of the side screens being seriously encroached upon, so that the westernmost of the large statues on the north side has been removed, and on the south side is almost hidden from view. At this time also, the desking of the return stalls was run together in a single line instead of being in two sections. The major refurbishment of the stalls undertaken at this time was the work of Henry Emlyn.[14] He was responsible, amongst other things, for adding two new stalls on each side at the east end, so as to close off the fifth bay from the west altogether, replacing many of the poppy heads, and providing a low tester for the monarch below the original canopy.

An unusual feature of the furniture is the way in which the entire substructure is made of wood. Care is taken to demarcate the zone at the base, that would normally constitute a stone plinth (Pl.164). The conceit is applied consistently throughout the choir woodwork. Even the lower zones of the choir-aisle screens, erected en suite with the choir-stalls, incorporate the same idea (Pl.165). In the choir-stall seating a wooden plinth is provided for the seat rails and standards to rest on (Pl.166a). There are no ventilation holes at the base of the substall desking but they appear, quite unexpectedly, pierced through the wooden seat rail of the substalls (Pl.166b). The doors of the entranceway were retained by Emlyn. The misericords are all metal hinged. For some reason, in a few cases, the brackets of earlier-type misericords have been nailed on to the ledges.

The lower stages of the canopies are the same throughout (Pl.167), including the Prince of Wales' on the north side (Pl.168). They consist of three ogee arches with, reading from the base, traceried lights in the spandrels, embattled quatrefoil frieze, a pair of double-light geometrically traceried windows with cusped and traceried hoods, topped by rounded battlementing. The uprights between the three main arches support flying buttresses. The springing of the side arches is noticeably higher than that of the main arch. This device overcomes the potentially monolithic appearance of three canopies in echelon, which the designers at, for instance, Carlisle, Whalley and Ripon had attempted to overcome by 'tipping up' the fronts of the canopies (Pls 78, 79 & 53). At Windsor, the resulting alternation of a single outward, followed by a pair of inward facing arches, is a remarkably successful solution to this perennial problem (Pl.81).

The emphasis throughout is, as far as possible, on curved rather than straight lines. This applies even to the plan of the canopies themselves. At the next level similar convex towers, placed on the diagonal, rise up from inside the lower canopies. The structure is a skeleton of curving tracery topped by a series of semi-circular and ogee gablets, which support a waving traceried and embattled frieze, similar to the one below. Between these towers emerge the tops of the uprights on the seat capping which support the canopywork. These are crowned with decorative four-sided tabernacles with a miniature spire above. The towers at the mid-level are either polygonal, for the knight-companions, or circular in plan, for the canons. A feature of the knights' is the unusual cusping within the bisected heart-shaped tracery (Pl.169).[15]

In the upper zone, the canons' seats had crocketed spires, again emerging from within the 'architecture' of the structure below (Pl.167). The metalwork-

14 Emlyn's contribution has been itemised by Hope. See ibid., II, 436–44 et al..

15 It can, as it happens, be compared to some cusping on the early fourteenth-century Exeter Cathedral bishop's throne.

like detailing is handled with evident enjoyment. It is a great pity that most of these spires have been removed.[16] The subsequent invasion by knights' canopies gainsays the original aesthetic intentions of a regular alternation of spire and tower. The resulting uniformity creates a somewhat oppressive effect. The upper zone of the knights' canopies is hexagonal in plan in the first stage, the alignment agreeing with the bottom canopy. The additional top stage exploits the monumental potential of a free-standing tower. The components are linked by a traceried frieze, with large buttresses at the corners, from which the upper circular platform, to carry the helms, emerges. This 'girdle' motif is one of the out-of-scale metalwork-like conceits used by the architect to embellish the superstructure. The monstrance-shaped poppy heads of the desk ends exploit the same device (Pl.170).

The monarch's stall, at the south side of the entranceway, is the only one in the sequence to vary from either of the two basic canopy formulae (Pls 163 & 171). It is very much wider than the other canopies apart from the Prince of Wales' (Pl.168). To get an idea of the difference, it is useful to note that the width of the misericord below is 110cm, against the normal misericord width at Windsor of 73·5cm. Its design is highly intricate. Before Emlyn's tester was inserted, the base of the lower canopy consisted of three gablets intersected by buttresses (Pl.163). Unlike the gablets on the other canopies they were not spired, and the design immediately changed into a miniature version of one of the side screens (Pl.171). The structure is too overlaid with decoration and too heavy to produce anything like a satisfactory profile. The introduction of the portcullis motif in the miniature image housings is reflected in the arms borne by the heraldic figure of an angel above.

The highly decorated screens, which link the return and lateral stalls, are one of the furniture's most attractive features (Pl.94). It is unfortunate that they have been mutilated and crowded-in by the process of moving the return stalls. Also Emlyn's tester for the monarch's stall obstructs the view of the side screen on the south side. Although highly decorated, the overall design of the side screens is well enough organised, and the motifs on a sufficiently large scale, for it to be readable. The gabled canopy with traceried box behind is a tried and tested Gothic formula. More advanced features such as the domically-capped tourelles and the tester across the top are also extremely effective.

The vaults of the lateral stalls are divided into two parts (Pls 172–74). At the back a simple lierne-type star pattern runs continuously along the underside of the canopy (Pl.172). At the front, underneath the projecting gables, is another lierne-type pattern. On the return stalls, where the canopies are wider than normal, the same star-pattern lierne-type with slight embellishment is used at the back. In the front, most of the vault patterns are the same as on the lateral stalls, an exception being above the seat next to the Prince of Wales's (Pl.174). The monarch's vault has segments of fans in the centre and corners, but is probably wholly by Emlyn. The Prince of Wales' vault has a reticulated pattern in the front with a pendant flower boss in the centre at the springing of the parallel sub-arches (Pl.173). The uprights of the south return stalls are decorated with semi-circular ribbed tracery at the bottom and arched window-type tracery above (Pl.172, for detail only). It is evident that it must have been intended in the first place that the uprights should be so treated throughout. The work peters out in the north return stalls where a plain uncarved upright has been left merely scribed in preparation for carving.[17]

[16] Several of the discarded spires are stored in the chapel. One found its way to the V & A Museum. See Tracy (1988), Cat.92.

[17] I am indebted to Canon John White for bringing this valuable insight to my attention.

18 The siting of the choir-stalls is implied in the Hollar engraving of the Henry VII tomb of 1665. See F. Sandford, *Genealogical History of the Kings of England*, London, 1677, II, 442–43. It can also be verified in the Museum of London 'Canaletto' view. See Note 24 and Plate 178.)

19 Museum of London, Acq. No. A 20964. See John Hayes, *Catalogue of Oil Paintings in the London Museum*, London, 1970, Cat. 27. The western block of substalls has been reduced to seven.

20 Francis Bond, *Westminster Abbey*, London, 1909, 146.

21 Henry VI was never canonised, and the removal of his remains to Westminster, another of Henry VII's schemes, was not carried out.

22 Colvin, III, 218.

23 The Order of the Knights of the Bath gets its name from the ceremony of bathing practised at a knight's inauguration. Established in the reign of Henry IV, the last knights were created in the ancient manner at the coronation of Charles II in 1661.

24 There are enough old stall uprights for 14 seats each side, including those lost at the end of the eighteenth century to the intervening piers. At the reconstitution of the Order of the Bath there were 38 Knights. The need for another twelve stalls points to there having been 26 originally, but the evidence of the remaining material suggests that this cannot be so. In any case, the original number (28) is confirmed in the Museum of London 'Canaletto' view.

25 P.R.O., Office of Works, Vol. 4, *Minutes of Proceedings April 1731–August 1733*, Part 5, entries for 2 and 7 March, 1732. In his trawl of the accounts Colvin picked up references to the making of six new stalls. He seems to have overlooked the entry for 7 March in which it is made clear that the number of new stalls required was much greater (See Colvin III, Note 7, p. 218). On 18 April the projected work was estimated to cost £716, and it was 'Ordered that the same be forthwith proceeded on accordingly'.

26 Not unreasonably, Colvin assumed that the expenditure statement in the royal accounts in respect of May 1733, amounting to £587–04–05, related to the project for extending the choir-stalls, which was discussed the previous year (See P.R.O., Office of Works, 5/58, May 1733 and 5/141, 1733). The sum of money was considerably less than had been allowed for. Moreover, none of the named craftsmen involved can be identified as joiners. The only identifiable protagonist is Andrews Jeffe (sic.), presumably the well-known master-mason and builder Andrews Jelfe (See H. M. Colvin, *A Biographical Dictionary of British Architects. 1600–1840*, London, 1978). It is hard to imagine how he could have been involved in such a joinery project. Admittedly, his contribution can only have been small as he was paid only £48–04–09.

Originally, there were twenty-eight back and twenty-four substalls. In addition there were the two royal seats at the west end. The furniture ran in an unbroken line in front of the arcading through the first three western bays of the chapel.[18] The present 'returning' of the royal stalls, and the way they are jammed into the corner junctions of the western pier and screen, is patently inauthentic. The way that the terminal angel figures of the western frieze cornice of the stone screen are hidden by the back of the royal canopies (Pls 161 & 175) can never have been originally intended. Clearly the royal stalls must have been aligned in the first place with the others. In their present positions they interfere with the choir screens. The royal stalls were fronted by panelled desking, some of which is still extant (Pl. 176). However, it is evident that this feature was rather more extensive than it is today, as the plinth continues on each side beyond the confines of the surviving panels. It would have been highly unusual for there not to have been any desking in front of the substalls. However, because of the need to keep the furniture as much out of the centre of the chapel as possible, it may have been deemed that desking constituted an unnecessary encumbrance. The recorded absence of desking in front of the substalls from at least the mid eighteenth century does not, of course, prove that there was none originally. The existing entranceways on both sides of the choir-stalls at the west end are authentic features (Pl. 177). But they are wider than in the first place, and raised on five instead of four steps. The two original blocks of substalls (eight and five respectively), showing an absence of desking, are clearly visible in the painting of the chapel attributed to Canaletto, executed c. 1750 in the Museum of London (Pl. 178).[19]

The inordinate width of the chapel is explained by its intended function, stipulated in Henry VII's will. The founder's tomb was to be incorporated within a metal chantry chapel dedicated to the Virgin, which was to occupy the space between the choir-stalls.[20] Hence the raising-up of the back stalls a whole seat's height above the substalls, for better visibility. In the event, the internal arrangements were not completed according to Henry VII's wishes. The chantry chapel was reduced to a metal shrine for the founder which was placed behind the altar.[21] The stalls were probably intended for use at the founder's anniversary services stipulated in Henry VII's will.[22]

Between about 1755 and 1792 a number of drastic changes was made to the furniture. With the revival of The Order of the Knights of the Bath in 1725[23] additional seats were needed to make the numbers up to the complement of thirty-eight Knights.[24] It has always been thought that the additional twelve back and ten substalls, which extend across the fourth arcade bay from the west, were added soon after the refoundation of the Order. However, as Colvin has pointed out, there is no reference in the royal accounts to the desired augmentation before the early 1730s. Indeed, it will be shown that no alterations whatsoever were carried out for another thirty years. On 7 March 1732 an estimate 'for making 12 Stalls for the Knights Companions of the Most Honourable Order of the Bath and 22 for their Esquires' was approved.[25] However, for some reason this work was not undertaken until very much later, probably c. 1760. Otherwise the second of the stone screens from the east would not be visible in the view by 'Canaletto' (Pl. 178). This painting cannot be earlier than 1746, when the artist first came to England. It shows a unique view of the choir-stalls in their original state.[26] Unfortunately, the royal seats are out of the picture, but the entire echelon of desking and substalls with uprights on the seats, is visible.

Another view in oils of the interior of the Henry VII Chapel, at present in the abbey muniment room, provides a record of the first stage of the subsequent

late eighteenth-century metamorphosis. A wholly new block of twelve back stalls, with reproduction desking to match has been thrown across the fourth bay at the expense of the westernmost of the two sixteenth-century stone screens. This was separated from the earlier work by a new generously wide six step gangway (Pl.161, right). Another was interpolated at the west between the royal stalls and the start of the original back stall desking. New desk ends-cum-stair guards were fitted on either side of the entranceways. In the process, the ends of the original desking cornice were sacrificed, and the attached columns on the back of the substall seat capping cut into.[27] The hand rails on the west side of the royal stall gangways, and the figure of a king on the cornice of the northern royal stall front, must date from this time. The canopies for the new back stalls were taken from the backs of the original structures which in the first place were designed fully in the round. Such wilful disregard by the abbey authorities for their Gothic woodwork was to become a feature of their record of guardianship for the rest of the century.[28] Curiously at first, no new substalls were provided at the east end. The original block of five in the centre, albeit mutilated, were retained, the uprights on the seat capping being still clearly visible. It has been suggested that the abbey's painting may be a copy of another view of the chapel by Canaletto.[29] In any case, the important discrepancies between the two versions under consideration indicate that the abbey's view must have been executed a little later. The artist returned to Venice in the mid 1750s. In any case, the painting cannot be much later than this judging by the dress of the figures.

That the stalls and the fitted stone screens were suffered to endure such indignities seems to have been of no account to the abbey authorities since, by the end of the eighteenth century a further and possibly greater act of vandalism was licensed. Sometime between the date of the execution of the abbey's painting and 1792 the stalls were pushed back some 33cm between the piers of the arcade. This second drastic alteration was, presumably, devised by James Wyatt, Surveyor of the Fabric 1776–1813. In an engraving of the inside of the chapel dated 1792 by a 'Mr Chambers', this second rearrangement seems to have been recorded for the first time. In the process, the integrity of the design was violated, seats removed at the interposition of the piers, and canopies pushed up against stonework in a meaningless fashion.[30] At the same time the eastern block of back stalls was provided with matching substalls. The centre blocks of Gothic substalls seem to have been replaced, and the royal stalls were 'returned'. One is at a loss to divine the motive for such a radical alteration. The disjunction of the seating, and the removal of four back stalls was a heavy price to pay for an insignificant measure of marginalisation.[31] Although the number of stalls is supposed to have been increased again in 1815,[32] there is no sign of any nineteenth-century workmanship. Nor indeed would there have been any room for it.

The canopy design represents a reworking of the traditional English three-tier structure (Pls 179 & 213). A band of decorative foliage carving is applied at the lower level to a series of alternating hexagonal and octagonal canopies. Above this, a four-sided traceried oriel, placed at 45 degrees to the front plane, is linked to the lower canopies by flying buttresses. Finally, the twisted columns which spring from the base of the lower canopies support domed hexagonal shrines supported on corbels. The design is of considerable originality and is aesthetically very successful. The horizontal zones are only subtly emphasized. The top and bottom layers catch the light and provide the necessary impression of architectural substance. The middle zone suggests a dark impenetrable depth.

The decorative carving at Westminster shows itself to best advantage in the lower canopies of the superstructure, on the misericords (Pls 180 & 181), the

[27] A 'stall end from Henry VII's Chapel, Westminster Abbey' is listed in the sale catalogue of the Cottingham Collection. This may well have been one of the original desk ends. See *Descriptive Memoir and Catalogue of the Museum of Mediaeval Art collected by the late L. N. Cottingham*, London, 1850. For Cottingham's drawings of the chapel stalls see L. N. Cottingham, *Plans, Elevations and Details of the Interior of Henry VII Chapel, Westminster*, London, 1829, Pls XVIII & XXVII, and Pl.213 below.
[28] In Dean Thomas's time (1768–93) the abbey's complete set of thirteenth-century choir-stalls was removed.

[29] John Hayes, *Catalogue of Oil Paintings in the London Museum*, London, 1970, Cat.27.

[30] In the gaps between the seating complete canopies were trimmed at the back so that they could be pushed up against the piers. Of the original 28 standard canopies some 15 have been more or less mutilated.

[31] New choir-stalls designed by Wyatt were placed between the choir piers at Lichfield Cathedral c.1815 to replace the late-17th c. furniture of Bishop Hacket. See Cobb (1980), 147–48.
[32] Colvin III, Note 7, p.218.

33 There are carved panels on the boarding behind the choir-stalls.

panelling in front of the royal stalls (Pl.176). and on the underside of the desk tops.[33] The overhanging desks for the back stalls do duty as canopies for the substalls. The care which was lavished on the substalls is one of the monument's most attractive features. Originally, there were uprights on the capping, since removed, which were fastened at intervals along the leading edge of the desking above (Pl.182). The backing of the substalls comprised two finely moulded open arches filled with gablets in the apex. Underneath was a frieze of battlementing above a row of quatrefoils. The underside of the desking is decorated with an elaborate net vault inside the cells of which on the south side are cusp terminations comprising the badges of the Tudor dynasty. The earlier of the two 'Canaletto' paintings shows that the eastern entranceway to the stalls was of only a single seat's width. The desk ends, although tall like their successors, were formed in a different way at the top, possibly using heraldic animals as poppy heads.

In spite of the strong Continental influence in their design, both these monuments, separated by some thirty years, are deeply rooted in the English traditions of ecclesiastical joinery. The Windsor furniture seems to have been entirely executed by English craftsmen. On the other hand, at Westminster, Netherlandish workmanship is almost certainly attested by the decorative carving.

34 Tracy (1987), Pls 56–58.

At Windsor, the form of the seating is entirely English and quite unlike any contemporary examples on the Continent. The carved heads underneath the capping projections (Pl.166a) are reminiscent of those on the early fourteenth-century stalls at Winchester Cathedral.[34] The rather thin seat standards, fronted in the lower part by small columns, the treatment and mouldings of the seat capping, and the handling of the uprights of the double-screen super-structure are typical of English choir-stalls. The use of native-type misericord supporters, and moulded ledges, confirms the furniture's origins. At the same time, Continental influence can be detected in the design of the canopies and the wing screens flanking the return stalls. It will be shown that the design source is Flanders. This conforms to the fact, already mentioned, that named Flemings are recorded as having made figure carvings for the chapel's rood screen. The figures on the wing screens on either side of the return stalls, with their heavy voluminous drapery and slightly swaying poses, are most probably Flemish also.[35]

35 The figure of St George slaying the dragon, said to have been removed from the western bay on the north side, is not related stylistically to the other figures. It is, presumably, English work.

For all its allusions to the vocabulary of up-to-date Low Countries mid fifteenth-century architecture, the Windsor canopywork can be seen to retain a stubborn association with traditional English forms. The flattened and cusped ogee arches of the lower wing screen canopies (Pl.94), with uprights breaking the line of the double-curves and perpendicular tracery in the spandrels, are reminiscent of the mid fourteenth-century interior wall arcading in the main chapel at St Stephen's, Westminster.[36] The filling of arch spandrels with large-scale cusped traceried forms, as seen at the top of the Windsor wing screen bays, is similar to the treatment of the stall backs on the metropolitan-style mid fourteenth-century choir furniture at Hereford Cathedral.[37] The semi-hexagonal, vaulted, traceried and buttressed projecting niche bases on the screens at Windsor recall features on the English fourteenth-century tomb of Sir Oliver de Ingham, Ingham, Norfolk[38] and the tomb of Edward II at Gloucester Cathedral.[39] The use of battlementing throughout the canopywork at Windsor echoes a typically English decorative obsession of the Decorated period. Finally, the vine-scroll friezes and voluted 'trefoil' leaf cresting on the parclose screens are typically native work (Pl.185). Even the handling of the lower canopies

36 Illustrated in Tracy (1987), Pl.94.

37 Ibid., Pl.95.

38 Ibid., Pl.110.
39 Ibid., Pl.112.

with their raised side arches cannot be matched on the Continent. It can be compared to the solution of the problem adduced by the Ripon master some five years later. Its intention was to reduce the monotony of a regular echelon of semi-hexagonal canopies, a problem which Netherlandish altarpiece designers in similar circumstances failed to address. If there ever were fully canopied double-screen choir-stalls in the Netherlands, which is doubtful, they have not survived the depredations of the Reformation and the French Revolution. The canopywork which remains, such as that at St Sulpitius, Diest, in Brabant of the late fifteenth century, or St Nicholas, Kalkar (1505–08) is of the single-screen type and conservative by English standards.

A very striking, and often recorded, phenomenon at Windsor is the lack of any stylistic relationship between the choir furniture and the containing architecture. In earlier times when these constituents were coeval, as for instance at thirteenth-century Salisbury Cathedral or fourteenth-century Gloucester Abbey, either the ornament or the architecture in each case was closely related. Apart from the use on the side screens at Windsor of something akin to the ogee domes, fenced around by large-scale open-traceried crenellation, crowning the towers on the exterior at the west end of the nave,[40] the contrast between the two elements could not be stronger. The dichotomy of the *horror vacui* of the side screens (Pl.94) and the austerity of the architectural vessel is compelling. Yet parallels can be pointed to in the Low Countries such as the extravagantly ornamented miniaturised architectural sacrament houses of about the same date at St Peter and St James, Leuven.

In any discussion of the Flemish influence on the design of the St George's Chapel choir-stalls, the Netherlandish character of the iron gates of the Edward IV Chapel should be taken into account (Pl.186). Unfortunately, this work is not documented. Its authorship was attributed by Hope to the Englishman, John Tresilian, who was the 'principal blacksmith' at the chapel from 1477.[41] The manufacture of the gates is probably coeval with the stalls since Edward IV died in 1483. Hope considered that the monuments were closely related. On inspection it can be seen, however, that they are only superficially alike. Apart from the motif of the little free-standing buttressed parapets employed in both places, the treatment of tracery, canopywork and mouldings are quite distinct. The gates can be shown to be Flemish in their manufacture on account of the use of Flamboyant-type panel tracery.[42] The canopywork shows no sign whatsoever of a knowledge of the problems of making such structures on a large scale in wood. Far from the possibility of the two artists having worked side by side, as is implied by Hope,[43] it is much more likely that the gates were made in the Netherlands. Although they share the aesthetic of contemporary Flemish altarpieces, their precise stylistic sources have not been satisfactorily identified.

At Windsor, apart from the use of supporters on the misericords in the English fashion, the usual profusion of foliage ornament is to be found. Some of the carvings, purely foliate in content, look back to English fourteenth-century precedents (Pl.187). Although the treatment of the different species is somewhat undifferentiated, a limited range of types is attempted, such as hawthorn, oak, rose, vine and 'pomegranate'-type (Pls 166a, & 188a & b). The appearance of the last-named in the repertory of English decorative fruit and foliage at Windsor coincides with the recorded recurrence of this ancient motif on a limited basis throughout England during the last two decades of the fifteenth century. Indeed, at Windsor, pomegranate is by far the most popular plant represented. The evident traditional interest in botany is not reflected on the superstructure where the gable crockets, all of the same design, are extremely conventional. A fleuron motif is used in the spandrels of the lower canopy gables and elsewhere. The contrast in approach between the seating and

[40] See Ashmole (1672), 139.

[41] Hope (1913), II, 429.

[42] That Tresilian was capable of producing high quality cast work is demonstrated by the fittings on the door leading out of the north choir aisle.

[43] Hope (1913), II, 429.

44 James, (1933), 23.

45 *Ibid.*, and see W. L. Hildburgh, 'An Alabaster Table of the Annunciation with the Crucifix: a Study in English Iconography', *Archaeol.*, LXXIV, 1923–24, 203–32. The examples in woodwork at early fifteenth-century Wigmore Abbey (now at Leintwardine parish church, Herefs and late fifteenth-century Tong, Salop have already been discussed. See Chapter VI, and Pls 137b & 138.

46 Meyer Schapiro, 'The Image of the disappearing Christ', *Gazette des Beaux-Arts*, March 1943, 35–52.

47 The bibliography on Netherlandish and Spanish choir-stalls is unsatisfactory, but see Borchgrave (1937) and Kraus (1986). Flemish stalls in the Netherlands, and a few in Spain, are either canopyless, or more or less elaborate examples of the 'single-screen' type.

48 The canopies above Archbishop Kempe's tomb (d.1454) at Canterbury Cathedral are also telescoped.

49 With regard to the Virgin and Child group on the north wing screen at Windsor, a general resemblance can be adduced with the strongly Flemish-influenced Virgin and Child at Winchester Cathedral, dated by Stone to c. 1470–90. See Stone (1955), 225 & Pl.184.

the canopywork must be due to the circumstances of manufacture. The stalls themselves, and probably the screenwork, were made in a lodge attached to the building. Some of the canopies are recorded as having been ordered 'on spec' from a London workshop. This is the first time that such a bifurcation in the manufacturing process has been encountered in English choir-stalls. It presumably reflects the special nature of the commission, the unlimited means of the patron and the accessibility of the metropolis.

There are also iconographical pointers to an English origin for the Windsor woodwork. In the Annunciation spandrel on the front of the sovereign's desk, the bleeding heart within a crown of thorns appears in front of the lily stalks.[44] James considered this to be analogous with the peculiarly English feature of the Crucifix growing out from among the lilies in Annunciation representations.[45] The treatment of the Ascension on the Prince's desk is typically English with the disciples looking up at the feet of Christ seen in a cloud.[46]

If the design of the St George's, Windsor stalls was the creation of a Brabanter, Hainaulter or Bruxellois architect it should be possible to verify this by reference to appropriate furniture still surviving in the artist's native district. But, as already stated, an investigation reveals no sign whatsoever of the fully-fledged, 'double-screen', 'ciborium'-type stall canopy in Flemish workmanship.[47] Moreover, it will be shown that the 'foreignness' of the Windsor stalls runs only skin deep.

So what are the apparently unprecedented and un-English design features of these stalls? The canopywork consists of round and hexagonal towers piled one on top of the other in diminishing scale. This breaks with the canonical English custom of placing a spired image housing on top of a canopy.[48] At Windsor, the polygonal ground plan of the canopies with their fenestrated lanterns comprising the first two stages of the structure, and the semi-detached buttresses at the angles of the spire above, on the canons's canopies, are perfectly conventional (Pl.167). But the waving crenellation above the lower canopies, the purely circular towers of the canons's stalls, and the frilly traceried girdles above the second zones are totally unexpected. One of the stalls' most engaging features is the incurving traceried 'girdle' on the knights' canopies between the third and fourth zones. This has exaggeratedly large semi-detached buttresses at the angles. The motif may have been inspired by the platform-canopies at the base of the wing screens. But it has been made fully in the round, and small-scale versions of it surmount the great standards which rise up between the canopies. A simplified version of it in two dimensions comprises many of the poppy heads of the stall desk ends (Pl.170). The wing screens have a distinctly exotic flavour, produced by a combination of unusual elements packed together in the spirit of *horror vacui*. Tiers of traceried tourelles surmounted by ogee-profiled, crocketed and shingled domelets are ranged side by side. Different varieties and scale of crenellation and ogee arches stand out from the galaxy of enterprising playful motifs (Pl.94).

Although the syntax of this furniture can be seen to be English, the language of architectural expression is inspired by Flemish art. It is surprising, therefore, that there are no close stylistic parallels to be made with extant Netherlandish ecclesiastical woodwork. On the other hand, the niche sculpture of the Windsor wing screens is quite possibly Flemish (Pl.190), although it could be said that the figures in general are stocky and lacking in grace. Moreover, their drapery style is decidedly conservative for the date.[49]

The Windsor choir-stalls are pervaded by a distillation of mid-fifteenth-century Low Countries art. The principle of telescoping towers, square, hexagonal, octagonal and round, one on top of another, and the use of angle-turrets, external squinches and traceried parapets can be seen in the

urban landscapes of early fifteenth-century Flemish panel paintings, such as the well-known 'Ghent Altarpiece' at St Bavo's, Ghent, of 1426–32, by Hubert and Jan Van Eyck. In real architecture, many of the features of the main stall canopies at Windsor can be found on the west front of St Peter, Leuven, including the liberal use of semi-detached buttresses. It is true that onion-shaped domelets and out of scale traceried parapet 'crenellation' were originally to be seen on the west front at Windsor.[50] But, in general, St George's was a remarkably unornamented building. As such, it was hardly likely to have provided any inspiration to the choir-stall designer. In the Netherlands, domelets are ubiquitous at this time, as on the west-front at St Janskerk, 's Hertogenbosch (1366–1410),[51] although many are of the early sixteenth century. Good examples of multi-stage telescopic lanterns are the Brussels Town Hall (1376–1420) (Pl.191),[52] the Bruges Cloth Hall, of which the upper part dates from 1482–87, and the Belfry at Ghent (1321–80). Lanterns were, of course, not uncommon in England, the best known example being the one at Ely of mid fourteenth-century date. An East Anglian example, contemporary with the St George's, Windsor choir-stalls was formerly at St Margaret's, King's Lynn.[53]

In the wing screens at Windsor, we are confronted by the decorative aesthetic typically found on the facades of Netherlandish town halls and great churches. The organisation of these characteristic architectural 'frontispieces' with vertical panelled divisions and tiers of image housings share the same *horror vacui*. The playful sense of scale, using exaggeratedly large crenellation, corbelled-out circular traceried parapets, reflecting the practice of the goldsmith more than the architect, are echoed at Windsor. The gabled poppy heads at Windsor (Pl.170) are an echo of the tower-flanked pediments on the Leuven (Pl.192) and Middleburg town halls. The skeletal cusping and traceried spandrels on the north side of the nave at St Janskerk, 's Hertogenbosch (Pl.193) are reflected in the overhanging tester on the Windsor screens (Pl.94). The curious bracket device surmounting the standards between the canopies of the main stalls (Pl.189) – a hybrid of parapet and monstrance, recall edifices such as the central towers of the town halls at Middleburg or Brussels (Pl.191).

As has already been said, in spite of its Continental stylistic veneer the St George's Chapel furniture still adheres closely to the English traditions of choir-stall making. Although the canopywork was sub-contracted to a London workshop, the designs must have closely followed the specification of the master-carver. He may have taken advice from a Flemish artist, quite possibly incorporating designs and motifs from speculative sketches provided for him. Equally, he may have been personally *au fait* with the state of Flemish contemporary architecture. There was probably pressure from the commissioning patron, Edward IV, for the monument to reflect, as far as possible, the contemporary taste of the Low Countries. To what extent the English craftsmen were aware of their native excellence in the designing and building of large-scale 'ciborium'-type canopies in wood we cannot tell. However, in bending to the whims of the royal taste, they succeeded, notwithstanding, in retaining the miniaturised architecture developed and perfected by their forbears, merely dressing it up in the guise of a fashionable neighbour. As a result the end product can be said to have satisfied the exigencies of both patron and artist!

As at Windsor, the canopywork in the Henry VII Chapel, Westminster seems to be uniquely English. Even by the second decade of the sixteenth century the motif of the large-scale 'ciborium'-type stall canopy had not been adopted on the Continent. In this second royal commission, the architecture of the stalls is still the traditional English double-screen formula. The treatment of

50 The appearance of the west front in the seventeenth century is shown in Ashmole (1672), 139.

51 Frans Vermeulen, *A B C van de Bouwstijlen in de Nederlanden*, The Hague, n.d., 277–78.

52 *Ibid.*

53 An eighteenth-century sketch of this is reproduced in Beloe (1899), Pl.20.

54 Purvis (1935), 124–27. Continental influences on the misericord subject matter at Windsor is also evident.

55 For example, the foliate ornament design by Israel van Meckenem. See Max Lehrs, *Geschichte und Kritischer Katalog Des Deutschen, Niederländischen und Französischen Kupferstichs im XV. Jahrhundert*, IX, Vienna, 1934, reprinted New York, Cat. 620.

56 The Langton Chapel, Winchester Cathedral has been dated *c.*1500. See Nikolaus Pevsner and David Lloyd, BOE, *Hampshire and the Isle of Wight*, London 1967, 676. The Winchester Lady Chapel is probably of about the same date, see *ibid.*, 668–71. The Corporation benching at Southwold must again be early sixteenth-century, whilst the Spring Chantry, Lavenham is dated by the will of Thomas Spring, d.1523. See Nikolaus Pevsner, revised by Enid Radcliffe, BOE, *Suffolk*, London, 1974, 324.

the seating and the misericords is typically English too. The major difference in this case is that the manufacture must have been the responsibility of Flemish craftsmen working under the close supervision of an English architect. Alternatively the work was designed and executed by Flemish craftsmen who had lived in England long enough to have fully absorbed the native practice of choir-stall designing. The decorative carving can be closely compared with Flemish work. Moreover prints by the German engravers Durer and Israel van Meckenem inspired some of the subjects on the misericords.[54] Examples in Flanders of monuments using the same ornamental vocabulary are the Tongres, Notre Dame retable with the Life of the Virgin, *c.*1510 (Pl.194), the pulpitum at St Martin, Tessenderloo, *c.*1500 (Pl.195), and the pulpitum in the Onze Lieve Vrouwkerk, Aerschot (Pl.196). It can also be seen on contemporary German engravings.[55] The putative arrangement of the stalls at Westminster in two opposing ranks, with no return stalls, is typically found in the Netherlands and elsewhere on the Continent, as at Aerschot, Bruges Cathedral and St Janskerk, 's Hertogenbosch. It cannot be seen anywhere else in England. None of the rather limited amount of stone decorative carving in the Henry VII Chapel resembles especially closely the ornament on the stalls.

A few English monuments are sometimes cited as being related to the Westminster stalls, such as the Langton Chapel and Lady Chapel furniture at Winchester Cathedral, and the Corporation benching at Southwold, Suffolk. None of these monuments is directly comparable, and the Spring Chantry at Lavenham is quite a lot later than the Henry VII Chapel furniture.[56] The Winchester Cathedral Lady Chapel stalls are in a conservative Perpendicular style little influenced by Continental art. The decorative carving is of a high quality, and the treatment of foliage has a plasticity reminiscent of the Westminster misericords (Pl.197). The alternating semi-circular and angled canopies in the Langton Chapel, Winchester Cathedral (Pl.198) recall Westminster in a general way. The approach is patently more traditional as the canopy fronts are merely modified tracery panels, instead of the non-structural filigree work at Westminster. In fact the Winchester canopies are much closer to Windsor than Westminster, as is the display of black figure lettering and the handling of the foliage carving.

The use of the English 'ciborium'-type canopy at Windsor and Westminster during a period of radical stylistic change is a remarkable tribute to the tenacity of English ecclesiastical joinery practices. Indeed, the making of large-scale architectural canopies in wood seems to have been a uniquely English contribution to the last two hundred years of the medieval Gothic period.

CHAPTER VIII

The Sefton Church Choir-Stalls – A Provincial Response to the Classical Revival

The language of classical art infused itself into England in two ways. Only rarely were whole monuments made in the Renaissance style, such as the tomb of the Countess of Salisbury at Christchurch Priory, Hants of c.1540.[1] More often Italianate motifs were infiltrated conceit by conceit. The first structure of any kind to contain Renaissance ornament is generally given as the Henry VII tomb in Westminster Abbey, designed by Pietro Torrigiano, commissioned by Henry VIII and made 1512–18.[2] This is a better-known example of an integrated design. Generally, the Renaissance style seems to have been regarded as a cornucopia of decorative motifs – the 'anticke', 'Romayne' and 'savage' work of contemporary accounts – suitable for dressing up traditional architectural forms. Apart from a detectable tendency towards a tidying-up and re-ordering of ground planning, the new style had little structural influence upon indigenous architecture. Its effects were felt much more strongly in the decorative arts where the new vocabulary of ornament was gradually assimilated. Moreover a number of new or improved ornament techniques, probably introduced by Italians themselves,[3] stimulated an interest in Renaissance ornament for use in a whole variety of media.

The reigns of Henry VII and Henry VIII were prolific for the manufacture of ecclesiastical woodwork generally. Much of it conformed to settled Gothic conventions, such as the choir furniture at Manchester Cathedral and Beverley Minster.[4] Exceptionally, at the Henry VII Chapel, Westminster Abbey contemporary Flemish decorative ornament was used to dress-up traditional English choir-stall architecture.[5] The vast majority of the huge output of church woodwork, the preponderance in the West Country,[6] remained Gothic in design whilst paying discreet lip-service to the new stylistic language. Instead of usurping them, Renaissance dolphins, putti and urns unobtrusively take their place alongside the traditional Gothic vine-trail, foliage crocketing and cresting, and battlementing devices. At the Henry VII Chapel, Westminster, of c.1512, the decoration of its choir-stalls are late Continental Gothic. However, on a few of the misericords distinctly Italianate mannerisms and motifs occur.[7] Again, the choir-stalls at Christchurch Priory, of 1525–30 are Gothic in design but decorated with Italianate ornament, of only provincial quality.[8] Only the choir-stalls at King's College, Cambridge, probably made 1530–35, can claim to be Renaissance through and through.[9]

Sefton Church in Lancashire has one of the most comprehensive collections of fitted wooden furniture of any parish church in England (Pls 199 & 200). The cavernous rood screen with its double-sided cantilevered loft, even if containing inauthenticities,[10] parclose and aisle screens, and nave pewing must

[1] The Countess was beheaded in 1541. See Nikolaus Pevsner and David Lloyd, BOE, *Hampshire*, London, 1967, 176.

[2] See Nikolaus Pevsner, revd Bridget Cherry, BOE, *London. I*, London, 1973, 438.

[3] In particular, terracotta work, the best known examples being the roundels at Hampton Court and Whitehall, and the decorative work at Sutton Place and Layer Marney. For standard texts on the impact of the Italian Renaissance on English architecture see J. A. Gotch, *Early Renaissance Architecture in England*, London, 1901, and J. Lees-Milne, *Tudor Renaissance*, London, 1951.
[4] See Chapter III.

[5] See Chapter VII.
[6] See in particular Bond & Camm (1909).

[7] In particular the misericord on the royal stall on the south side with naked family picking grapes.
[8] Nikolaus Pevsner and David Lloyd, BOE, *Hampshire*, London, 1967, 175.
[9] Nikolaus Pevsner, BOE, *Cambridgeshire*, London, 1970, 108.
[10] 'The projecting canopies of the rood screen are not in their original position, the eastern canopy having been formerly a canted tester with a parallel soffit, and a brattishing of nine hanging cusped arches. No other part of the rood-loft remains, and the position of the stair which led to it is doubtful'. See VCH, *Lancashire*, III, London, 1966, 60. Vallance never made a detailed study of the Sefton choir screen. It is difficult to see how the eastern canopy can ever have been horizontally placed, given the limitations of the existing arcading. The present arrangement goes back certainly as early as 1822, *cf.* Bridgens (1822), Pls XXIX & XX.

11 Nikolaus Pevsner, BOE, *Lancashire I*, London, 1969, 399–401.

12 See Bridgens (1822), Pls XXIX & XXX. The desks now placed in front of the stalls are modern.

13 There is much restoration and replacement in the choir-stall backing and parclose screens.

14 There are no tip-up seats in the choir-stalls at Astbury, Cheshire. See Pl.143.

15 W. D. Caroe and E. J. A. Gordon, *Sefton . . . comprising the collected notes and researches of the late Rev. Engelbert Horley*, London, 1893, 63.
16 His will mentions that he has 'made so great costes of ye chauncell and revestie'. See VCH, *Lancashire*, III, 59.
17 *Ibid.*
18 *Ibid.*

all have been made during the first half of the sixteenth century. With sympathetic additions,[11] none later than the eighteenth century, the overriding impression is of an unrestored fully-furnished late Gothic interior.

The set of choir-stalls totals twenty-six seats, comprising six return and twenty lateral stalls. There were never any substalls but, as has been suggested, the recesses of the desks of the back stalls may have been designed to seat some fourteen choir-boys (Pl.201).[12] The furniture rests upon raised and ventilated stone foundations in typical fifteenth-century fashion. The parclose screens, which extend into the presbytery, utilise a variety of late Gothic tracery, and incorporate panelled doors on either side at the east to give access to the choir aisles.[13] The lower parts of these screens, and the openings of the rood screen, are filled with iron trellis-work. The effect produced is of the choir enclosed in a cage. This is contradictory to the striving of the earlier Middle Ages for privacy. If the openness of the enveloping structure seems to reflect a fresh set of period liturgical and constructive considerations, the same might also be said of the seating. This must be one of the first instances in England of the abandonment of the ubiquitous medieval tip-up seat (Pl.202).[14] The seating at Sefton retains the usual components of rail, capping and standard, but now the seats themselves are a fixture. Both developments here seem to anticipate the preoccupations of the soon to be reformed Church.

The carving on the stalls, whilst not being of the finest quality, is vigorous and of some originality. Superficially, the furniture appears to be stylistically still in the Gothic vein. The tracery is late medieval in form and there are traditional-type stall, bench and desk ends with foliate poppy heads (Pls 200–202 & 204–205). Most of the decorative ornament is also typically Gothic, such as the vine-trail friezes, arch crocketing, foliate brattishing, cusp terminations and spandrel motifs. The last two make a nice contrast on the bench ends with the large-scale decorative motifs which they enclose. Some of these figures may have heraldic significance, such as the gorged unicorn and displayed eagle. In contrast, their carving is influenced by the Renaissance style, although there are few specific allusions to classicism. In certain specific positions on the rood screen there are bands of early Renaissance decoration incorporated into the structure. On the dado rail, including both sides of the main doors (Pls 205 & 206a & b) and the architrave, are bands of ornament including winged putti, cornucopiae, candelabra motifs and profile busts. These parts are clearly distinct in technique as well as style from the rest of the work. They were most likely carved elsewhere to order and included in the design to provide a fashionable constituent. Their juxtaposition against the Gothic decoration is somewhat bizarre to our eyes.

The inclusion in the Renaissance ornament, and on the south return stall end, of the initials 'I.M.' (Pl.207) has prompted speculation that the initials refer to the Rev. James Molyneux, archdeacon of Richmond, who vacated the living in 1509.[15] On the other hand the appearance of the displayed eagle on the stalls could refer to a later Molyneux rector, Anthony (1535–57) (Pl.208). He is traditionally credited with the rebuilding of the church.[16] Also there are gifts of windows recorded in the early 1540s.[17] A displayed eagle appeared on the arms of the family of Cotton to which Antony Molyneux's mother belonged.[18] However, it seems unlikely that Antony would have wanted to record his predecessor in quite such a prominent place some thirty years or more after his death.

Most of the choir woodwork seems to have been carved by the same workshop if not the same master-carver. A characteristic trait is the liberal use of punched circles in the hollows of the mouldings (Pl.210). These can be seen on both rood screen and choir-stalls. This suggests that both parts belong to the same campaign. James Molyneux was rector from 1489 to 1509. The period of

his tenure would have given him ample time to complete the project himself. The displayed eagle on the choir-stalls is only one of a number of such images featured, including gorged antelope, yale, and unicorn, griffin, lion, and mobbed owl. The suggestion that the manufacture of the woodwork was shared by James and Antony Molyneux is unconvincing.[19]

As much as one would like to give the wooden furniture to James Molyneux, there is a very real problem in accepting such an early date for the Renaissance ornament. After all, the earliest instances of the use of Classical ornament in England do not occur before the period 1520–30. It seems questionable, to say the least, that a country church in the north-west of England, however well-connected the living, would be commissioning furniture with early Renaissance ornament before 1509.[20] The Gothic style at Sefton is more likely to have been the product of a tenaciously conservative milieu. Purely fifteenth-century-type foliage is juxtaposed side by side with a stylised classicising 'pomegranate'-type motif (Pl.204).[21] The heraldic beasts on the other hand seem to retain overtones of the medieval bestiary.

The evident provincialism of the Renaissance ornament on the desk and stall ends at Sefton is confirmed by a comparison with another early sixteenth-century monument from the north-west of England, the 'Crackenthorpe Bed' now in the Victoria and Albert Museum (Pl.209).[22] It comes from Cracken-thorpe Hall, Westmoreland, and displays 'pomegranate'-type foliage carving quite similar to that at Sefton. Also, comparable heraldic beasts occur. The bed has been dated c.1530–40. The displayed eagle at Sefton is very probably one of a series of decorative motifs with no particular heraldic significance.

There may well have been a hiatus after the retirement of James Molyneux in 1509, the furnishings not being commissioned until the appointment of his cousin in 1535. The absence of misericords and the insubstantiality of the screening suggests an anticipation of the impending liturgical changes hardly likely as early as 1509. The final completion of the rebuilding programme has always been ascribed to the later Molyneux (1535–57). In dating the woodwork no later than c.1540, I have assumed that the long overdue making of the choir-stalls would have been an early priority of the commencement of Antony Molyneux's tenure.

The Sefton rood screen can be compared to several of its predecessors in the north of England in a general way, although its great height, transparency and the handling of its tester are features all its own. There are no really close comparisons with other choir-stalls available, although the desking with arcaded front recalls that in the Henry VII Chapel, Westminster Abbey (Pls 201, 210, 182 & 183).

Although made well into the sixteenth century, the Sefton woodwork is still unequivocally Gothic. The references to classicism are distinctly muted and do not interfere with a largely traditional presentation. Although trying much harder to conform to the tenets of the new style, the choir-stalls at Christchurch Priory, Hants betray a commitment that is still only half-hearted. But whereas at Christchurch determined efforts are being made to come to terms with the Classical manner, at Sefton, a remote north-country church, the response is unfocused. The handling of Renaissance ornament in the rood screens of the West Country, another remote province, is comparable. In many early sixteenth-century screens traditional Gothic architecture is, again, retained in association with classical ornament. At Atherington, Devon for instance, the cells of the conventional Gothic vaulting below the rood loft are filled with Italianate motifs (Pl.211).

[19] Caroe and Gordon (1893) above, 63.

[20] The same opinion is expressed in VCH, *Lancashire*, III, 60.

[21] Quite distinct from the late fifteenth-century English 'pomegranate'-type ornament.

[22] V & A Museum, Acq. No.W.12–1943. I am indebted to Mr Simon Jervis for drawing my attention to this analogy. See 'Fifty Masterpieces of Woodwork', *Victoria and Albert Museum*, London, 1955, No.15.

A Note on Design, Joinery Technique and Workshop Practice in England During the Later Middle Ages

[1] For an account of the design principles prevalent during the previous two centuries and the limited technical developments of the 14th century, see Tracy (1987), 62–69.

[2] See for instance Tracy (1987), Pls 214c, 234 & 236.

[3] Chapter I, 7.

[4] It will be recalled that the principal models for the Lancaster choir-stalls in the mid-fourteenth century are to be found across the Pennines in Yorkshire. See Tracy (1987), 40–43.

[5] Tracy (1987), Pl. 180.

Throughout the nearly one hundred and fifty years spanned by this volume, there were no substantive changes made to choir-stall design, joinery technique or materials employed.[1] Choir furniture was little affected by the advances in joinery and decorative techniques more usually associated with this period, such as true panel-and-frame construction and linenfold ornament. The former was more relevant to the making of wainscoting and secular furniture, such as armoires and chests. In any case, the principles of panel-and-framing had been understood, and sparingly used in the making of choir-stalls, since the thirteenth century.[2] A rare appearance of linenfold ornament on choir-stalls can be seen on the late fifteenth-century furniture at Astbury Church, Cheshire.

The developments in England during the second half of the fourteenth century in canopy design, although capitalised upon at fifteenth-century St George's Chapel, Windsor and early sixteenth-century Henry VII Chapel, Westminster Abbey, were not surpassed in the later Middle Ages. The placing of choir-stalls on ventilated ashlar plinths, an exceptional practice in the earlier period, seems to have been almost the rule from c. 1400, although it is not found at St George's Chapel, Windsor. The curious trick of leaving the front part of the seat standard in the solid, at the end of a run of stalls, where the material is otherwise cut away in a semi-circle, is found at Cartmel Priory and Carlisle Cathedral (Pls 16a & b). This unique device, apart from the other stylistic similarities, links the first two monuments closely together.[3] Its occurrence later at Ripon Minster points up the conservatism and homogeneity of north-country ecclesiastical joinery in the fifteenth century.[4]

Corner seat capping junctions are found both butted together, and carved out of a single piece of wood, as first seen at St Katherine's-by-the-Tower, c. 1365.[5] Canopy vaults are both built up or carved in the solid. Misericords are peg and metal hinged. But it is, as in the fourteenth century, to canopywork that English choir-stall designers seem to have given most attention during the later Middle Ages. From the extant evidence it would appear that in this, rather than sculpture, English master-carpenters were never rivalled by their Continental counterparts. By far the most common surviving form in England at this time is the tiered structure based on a semi-hexagonal plan. Over a period of some one hundred and fifty years, English joiners became highly skilled in constructing large-scale architectural canopies in wood, refining their techniques and designs. By the end of the fourteenth century at Nantwich a

successful attempt had been made to mitigate the potentially monotonous effect of long echelons of canopies, the gables of which all spring from the same level. There the springing line of the side gablets is lower than at the front.[6] This gives the effect of the vaults being pushed up, as one might partially lift a hinged ciborium cover. Cutting across the established aesthetic of a hierarchy of horizontal architectural elements, Nantwich essays a disjuncture in the upper canopy levels. This stroke of originality, however, was not taken up again.

The barely perceptible 'tipping-up' of the lower canopies is to be found again at Carlisle Cathedral, c.1415 (Pl.78). In other respects the canopywork at Carlisle is very conservative, the tripartite conformation of the vault tending to strengthen the 'ironing-out' effect produced by the unelaborated gables. The Whalley Abbey canopywork (Pl.3) must originally have been more successful than its cousin at Carlisle. The 'tipping-up' effect is much more noticeable there (Pl.79), and is backed by a centralised vault plan. At York,[7] c.1420 (Pl.80), super gablets over the main gables, employed here for the first time, are a reference to the doubled gables at Lincoln and Chester, a motif which had not subsequently been repeated.[8] At York, Ripon, and subsequently Manchester and Beverley Minster (Pls 55, 212 & 75), the 'tipping-up' of the lower canopies is given an additional emphasis by using three springing lines, for the backs of the lower canopies, their fronts and for the intervening gablets above. At Windsor the monotony of a perfectly aligned row of canopies is ingeniously overcome by raising, instead of lowering, the outer gable springers. This produces the effect of clearly separating each canopy from its neighbour, and allowing light and space to penetrate the structure at regular intervals. At the Henry VII Chapel, Westminster Abbey the potential aesthetic problems are overcome, not only by raising the springing line of the front gable, or gables, but, as previously at Windsor, by alternating the shape of the canopies between semi-hexagonal and octagonal (Pls 161 & 213). Moreover, the need for variety in both design and ornament is well understood. At Westminster the scantling of sculptured and ornamented members is pared down to the minimum ensuring that the canopies never seem overpowering.

It is self-evident that English joiners amassed considerable experience and a unique level of competence in constructing large-scale canopies in wood. On the Continent, an interest in wooden canopywork hardly extended beyond the manufacture of miniaturised architecture in the hundreds of late medieval altarpieces of the late fifteenth and early sixteenth centuries. In these, the whole canopy is often carved in the solid there being no imperative to take any account of the problem of structure (Pl.214). In the choir-stalls, in the few cases where cantilevered, never free-standing, canopywork is to be found, as at Erfurt, Bardowick and Hildesheim cathedrals, it is used in a strictly decorative and non-architectural manner.[9] Perhaps the nearest that any Continental artist gets to the typical English canopywork formula is on these stalls at Barcelona Cathedral. The two authors of this late fifteenth-century campaign were from Kassel.

It is a pity that we still know so little about joinery workshop practices and organisation at the end of the Middle Ages. It has been established for many years that the practice of certain crafts like goldsmithing, manuscript illuminating, alabaster carving, textile embroidery, bronze casting, and panel and glass painting were based in the major cities throughout the Middle Ages. F. E. Howard's opinion that much West Country parish church woodwork was made in local towns, and that in the 'Eastern School ... the bulk of the ... woodwork ... was probably made at town centres, such as Norwich or York'[10] seems to have been largely influential in the formation of Purvis's thesis that a good deal of the late Gothic woodwork in the North Country was made at

6 Tracy (1987), Pl.210.

7 See Chapter III, Note 46.

8 Tracy (1987), Pls 171 & 176.

9 See Meurer (1970), Pls 96, 103 & 109. For Flemish choir-stalls in the Netherlands see Borchgrave (1937), and in Spain Kraus (1984).

10 Howard & Crossley (1917), 37.

Ripon. To underscore this Purvis declared: 'Such unity of design in general, with such individuality of development, step by step in details, could surely be secured by no other means'. The clear implication is that Purvis believed, or wanted to believe, that the entire corpus of the so-called 'Ripon School' was made in the Bromflet workshop in Ripon.

The impracticality of transporting heavy fragments of carved oak across the Pennines and around Yorkshire inhibits this theory. Howard could have been correct in speculating that parish church rood screens were often manufactured in the local town. But, in the case of the choir-stalls of a greater church, the possibility that the furniture, particularly the seating, was imported in bits from up to fifty miles away, flies in the face of the surviving evidence. Exceptionally, the canopies of the St George's Chapel, Windsor choir-stalls were made in London.[11] But in that case convenient transport by river was available.

There were three possible ways in which a monument could be constructed – by a metropolitan workshop, a travelling team of craftsmen, or an estate or local carpenter. As mentioned above, the evidence for the use of the first method is limited to the St George's Chapel, Windsor case. Without doubt, as in the thirteenth and fourteenth centuries the second method was the commonest in the late Middle Ages. As at Winchester and Ely cathedrals in the fourteenth century, the team responsible for Bishop Goldwell's stalls at Norwich Cathedral in the 1480s most probably consisted of craftsmen of diverse origins.[12] Unfortunately, because of the loss of so much medieval woodwork, it is only very rarely that the same workshop can be recognised in two or more buildings. The few examples that have been adumbrated are at St Katherine's Hospital, London and Lincoln and Chester cathedrals in the fourteenth,[13] at Wigmore and Chirbury abbeys in the fifteenth,[14] and probably Manchester and Jervaulx Abbey[15] in the early sixteenth centuries. An example of the work of an estate carpenter can be seen at Whalley Abbey.[16]

In the category of the travelling workshop, a qualitative distinction needs to be made between provincial organisations and ones ultimately based on a metropolis. In the case of a workshop in the first division, although the furniture was not being made, for reasons of practicality, in London, Bristol or York, it was almost certainly the work of artists who owed their livelihood ultimately to the patronage of one of these cities, or to the royal court. As in stone masonry, the practice of lending a craftsman and his workshop must have been common. It is documented in the fourteenth century at Winchester and Ely cathedrals.[17] In the fifteenth century it probably occurred at Norwich and, in the sixteenth century at Manchester, Jervaulx and Bridlington.

Apart from the notion of centralised production, another unfortunately misleading supposition adduced by Purvis was that the later Middle Ages saw the introduction of 'modern industrial methods'.[18] His claim that every detail throughout the Ripon-associated corpus 'is carefully standardised' will not stand up to objective scrutiny.[19] To characterise the stylistic similarities of the different sets of furniture as 'a remarkable economy of design' is misleading, when one considers that the scantlings and carving methods used were no less wasteful than before. The notions of 'standardization and methods of mass production' which Purvis introduced have tended to confuse rather than elucidate.

At the end of our period, when a few patrons were experimenting with the classical style, the art of ecclesiastical joinery was still firmly rooted in the craft practices of the Middle Ages.

11 Chapter VII.

12 See Chapter IV.

13 Tracy (1987), Chapter IX.
14 Chapter II.
15 Chapter III.
16 Chapter I.

17 Tracy (1987), Chapters III & VI.

18 Purvis (1935), 112 for this and subsequent quotations.

19 See Figure 1 and Chapter III, 26.

GLOSSARY OF TERMS

Seat Capping	Planks of oak 5–10cm thick, about 50cm wide and up to 2·5m long, continuous on one side and cut away to form the top of the seating on the other. The capping projections carry the front supports of a superstructure, if any.
Counters	See Standards
Stall Elbow	Hand rest projecting from the seat division, counter or standard, in this context often referred to as the arm, of the stall. It consists of a knop of carved foliage, or is of animal or human form.
Stall End	This feature closes off a run of stalls. Where there are substalls, it occurs frequently because the gangways break the seating up into short sections. Stall ends are usually thicker than normal seat divisions and, at the end of the back stalls, sometimes carry a side screen above seat capping level.
Seat Rail	A thick plank of oak c.61 × 31 cm which sits on floor joists and supports the back of the stalls.
Stall Shoulder	The part of the seat capping that projects forward.
Back Stalls	The back row of choir-stalls ranged along the choir arcade and pulpitum.
Lateral Stalls	The stalls running along the axis of the choir.
Seat Standards	The division between one stall and another. Grooved each side to take the tip-up seats which were sometimes housed into the standard. The seats are secured into position, either by a pivot which is part of the seat, or by metal hinges attached to the back. Standards are sometimes called Divisions or Counters.
Substalls	The row of stalls lower than and in front of the back stalls.
Stall Upright	Buttresses or columns placed on the seat capping to support a superstructure.

ABBREVIATIONS AND SELECT BIBLIOGRAPHY

Arch. Camb.	*Archaeologia Cambrensis*
Arch. Jnl	*Archaeological Journal*
Archaeol.	*Archaeologia*
BAA Jnl	*British Archaeological Association Journal*
BOE	Buildings of England Series
BOW	Buildings of Wales Series
CWAAS	*Cumberland and Westmoreland Antiquarian and Archaeological Society Transactions*
RCHM	*Royal Commission on Historical Monuments*
VCH	*Victoria County History Series*

Note. Not all these works are specifically referred to in the text.

UNPUBLISHED DOCUMENTARY SOURCES

Crallan F. A. Crallan, Manuscript notes and sketches. Library of the Council for the Care of Churches.

PUBLISHED BOOKS AND ARTICLES

Architectural Museum (1877). *Catalogue of the Royal Architectural Museum*, 1877.

Ashmole (1672). E. Ashmole, *Order of the Garter*, London, 1672.

Behling (1957). Lottlisa Behling, *Die Pflanze in der Mittelaltterlichen Tafelmalerei*, Weimar, 1957.

Beloe (1899). Edward M. Beloe, *Our Churches: (King's Lynn, Norfolk)*, Cambridge, 1899.

Billings (1840). R. W. Billings, *History and Description of Carlisle Cathedral*, London, 1840.

Bond (Screens). Francis Bond, *Screens and Galleries in English Churches*, Oxford, 1908.

Bond (Misericords). Francis Bond, *Wood Carvings in English Churches: I. Misericords*, London, 1910.

Bond (Stalls). Francis Bond, *Wood Carvings in English Churches: I. Stalls and Tabernacle Work and II. Bishops' Thrones and Chancel Chairs*, London, 1910.

Bond & Camm (1909). F. Bligh Bond and B. Camm, *English Church Screens and Roodlofts*, 2 vols, London, 1909.

Borchgrave (1937). J. de Borchgrave d'Altena, 'Notes pour servir a l'étude des stalles en Belgique', *Annales de la Société Royale d'Archéologie de Bruxelles*, 41, 1937, 231–259.

Bridgens (1822). R. Bridgens, *Sefton Church*, London, 1822.

Busch (1928). R. Busch, *Deutsches Chorgestühl in Sechs Jahrhunderten*, Hildesheim, 1928.

Cobb (1980). Gerald Cobb, *English Cathedrals, The Forgotten Centuries*, London, 1980.

Colvin. H. M. Colvin (ed.), *The History of the King's Works*, 6 vols, London, 1963–73.

Cook (1947). G. H. Cook, *Mediaeval Chantries and Chantry Chapels*, London, 1947.

Cox (1907). J. C. Cox, *English Church Furniture*, London, 1907.

Cox (1916). J. C. Cox, *Bench ends in English Churches*, Oxford, 1916.

Cox & Harvey (1907). J. C. Cox and A. Harvey, *English Church Furniture*, London, 1907.

Crossley (1916). F. H. Crossley, 'Stallwork in Cheshire', *Trans Hist. Soc. of Lancs and Cheshire*, LXVIII, 1916, 85–106.

Crossley (1917). F. H. Crossley, 'The Church Screens of Cheshire', *Trans Hist. Soc. of Lancs and Cheshire*, LXIX, 1917, 1–53.

Crossley (1919). F. H. Crossley, 'On the Remains of Medieval Stallwork in Lancashire', *Trans Hist. Soc. of Lancs and Cheshire*, LXX, 1918, 1–42.

Crossley (1941). F. H. Crossley, *English Church Craftsmanship*, London 1941.

Crossley & Ridgway (1943 *et seqq.*). Fred H. Crossley and Maudie H. Ridgway, 'Screens, Lofts and Stalls situated in Wales and Monmouthshire', *Arch. Camb.*:

'Part I. Introduction', XCVII, 2, 1943, 135–60.
'Part II. Anglesey and Caernarvonshire', XCVIII, 1, 1944, 64–112.
'Part III. Merioneth and Flintshire', XCVIII, 2, 1945, 153–98.
'Part IV. Denbighshire and Cardiganshire', XCIX, 1, 1946, 1–56.
'Part V Montgomeryshire and Carmarthenshire', XCIX, 2, 1947, 179–230.
'Part VI. Radnorshire', XCX, 1, 1948, 207–51.
'Part VII. Brecknockshire', CII, 1, 1952, 48–82.
'Part VIII. Pembrokeshire', CVI, 1957, 9–45.
'Part IX. Glamorgan', CVII, 1958, 72–108.
'Part XI. Border influences; Additions and Corrections *etc.*', CXI, 1962, 59–102.

Crowther (1893). J. S. Crowther, *The Cathedral Church of Manchester*, Manchester, 1893.

Dickinson (1946). J. C. Dickinson, 'The Architectural Development of Cartmel Priory Church', *CWAAS Trans*, XLV, 1946, 49–60.

Ganz & Seeger (1946). Paul L. Ganz & Theodor Seeger, *Das Chorgestühl in der Schweiz*, Frauenfeld, 1946.

Harvey (1978). John H. Harvey, *The Perpendicular Style, 1330–1485*, London, 1978.

Harvey (1981). John H. Harvey, *Mediaeval Gardens*, London, 1981.

Harvey (1984). John H. Harvey, *English Mediaeval Architects*, London, Revd Edn, 1984.

Hibben (1933). T. Hibben, *The Carpenter's Tool Chest*, London, 1933.

Hope (1913). W. St John Hope, *Windsor Castle, An Architectural History*, 2 vols, London, 1913.

Howard & Crossley (1917). Frank E. Howard and F. H. Crossley, *English Church Woodwork. 1250–1550*, London, 1917.

Hudson (1924). H. A. Hudson, *The Medieval Woodwork in Manchester Cathedral*, Manchester, 1924.

Hudson (1929). H. A. Hudson, 'On some recent discoveries relating to the woodwork of Manchester Cathedral', *Trans Lancs & Cheshire Antiq. Soc.*,

XLVI, 1929, 93–106.

James (1933). M. R. James, *St. George's Chapel, Windsor: The Woodwork of the Choir*, Windsor, 1933.

Jervis (1976). Simon Jervis, 'Woodwork of Winchester Cathedral', Winchester, 1976.

Kraus (1986). Dorothy and Henry Kraus, *The Gothic Choirstalls of Spain*, London and New York, 1986.

Lasko & Morgan (1974). P. Lasko and N. J. Morgan (ed.), *Medieval Art in East Anglia 1300–1520*, London, 1974.

Lethaby (1906). W. R. Lethaby, *Westminster Abbey and the King's Craftsmen*, London, 1906.

Lethaby (1925). W. R. Lethaby, *Westminster Abbey re-examined*, London, 1925.

Letts (1886). E. F. Letts, 'Misereres in Manchester Cathedral', *Trans Lancs & Cheshire Antiq. Soc.*, IV, 1886, 130–44.

Loose (1931). Walter Loose, *Die Chorgestühle des Mittelalters*, Heidelberg, 1931.

Meurer (1970). Heribert Meurer, *Das Klever Chorgestühl und Arnt Beeldesnider*, Düsseldorf, 1970.

Neugass (1927). Fritz Neugass, 'Mittelalterisches Chorgestühl in Deutschland', *Studien z.d. Kunstgesch.*, 249, Strasbourg, 1927.

Perry (1921). M. P. Perry, 'The Stall Work of Bristol Cathedral', *Arch. Jnl*, 2nd Ser., XXVIII, 1921, 233–50.

Phipson (1896). E. Phipson, *Choir Stalls and their Carvings*, London, 1896.

Pollen (1874). John H. Pollen, *Ancient and Modern Furniture and Woodwork in the South Kensington Museum*, London, 1874.

Purvis (1929). J. S. Purvis, 'The Ripon Carvers and the lost choir-stalls of Bridlington Priory', *Yorkshire Arch. Jnl*, XXIX, 1929, 157–201.

Purvis (1935). J. S. Purvis, 'The Use of Continental Woodcuts and Prints by the Ripon School of Woodcarvers', *Archaeol.*, LXXXV, 1935, 107–28.

Remnant (1969). G. L. Remnant (with an introduction by L. M. D. Anderson), *A Catalogue of Misericords in Great Britain*, Oxford, 1969.

Salzman (1952). L. F. Salzman, *Building in England down to 1540 – A Documentary History*, Oxford, 1952.

Scott (1879). George Gilbert Scott, *Personal and Professional Recollections*, London, 1879.

Sirr (1883 & 1885). H. Sirr, 'English Stall-Work, Canopies, and Rood-Screens of the Fifteenth Century', *Art Journal*, 1883, 325–29; and 1885, 145–48.

Smith (1923). H. Clifford Smith, *Victoria and Albert Museum Department of Woodwork Catalogue of English Furniture and Woodwork*, Vol. I, *Gothic and Early Tudor*, London, 1923. Revised and reprinted 1929.

Stone (1955). Lawrence Stone, *Sculpture in Britain: The Middle Ages*, London, 1st Edn, 1955.

Symonds (1956). R. W. Symonds, 'Furniture: Post Roman', from *A History of Technology*, ed. C. Singer *etc.*, Vol. II, Oxford, 1956.

Thomas (1903). Archdeacon Thomas, 'Montgomeryshire Screens and Rood-lofts', *Arch. Camb.* 6th Ser., Vol. IV, Pt. II, 1903, 85–120.

Tracy (1987). Charles Tracy, *English Gothic Choir-Stalls. 1200–1400*, Woodbridge, 1987.

Tracy (1988). Charles Tracy, *A Catalogue of English Gothic Furniture and Woodwork*, V & A Museum, London, 1988.

Tredgold (1840). T. Tredgold, *Elementary Principles of Carpentry*, 2nd Edn, with Appendix including additions by S. Smirke, J. Shaw, J. Glynn *et al.*, London, 1840.

Vallance (1906). Aymer Vallance, 'The Development of the Linen Panel',

Magazine of Fine Arts, 1906, 212–22.

Vallance (1909). Aymer Vallance, 'Roods, Screens, and Lofts in Lancashire', from *Memorials of Old Lancashire*, 1909, 228–58.

Vallance (1917). Aymer Vallance, 'The History of Roods, Screens, and Lofts in the East Riding', *Yorkshire Arch. Jnl*, XXIV, 1917, 109–185.

Vallance (1936). Aymer Vallance, *English Church Screens*, London, 1936.

Vallance (1947). Aymer Vallance, *Greater English Church Screens*, London, 1947.

Walker (1982). Philip Walker, 'The Tools Available to the Mediaeval Woodworker', *British Archaeological Reports Int. Ser.*, 129, 1982, 349–56.

Whitaker. T. D. Whitaker, *An History of the Original Parish of Whalley*, London, 1st edn, 1801.

Whittingham (1948). A. B. Whittingham, 'The Stalls of Norwich Cathedral', *Friends of Norwich Cathedral. Annual Report*, 1948, 15–31.

Whittingham (1981). A. B. Whittingham, 'Norwich Cathedral Bosses and Misericords', Norwich, 1981.

Whitworth (1976). Whitworth Art Gallery, Manchester, *Medieval and Early Renaissance Treasures in the North West*, Exh. (15.1 – 28.2) Cat.

Wildridge (1879). Thomas T. Wildridge, 'Misereres in Beverley Minster', Hull, 1879.

Wildridge (1889). Thomas T. Wildridge, 'Misereres of Ripon Minster', Hull, 1889.

Wolfgang (1911). A. Wolfgang, 'Misericords in Lancashire and Cheshire Churches', *Trans Hist. Soc of Lancs and Cheshire*, LXIII, 1911, 79–87.

Wolfgang (1912). A. Wolfgang, 'Ancient Screens in Cheshire and Lancashire Churches', *Trans Hist. Soc of Lancs and Cheshire*, LXIX, 1912, 20–42.

Wright (1848). Thomas Wright, 'Carvings of the Stalls in Cathedral and Collegiate Churches', *BAA Jnl*, IV, 1849, 203–216.

APPENDIX

Notes on Miscellaneous Ripon-Related Woodwork

Barkestone Church, Leics: Stall ends.

The four stall ends are said to have come from either Croxton Abbey or Belvoir Priory. The form of the stall ends with the 'Ripon' 'house' motif raised above a traceried plinth recalls the compositions at Manchester and Jervaulx. After Manchester, once the arrangement was fixed it becomes difficult to date its different manifestations on style alone. In this case the use of rounded 'dentilation' on the traceried parapets recalls that motif found only at Beverley Minster. A date of around 1520 for the Barkestone stall ends is also indicated by the heavy, deep-fold Flemish drapery style of the saint figures under canopies. The latter recall in a general way the sculpture at Henry VII Chapel, Westminster Abbey of after 1512.

Bridlington Priory (Leake Church): Fragments from a tester.

If the tracery heads, now incorporated into the altar rails, are also from Bridlington Priory, the source of the bench ends at Leake, they are valuable evidence that the Priory choir-stalls had a tester. The mouldings and the lancets in the spandrel corners are very close to the testers on the north side of the choir-stalls at Manchester. The Bridlington arches were pointed and cusped rather than rounded and decorated with traceried lozenges as at Manchester. Some of the tracery heads at Leake seem to be too narrow for use above a choir-stall. Perhaps they were required for the terminal wing sections.

Bridlington Priory (Flamborough Church): Pulpitum loft and screenwork.

The rood loft at Flamborough Church may very well have come from the pulpitum at Bridlington Priory. The canopywork design is centralised with a larger tabernacle in the centre. It could, therefore, never have been part of a choir-stall superstructure. The canopywork resembles Ripon and Manchester only in a general way and the quality of the decorative carving is inferior. Vine trail friezes occur throughout the 'Ripon' corpus but the treatment varies considerably. Hudson and Purvis saw this motif as a 'trademark' but, of course, it is one of the most common forms of decoration in fifteenth and early sixteenth century English woodwork. The Flamborough frieze is not in 'precisely the same form' as that on the Jesus Chapel screen at Manchester, as Purvis claimed. The scale of the motifs is quite different in each case, and the vine stem at Manchester is ribbed whilst at Flamborough it is plain. The treatment of the rose trail on the loft is slightly closer to the same motif on the Manchester stalls particularly on account of the use of a ribbed stem. Unfortunately, *pace* Purvis, there are no useful comparisons to be made with the bench ends at Leake Church, also from Bridlington.

The screen on the south side of the chancel is similar to that in the Bolton pew, Wensley Church (from Easby Abbey) of c.1510. There is an interesting variety of vegetal motifs carved on the dado rail. Purvis puts great emphasis upon the perceived stylistic links between the screenwork at Flamborough and Ripon. Clearly the screenwork at Flamborough is earlier than the pulpitum loft.

Durham Castle Chapel: Choir-Stalls.

The stalls are a patchwork of different styles and periods. Some were imported by Bishop Tunstall in 1547–48 from the episcopal chapel at Auckland Castle, when the extant chapel was fitted out. The rest, coeval with the cathedral stalls, were provided by Bishop Cosin after the Civil War. Apart from the nineteenth-century seating the fragments appear to be from three sets of furniture. The seat capping from 24 stalls is ranged along the north side of the chapel and the south lateral stalls (set A). The seat capping, three seat standards and half a corner junction in the south return stalls represent the second set (B). Cosin's work (Set A) has some matching seat standards and misericords. Set B must have been made c.1490. It has misericords very close to those by Hand C at Ripon (see p.20). The foliage supporters are quite close in style but, more significantly, both sets of misericords use stems with bevelled sides. This is a rather unusual conceit but it is not handled in quite the same way in each place. At Ripon the stems are flat-topped whilst they are sloped at Durham. Both places feature the rarely used subject of the man wheeling an old woman in a wheel-barrow. This is derived ultimately from a Continental woodcut subject.

The third element in the mixture, the desk ends, must have also come from Auckland. They were presumably commissioned by Bishop Ruthall (1508–23), whose arms appear on three of them. Surprisingly, on the south-east desk end, the constituents of the coat are inexplicably reversed, a solecism which would be surprising had they been made for the same set of choir-stalls. Is it possible that only two of these desk ends are of Ruthall's time, and that the odd one out was, as Fowler suggested, 'copied from the matrix of a seal' in Tunstall's time, to match the desk-ends brought from Auckland?

Easby Abbey (Wensley Church): Screenwork.

The medieval screenwork used in the Bolton Pew is said to have been brought to the church from the dissolved Easby Abbey by John, Lord Scrope, d.1549. Purvis dates the woodwork from the heraldry to c.1510. The tracery and decorative carving is very close to that of the Jesus Chapel, Manchester. The choir-stalls from Easby were presented to St Mary, Richmond where in a restored condition they still are. The style and quality of this material is quite unrelated to the Manchester and Wensley screenwork.

Hauxwell Church: Desking.

In the chancel there are two modern desk ends linked by a four-bay length of new desking. The tracery heads in the desk fronts seem to be medieval. They have the same curvilinear patterning and broad unmoulded ribs as those in the desks at Manchester and the rood dado screen at Flamborough (Bridlington Priory). These two tracery heads must have been associated with the two worm-eaten and denatured medieval desk ends in the church. As Purvis has pointed out, these are of only provincial quality. The agreements in tracery pattern and moulding in three such different churches, at least ten years apart, points up the need for caution in using these characteristics as anything other than a general guide.

Jervaulx Abbey (Aysgarth Church): Pulpitum and desking.

There is no concrete stylistic evidence for attributing the woodwork to any of the wood carvers working at either Ripon or Manchester (See pp. 25, 26 & 27). None of the architectural or motival analogies adduced by Purvis are, in my view, close enough to be diagnostically substantive. None the less, as stated above, the Jervaulx stalls must have been constructed at about the same time as those at Manchester.

Newark Church: Choir-Stalls.

The desk end buttresses are decorated with fictive gabled and windowed structures reminiscent of the Ripon-associated type. Also the poppy heads have pomegranate flowers arranged in the same manner. However, the buttresses of the desk ends are not detached. The rood screen is attributed to the workshop of Nicholas Drawswerd, master carver and sculptor of York (he was Mayor in 1515). None of the woodwork in the choir has any substantive stylistic connection with the Ripon-associated corpus.

Wensley Church: Choir-Stalls.

Comparisons with any Ripon-associated monument other than Beverley Minster are not helpful since these stalls come chronologically at the end of the surviving body of material. Unfortunately most of the seating is lost. However, a fragment of a seat standard includes an elbow decorated with a rosette. This immediately suggests that a run-of-the-mill quality for this woodwork was what was needed. In practice the animal carving at Wensley is little worse than that at Beverley (the hare being particularly endearing). Some of the characteristic Ripon-associated poppy heads in both places include roses on each side of the spine.

Bibliography by present location

Aysgarth	Glyn Coppack (ed.), *Abbeys: Yorkshire's Monastic Heritage, Yorkshire Museum*, York, Exh. Cat., No.41. Purvis (1929), 165–67.
Barkestone	Nikolaus Pevsner, revd E. Williamson with G. K. Brandwood, BOE, *Leicestershire and Rutland*, London, 1984.
Durham Castle	J. T. Fowler, 'Durham Castle Chapels', *The Durham University Jnl*, July 1878, 5–8; C. Grössinger, 'Humour and Folly in English Misericords of the First Quarter of the Sixteenth Century', *Early Tudor England. Proceedings of the 1988 Harlaxton Symposium*, Woodbridge, 1989, 78–79; Phipson (1896), 91–92, Pl.87; Purvis (1935), 122 & Fig.17; Remnant (1969), 41–42.
Flamborough	Purvis (1929), 168–72; Aymer Vallance, 'The History of Roods, Screens, and Lofts in the East Riding', *Yorks Arch. Jnl*, XXIV, 1917, 128–32; 'St Oswald's, Flamborough', *Yorks Arch. Jnl. Proceedings in 1910*, XXI, Leeds, 179–80.
Hauxwell	Purvis (1929), 165.
Leake	H. Lawrence and C. V. Collier, 'Ancient Heraldry in Yorkshire', *Yorks Arch. Jnl*, XXVIII, 60; Purvis (1929), 160–63.
Newark	Remnant (1969), 123–24.
Richmond	Nikolaus Pevsner, *Yorkshire. The North Riding*, BOE, London. 1966, 291.
Wensley	Purvis (1929), 167–68; Purvis (1935), 110.

INDEX

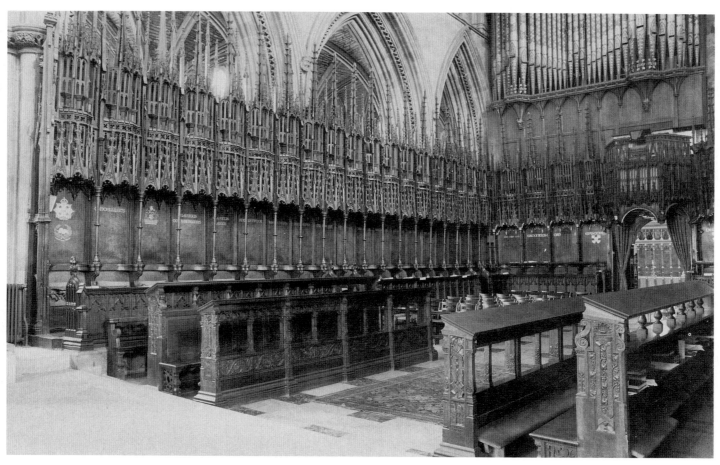

1. Carlisle Cathedral. View of choir-stalls from N.E.

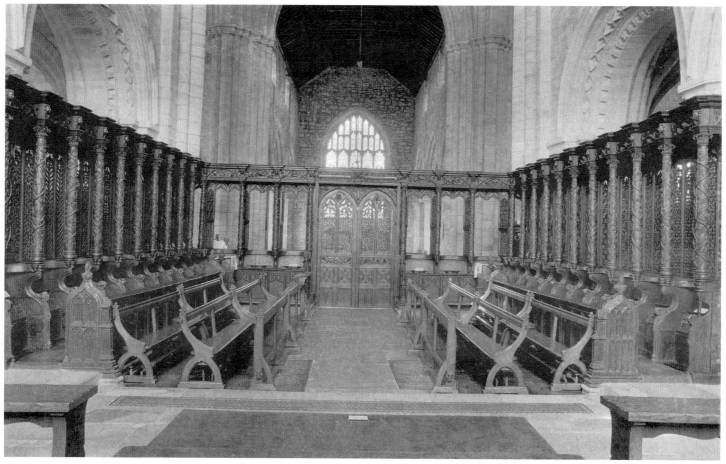

2. Cartmel Priory. View of choir-stalls from E. (the superstructure is 17th c.).

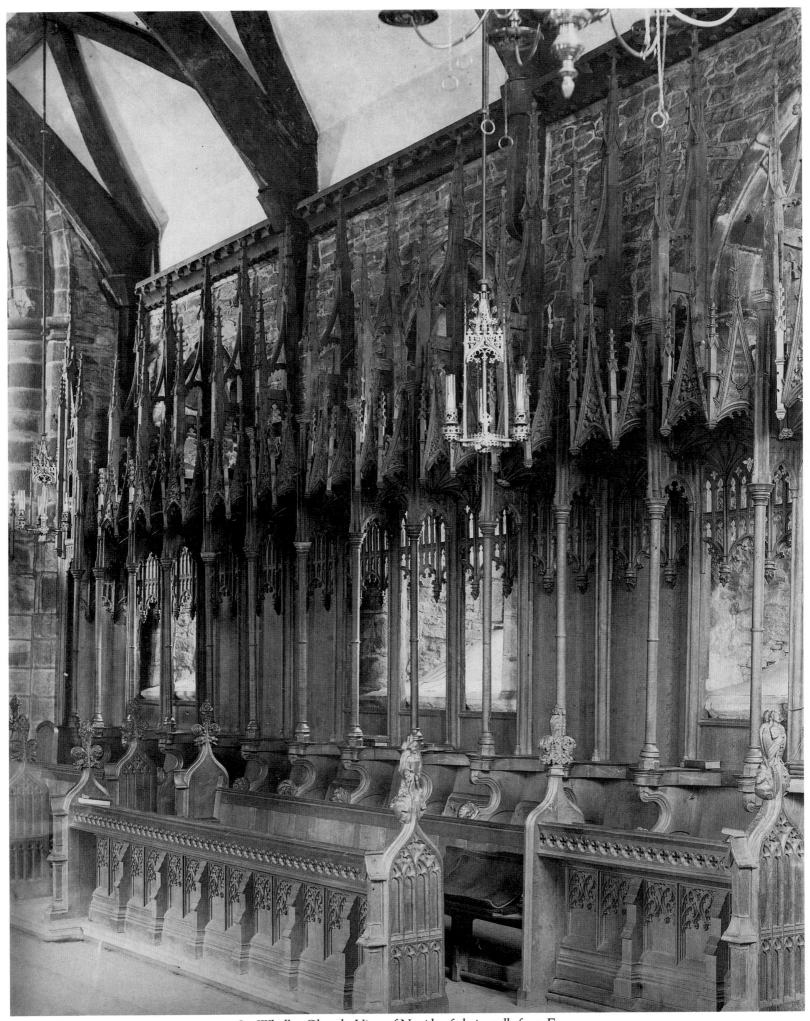

3. *Whalley Church. View of N. side of choir-stalls from E.*
(*Conway Library, Courtauld Institute of Art. Copyright Canon M. H. Ridgway*).

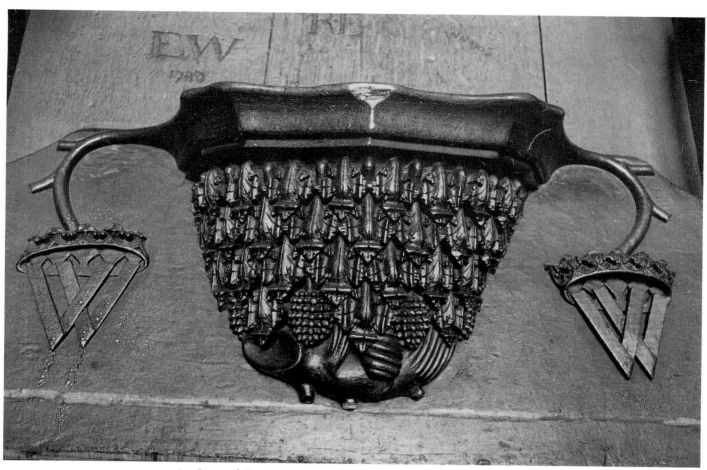

4. *Cartmel Priory. Misericord with W monogram supporters.*

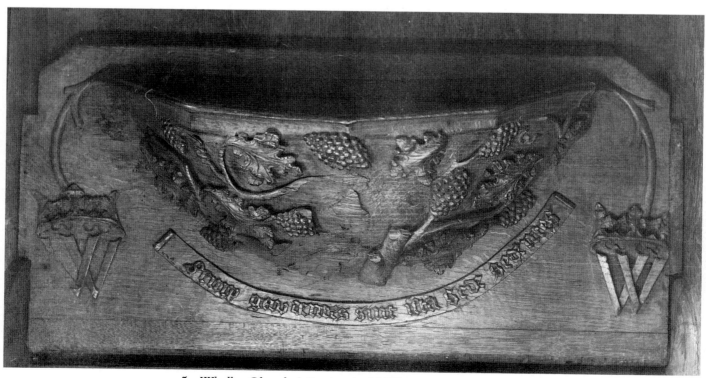

5. *Whalley Church. Misericord with W monogram supporters*
(Conway Library, Courtauld Institute of Art. Copyright Canon M. H. Ridgway).

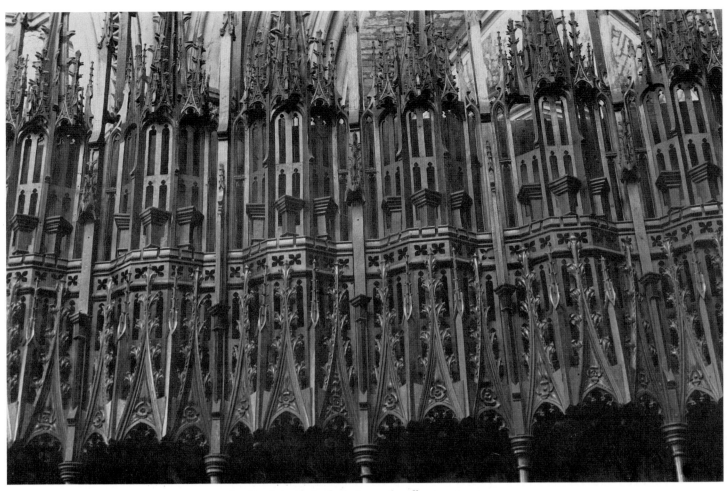

6. *Carlisle Cathedral. Lateral stall superstructure.*
Detail showing niches for statues in the lower zone and plinths for statues above.

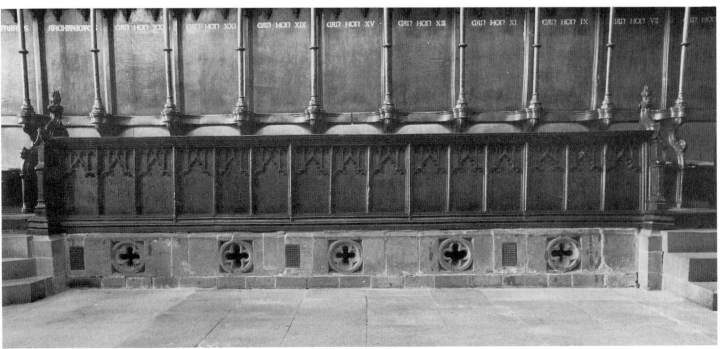

7. *Carlisle Cathedral. Choir-stall desking. S. side. Detail.*

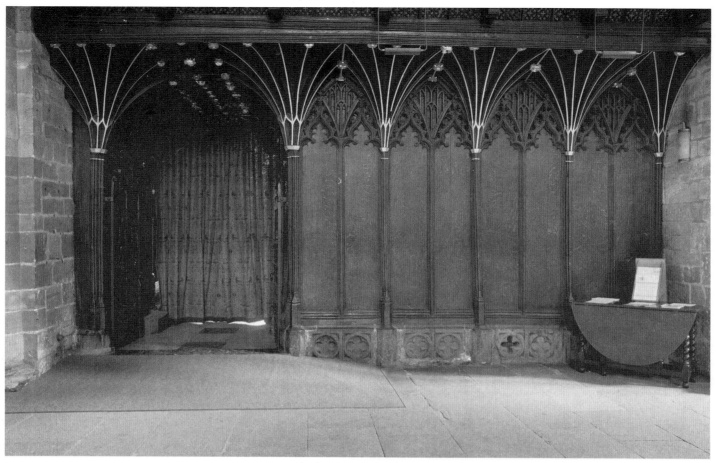

8. Carlisle Cathedral. W. side of wooden pulpitum.

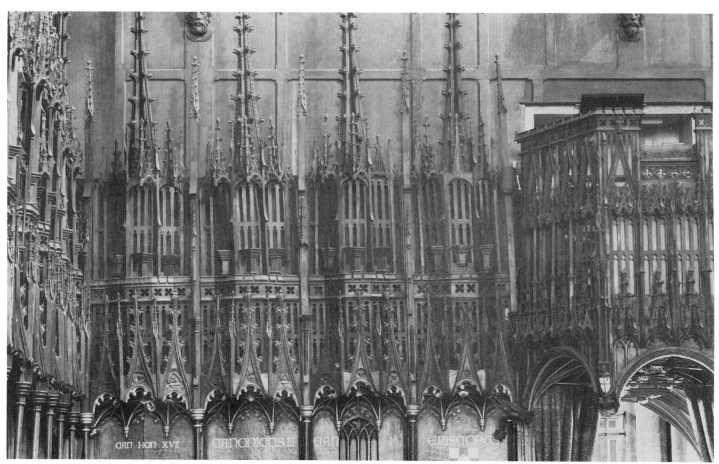

9. Carlisle Cathedral. Superstructure of S.W. return stalls and portion of pulpitum tribune.

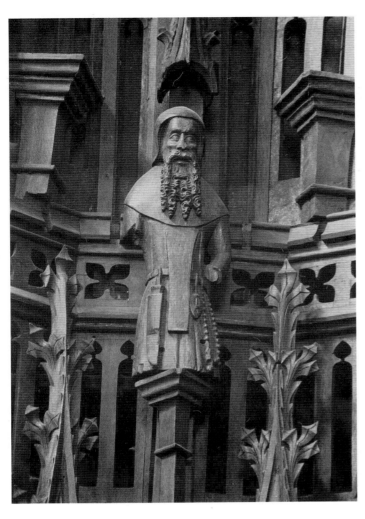

10. *Carlisle Cathedral. Choir-stalls. Figure of ecclesiastic* in situ *on canopywork of N.W. return seats.*

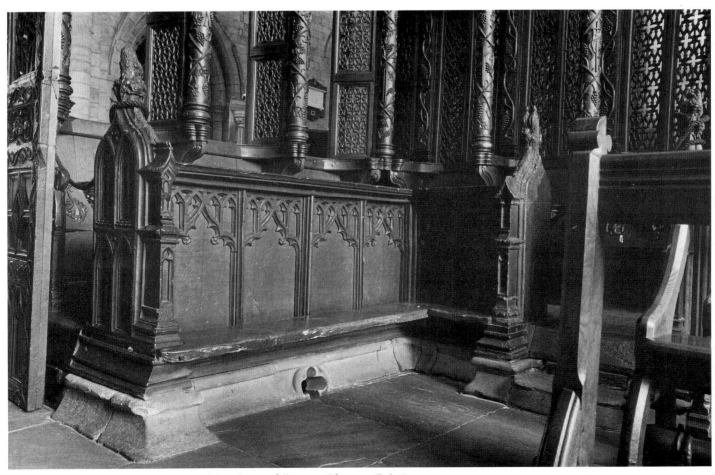

11. *Cartmel Priory. Choir-stall desking in N.W. corner.*

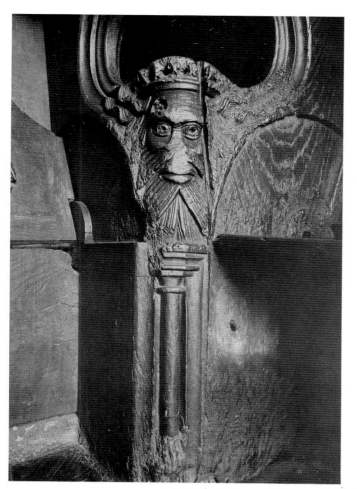
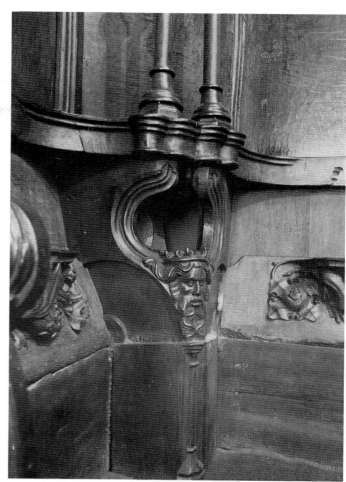

12a & b. Cartmel Priory and Carlisle Cathedral. Junctions of choir-stall seat standards.

13. Whalley Church. Engraving of choir-stalls
(from T. D. Whitaker, An History of the Original Parish of Whalley, *London, 1818, Pl. facing 247).*

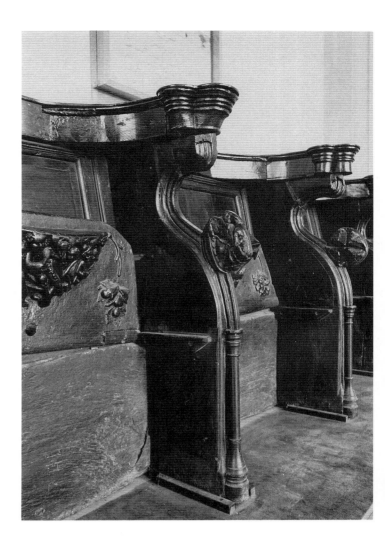

14a & b. Whalley Church and Blackburn Cathedral. Choir-stall seating. Details.

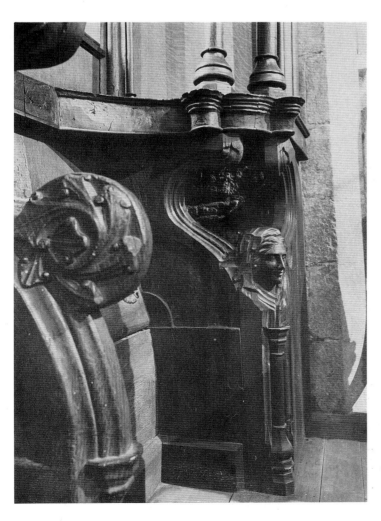

15. Whalley Church. S.W. junction of choir-stall seating (the northern seat standard and the carved junction motif are 19th c.).

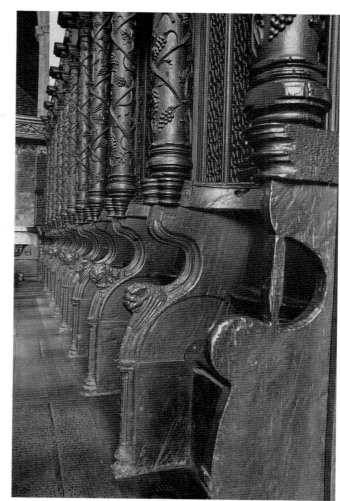

16a & b. Carlisle Cathedral and Cartmel Priory. Lateral choir-stall, E. terminal end seat standards. Details of bracing device.

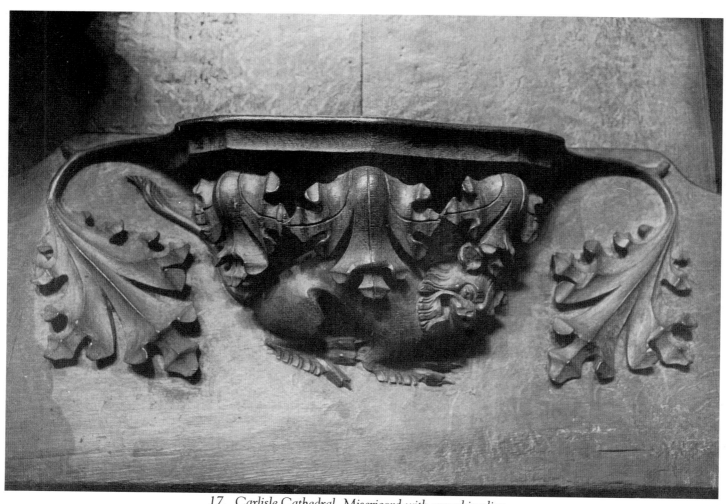

17. Carlisle Cathedral. Misericord with crouching lion.

18a & b. Cartmel Priory and Whalley Abbey. Desk ends.

a

b

19a–d. Carlisle Cathedral.
(a)–(b). Long-leaf; (c)–(d). Squared-up foliage misericord supporters.

c

d

a

b

20a–d. Carlisle Cathedral.
Conventional squared-up and circular foliage misericord supporters.

c

d

a

b

c

d

21a–d. Cartmel Priory.
Conventional squared-up and circular foliage misericord supporters.

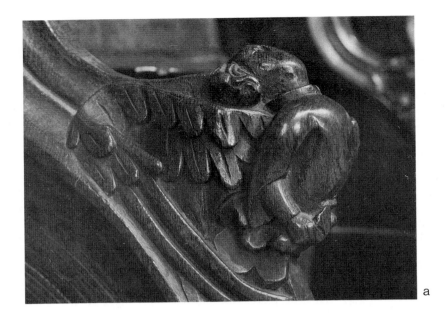

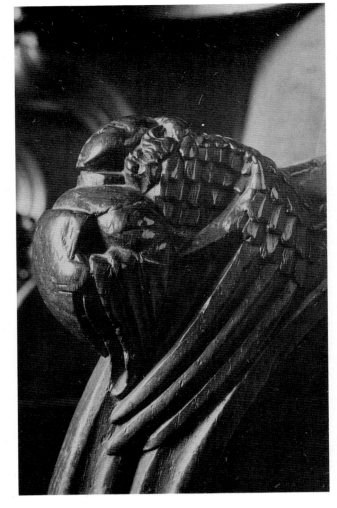

22a–c. Carlisle Cathedral, Cartmel Priory and Whalley Church.
Choir-stall seat standard angel elbows.

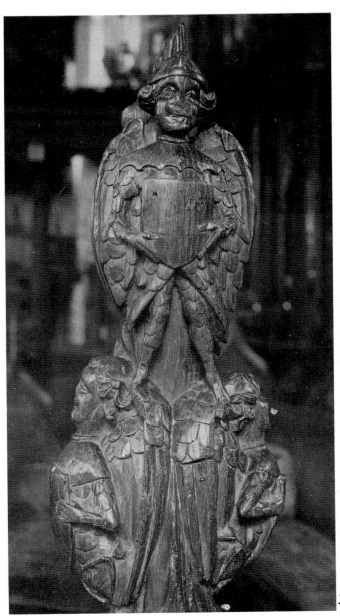

23. Whalley Church. Poppy head from stall desk end. N. side.

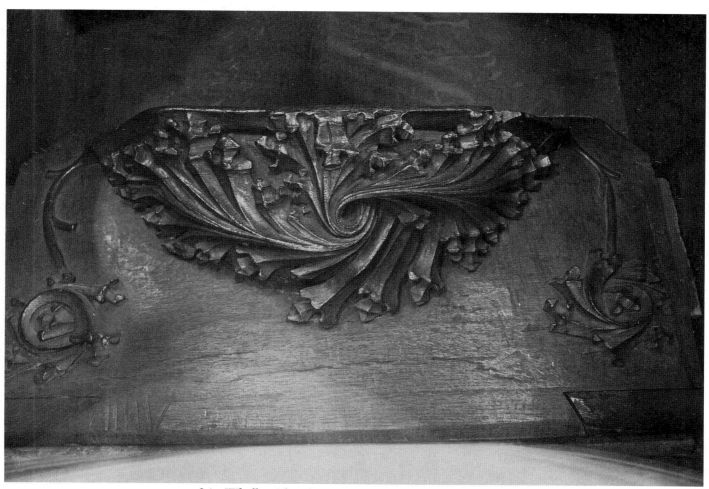

24. Whalley Church. Hawthorn foliage misericord.

a

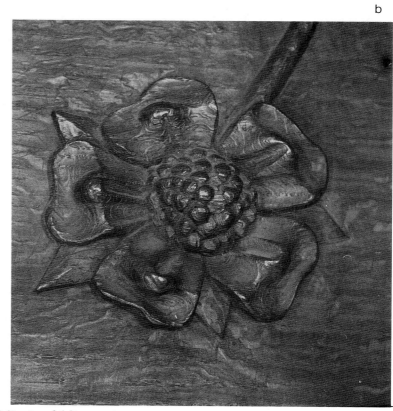

b

25. Whalley Church. (a)–(b). Misericord foliage supporters.

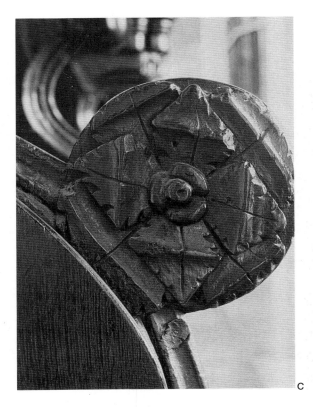

c

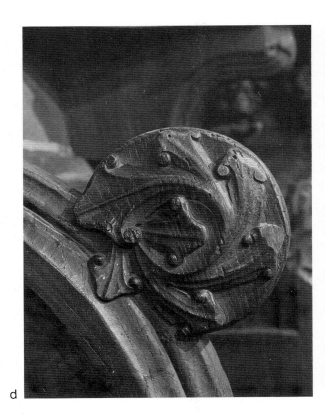

d

25. *Whalley Church. (c)–(d). Seat standard foliage elbows; (e)–(f). Misericord human head supporters.*

e

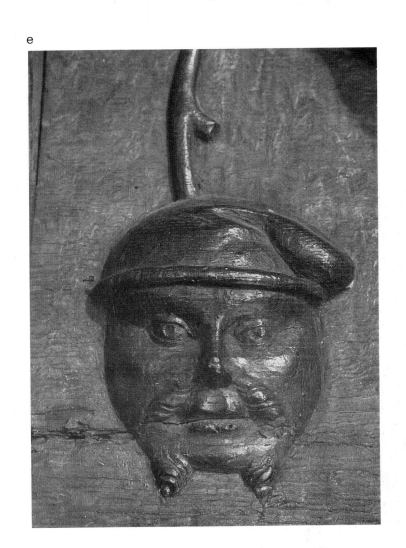

f

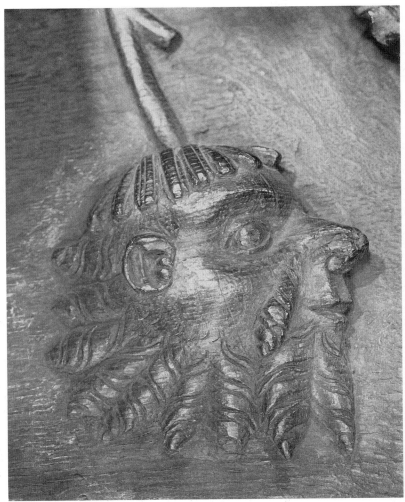

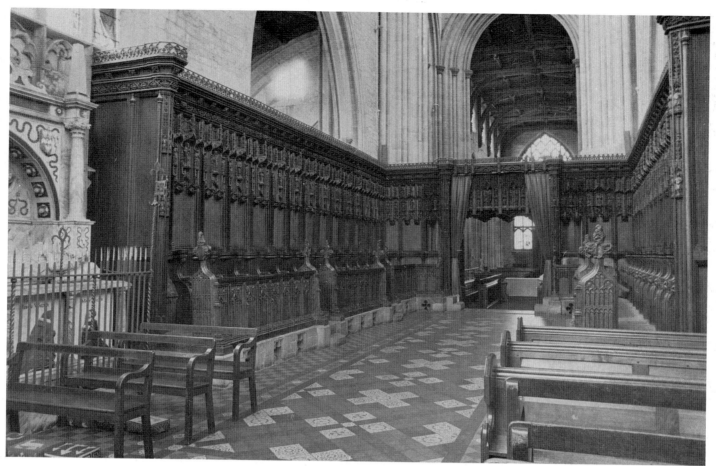

26. *St Laurence, Ludlow. General View of choir-stalls from N.E.*

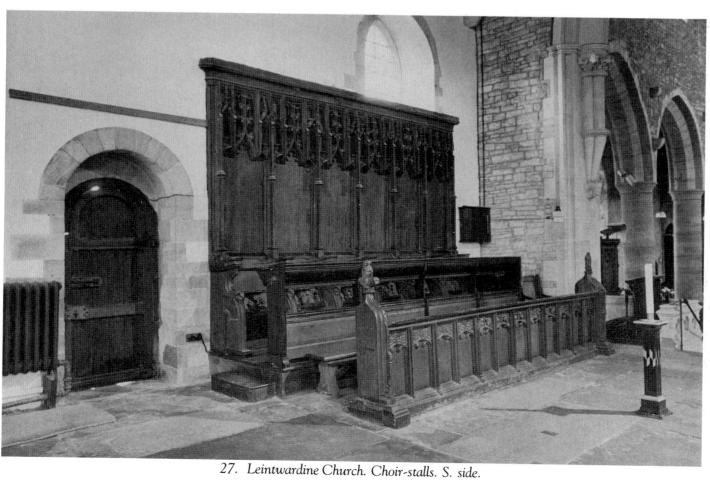

27. *Leintwardine Church. Choir-stalls. S. side.*

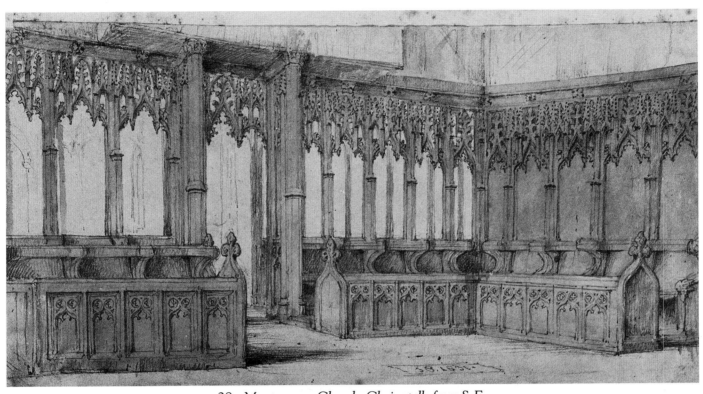

28. Montgomery Church. Choir-stalls from S.E.
Watercolour drawing by John Parker, 1831 (National Library of Wales).

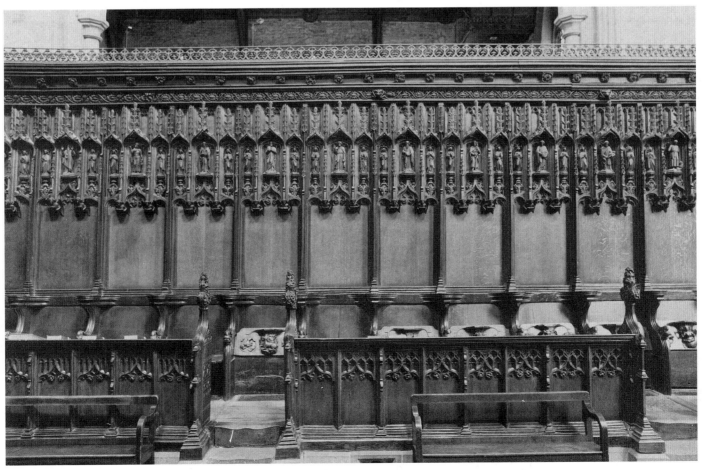

29. St Laurence, Ludlow. Choir-stalls. N. side. Detail.

30. St Laurence, Ludlow.
View of choir-stalls from the W.
Lithograph by I. Shaw,
c. 1850.

31. St Laurence, Ludlow. E. end of N. lateral choir-stalls.
Junction of seat standard and terminal wing screen.

32. St Laurence, Ludlow. W. face of choir screen. Detail of tracery
head on panelling.

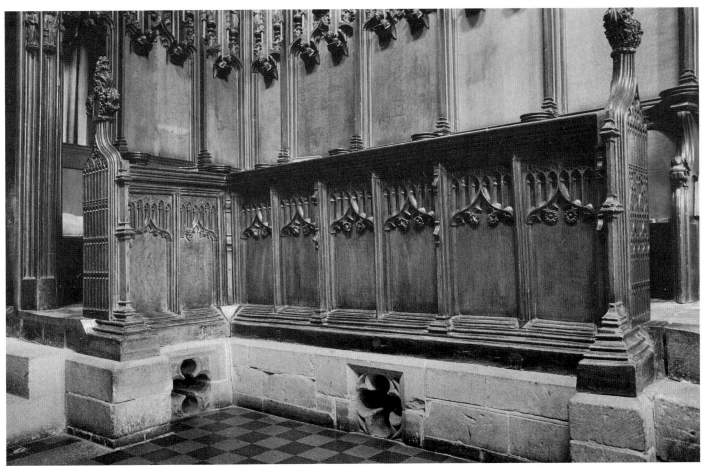

33. *St Laurence, Ludlow. Choir-stalls. Desking on N.W. side. Detail.*

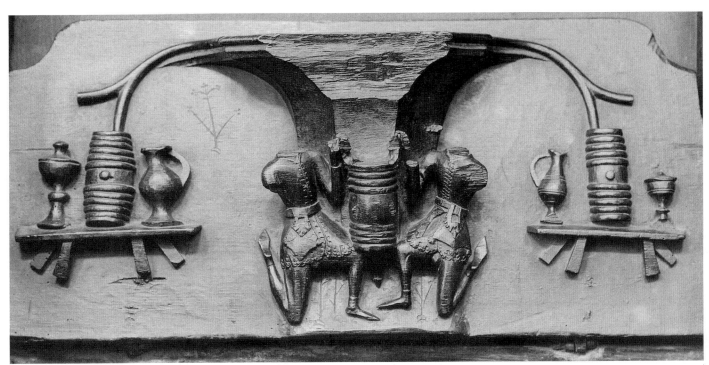

34. *St Laurence, Ludlow. Misericord carved with 'worshipping the beer barrel' subject and uprooted-plant motif 'signature' (S.11)*
(Royal Commission on the Historical Monuments of England).

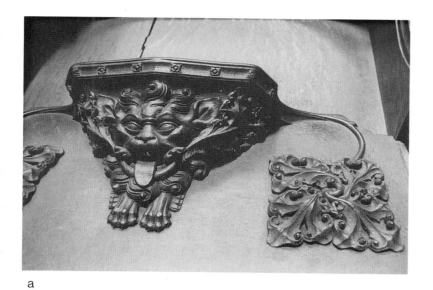

a

35. *Choir-stall foliage misericord supporters from (a)–(b) Lincoln; (c)–(d) St Laurence, Ludlow (N.5 & S.9 from uprooted-plant series).*

b

c

d

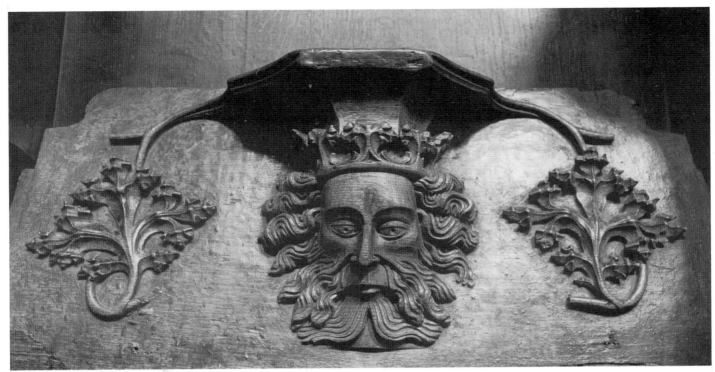

36. *St Laurence, Ludlow. Misericord with crowned head (N. 11).*

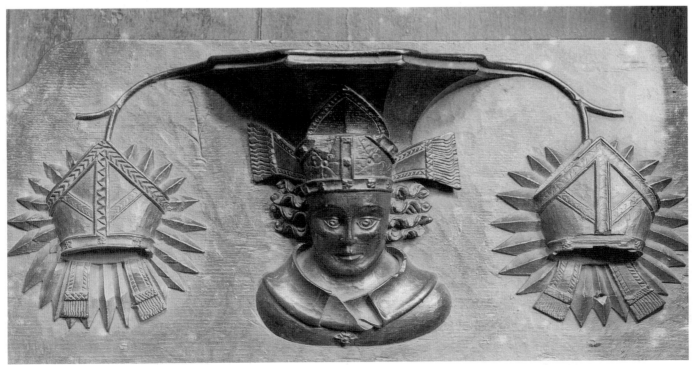

37. *St Laurence, Ludlow. Misericord with bishop's head and mitre from 'signed' group*
(N. 7) (Royal Commission on the Historical Monuments of England. Copyright Batsford).

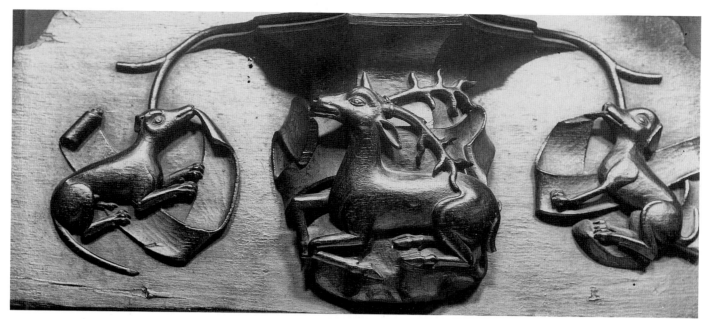

38. *St Laurence, Ludlow. Misericord with stag and hounds (N. 10)*
(Conway Library, Courtauld Institute of Art. Copyright Canon M. H. Ridgway).

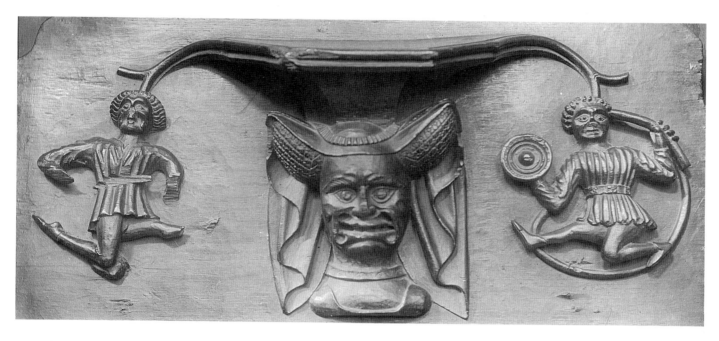

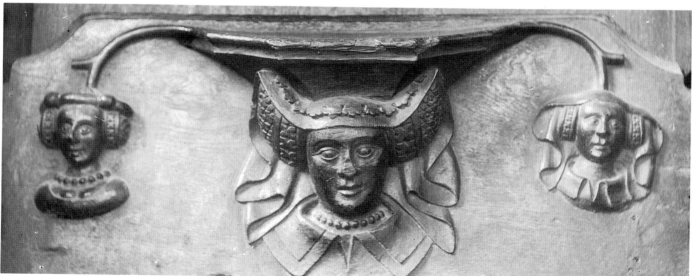

39a & b. *St Laurence, Ludlow and Tansor Church, Northants. Misericords displaying hennin and bunned head-dresses*
(Royal Commission on the Historical Monuments of England).

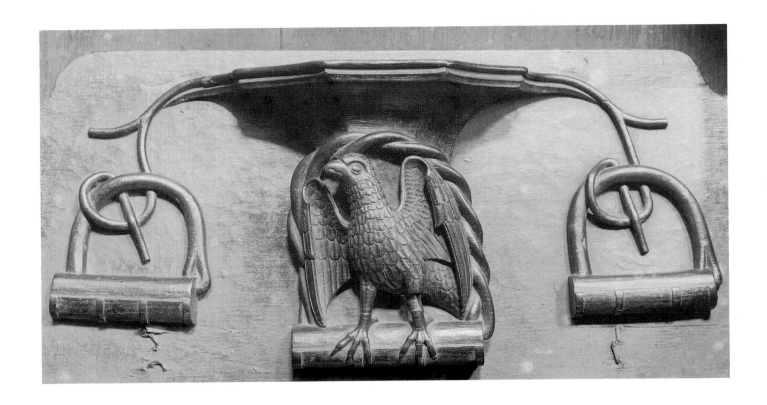

40a & b. St Laurence, Ludlow and Tansor Church, Northants.
Misericords displaying falcon and fetterlock
(Royal Commission on the Historical Monuments of England.
40a. Copyright Batsford).

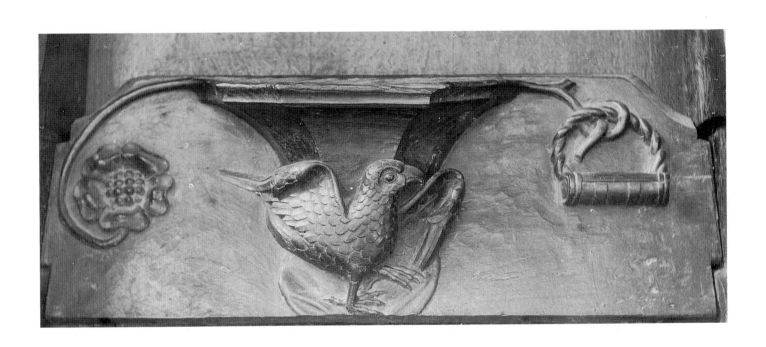

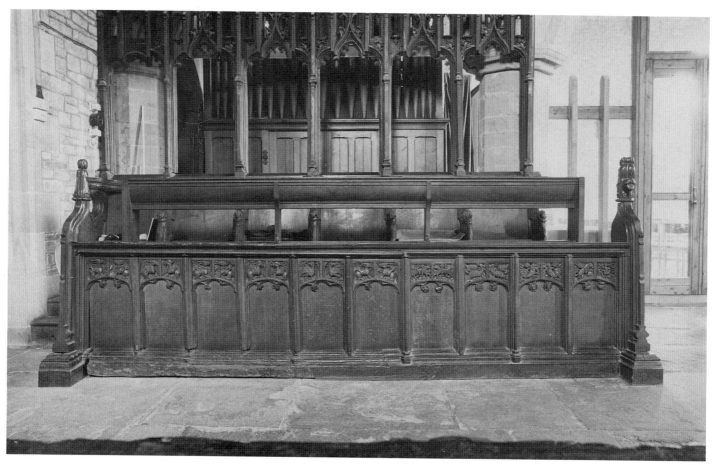

41. Leintwardine Church. Choir-stalls on N. side of chancel.

42. Leintwardine Church. Tripartite choir-stall canopy with statue niches.

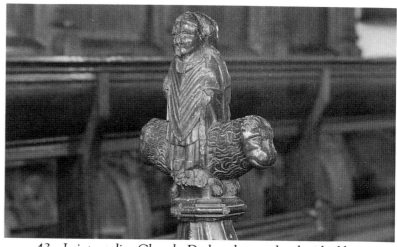

43. Leintwardine Church. Desk end poppy head with abbot and addorsed sheep.

a

b

c

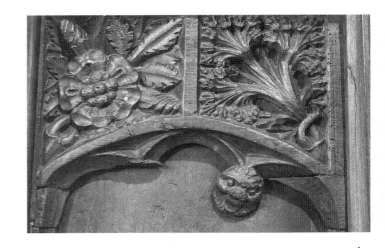

d

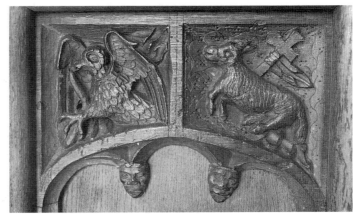

e

f

44. *Leintwardine and Montgomery Churches. (a)–(b) Choir-stall canopywork. Details;*
(c)–(d) Leintwardine and (e)–(f) Montgomery stall desk sculptured panel heads.

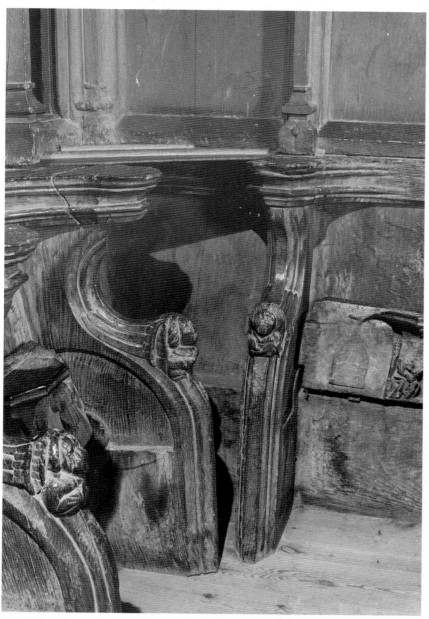

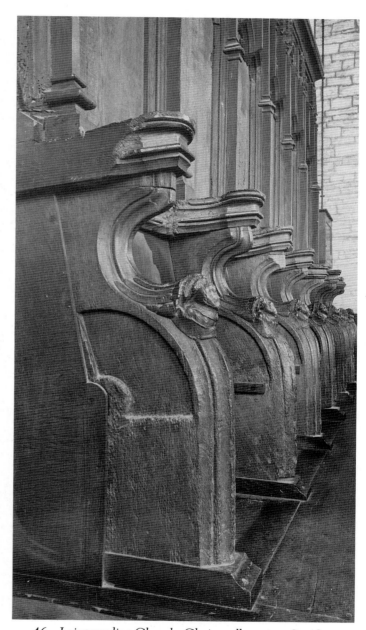

45. Montgomery Church. Junction of choir-stalls in N.W. corner.

46. Leintwardine Church. Choir-stall seating. S. side.

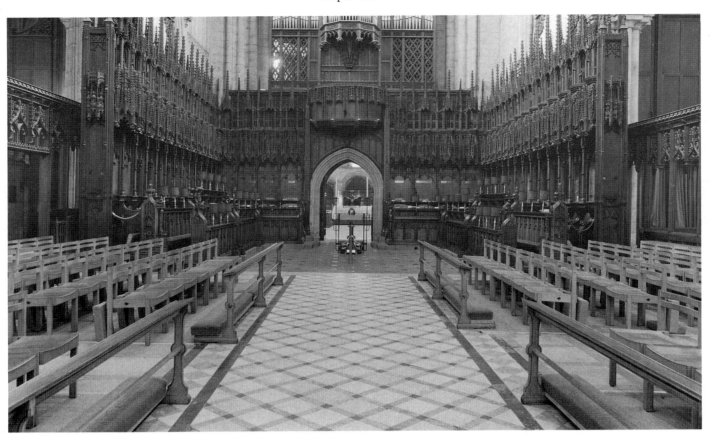

47. Ripon Minster. *View of choir-stalls from E.*

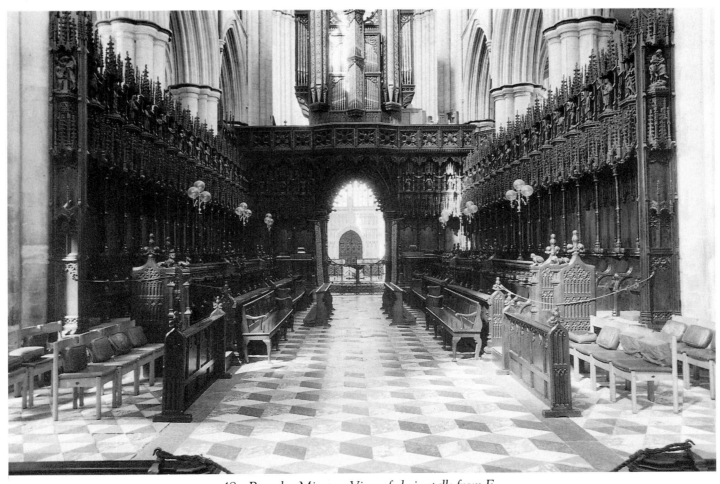

48. Beverley Minster. *View of choir-stalls from E.*

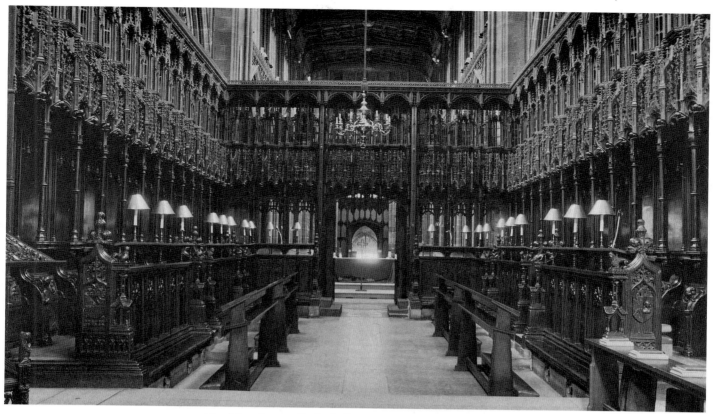

49. *Manchester Cathedral. View of choir-stalls from E.*

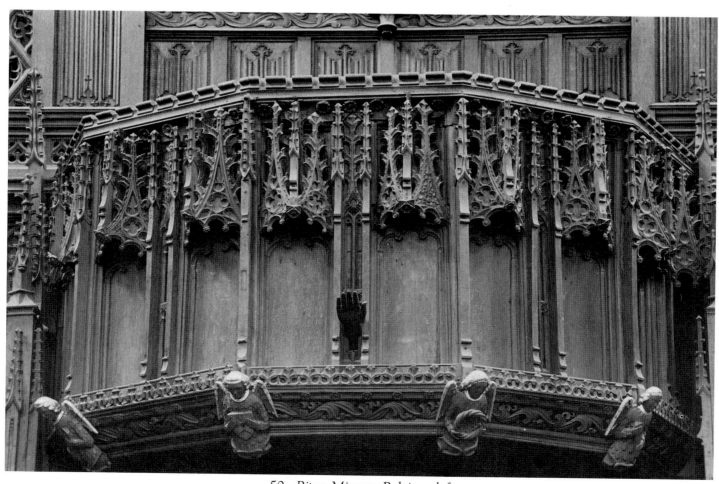

50. *Ripon Minster. Pulpitum loft.*

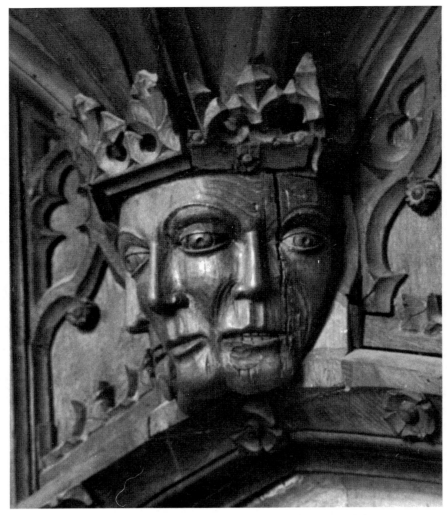

51. *Ripon Minster. Triple-head corbel on pulpitum loft.*

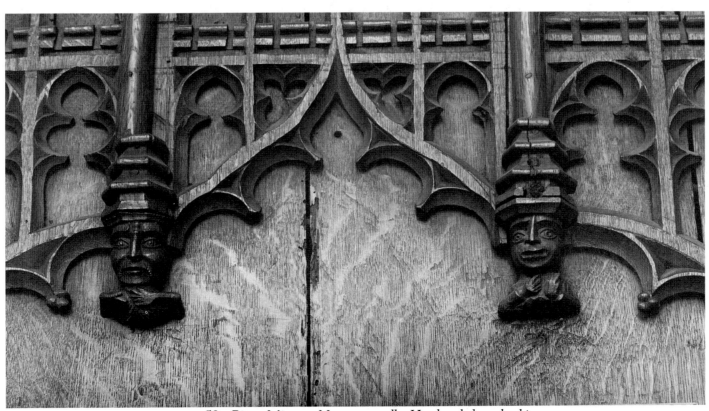

52. *Ripon Minster. N. return stalls. Head corbels on backing.*

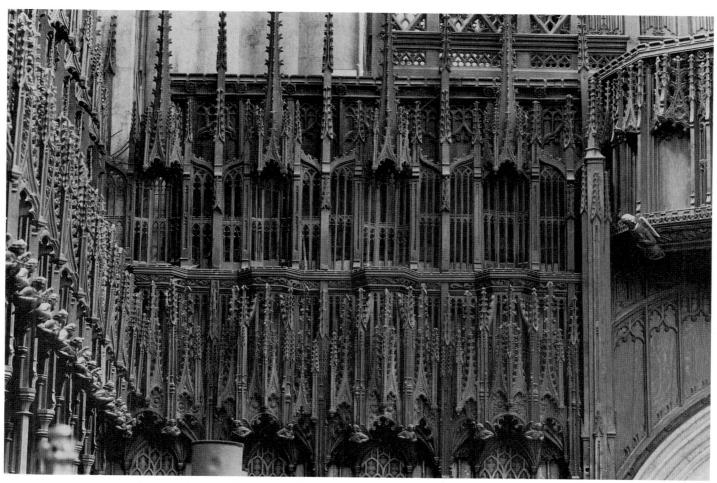

53. *Ripon Minster. S. return stalls canopywork.*

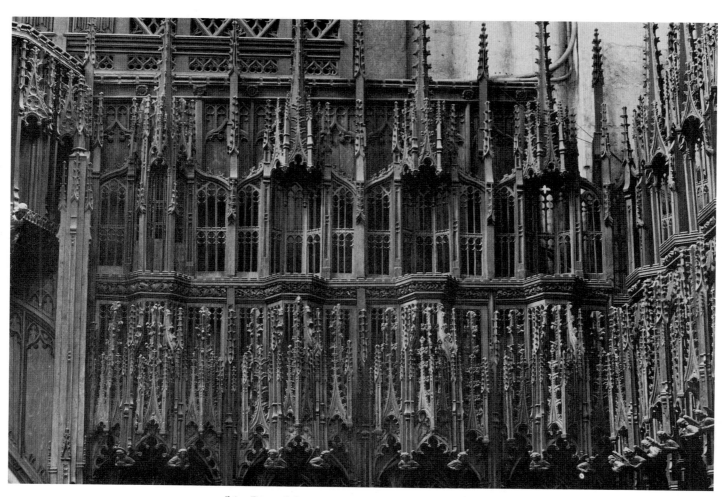

54. *Ripon Minster. N. return stalls canopywork.*

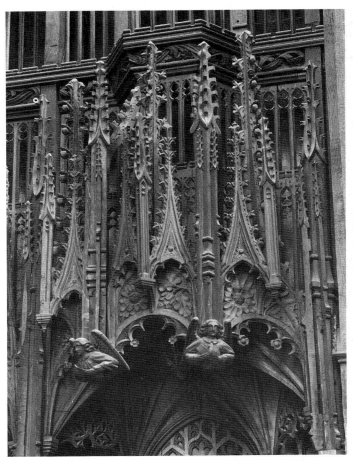

55. *Ripon Minster. S. return stalls. Lower canopy decoration.*

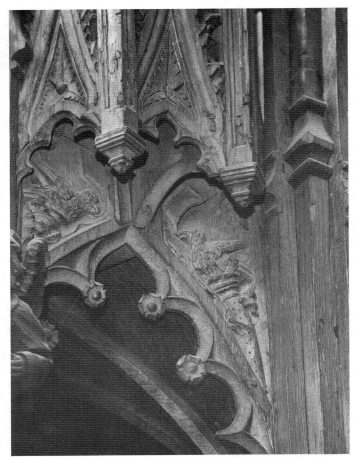

56. *Ripon Minster. N. return stalls. Lower canopy decoration.*

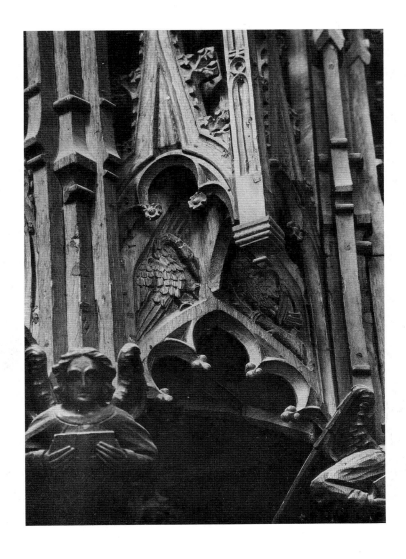

57. *Ripon Minster. N. return stalls. Lower canopy detail. Gablet with semi-circular arch.*

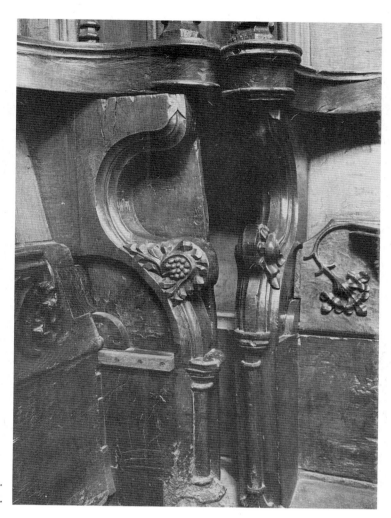

58. *Ripon Minster. Junction of N. return and N. lateral stall seats.*

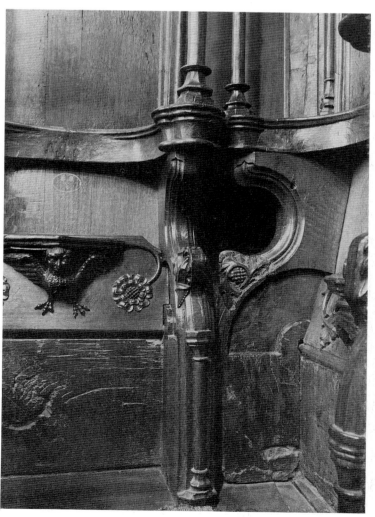

59. *Ripon Minster. Junction of S. return and S. lateral stall seats.*

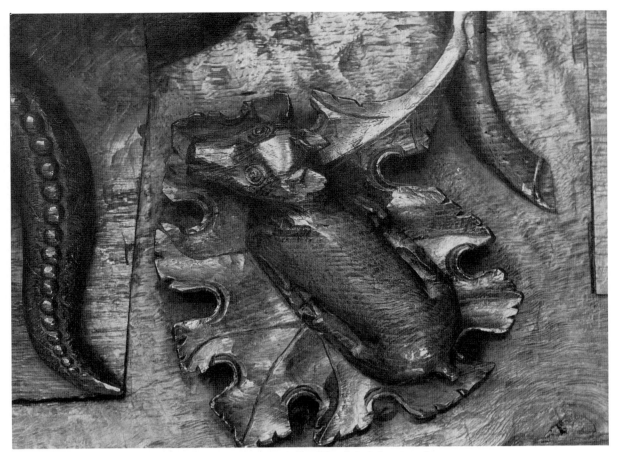

60. *Ripon Minster. N. return stalls. Hand A. Misericord supporter.*

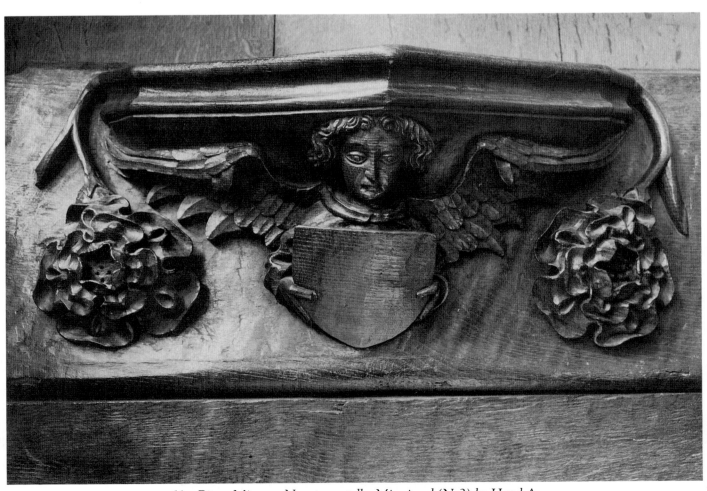

61. *Ripon Minster. N. return stalls. Misericord (N.3) by Hand A.*

a

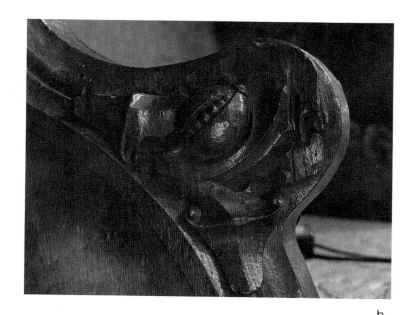

b

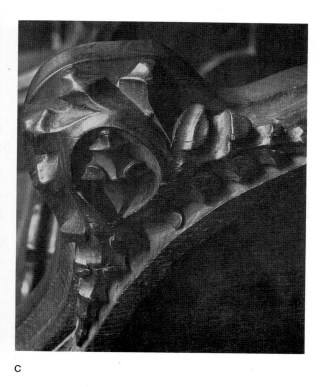

c

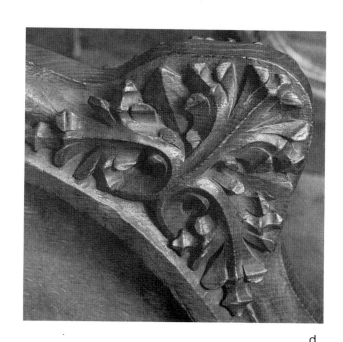

d

e

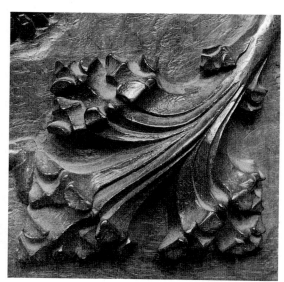

f

62. *Ripon Minster. S. return and lateral stalls.*
(a)–(d) Seat elbows; (e)–(f) Misericord supporters (Hand B).

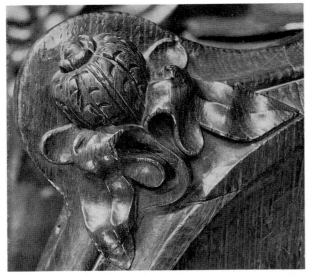

a

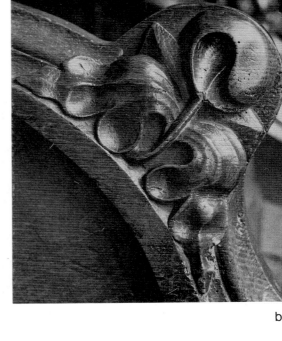

b

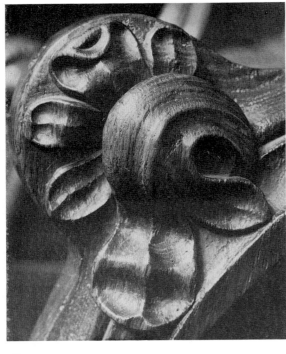

c

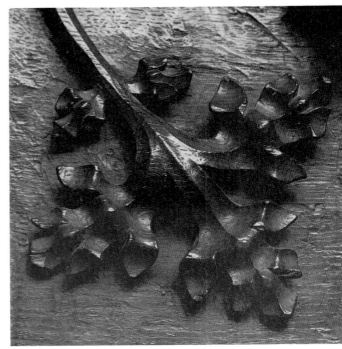

d

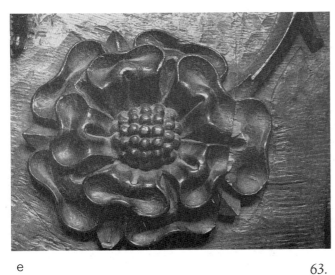

e

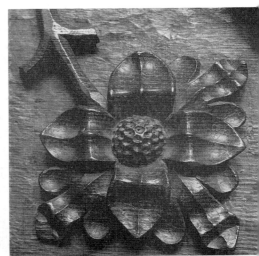

f

63. *Ripon Minster. N. lateral stalls.*
(a)–(c) Seat elbows; (d)–(f) Misericord supporters (Hand C).

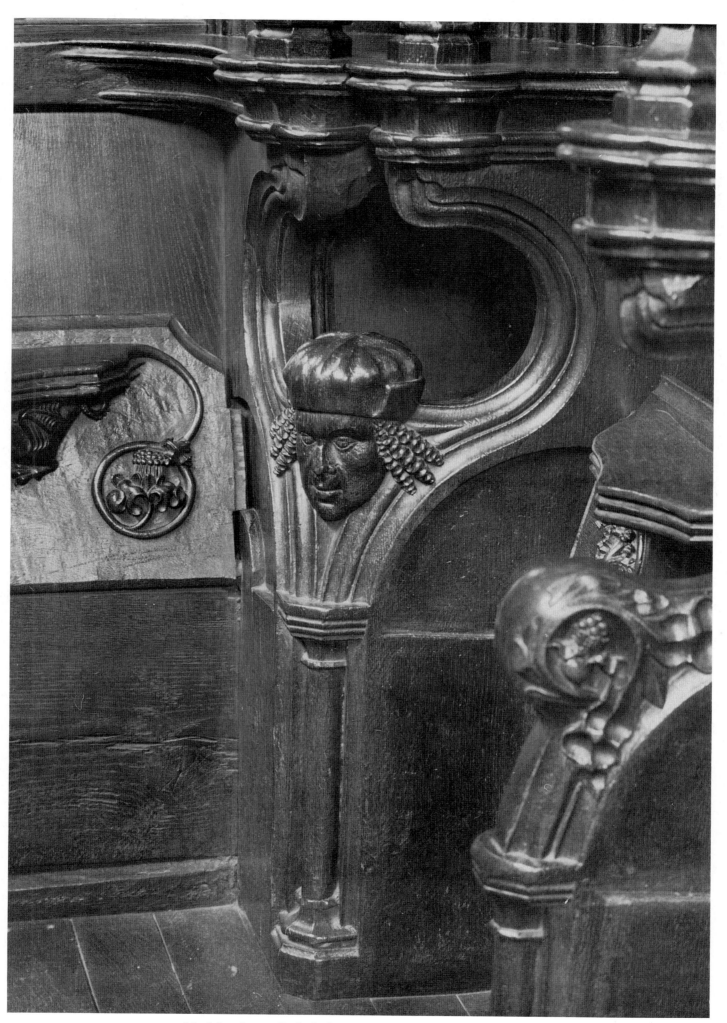

64. *Manchester Cathedral. Seat junction in north-west corner.*

a

b

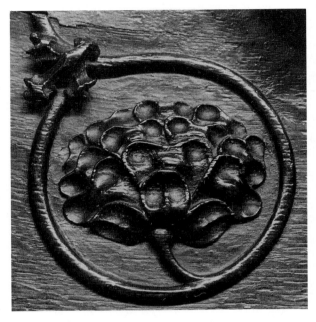

c

d

e

f

65. *Manchester Cathedral. (a)–(b) Seat standard elbows. (c)–(f) Misericord supporters.*

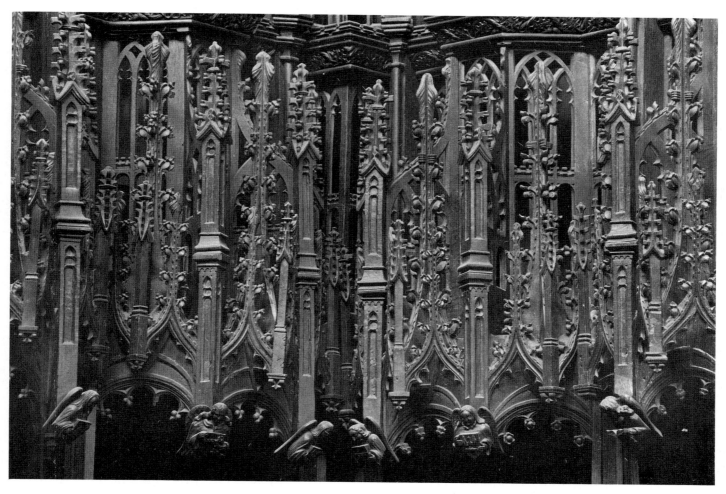

66. *Manchester Cathedral. Lower choir-stall canopies. Detail.*

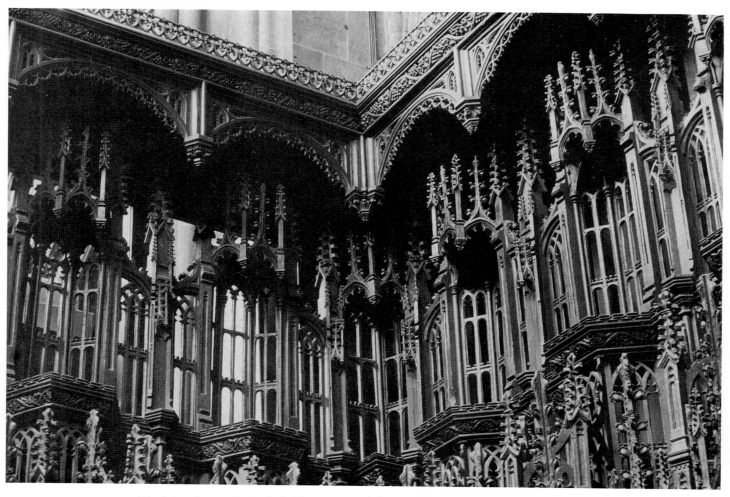

67. *Manchester Cathedral. Upper zone of choir-stall canopywork. N.W. corner.*

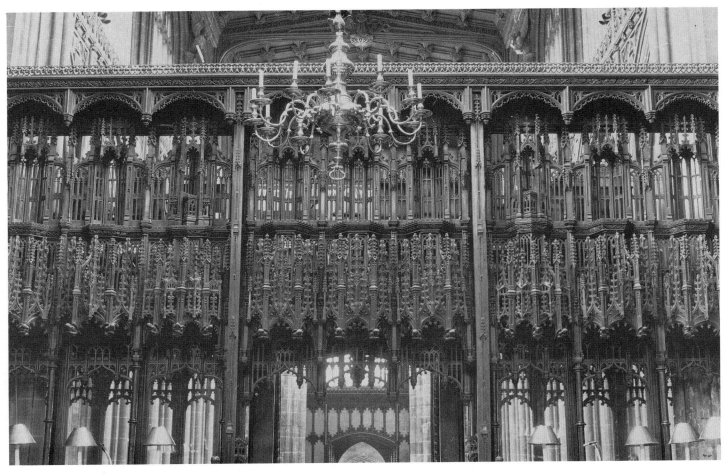

68. *Manchester Cathedral. Canopywork of return stalls (the centre bay is a 19th c. reconstruction).*

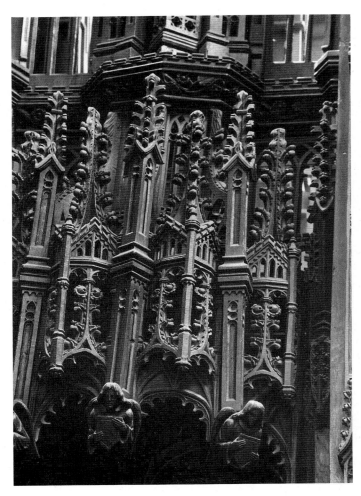

69. *Manchester Cathedral. Dean's stall lower canopy. Detail.*

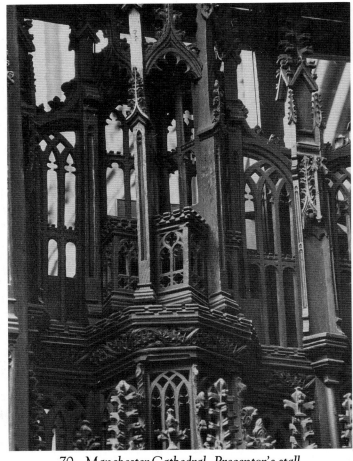

70. *Manchester Cathedral. Precentor's stall. Upper canopy. Detail.*

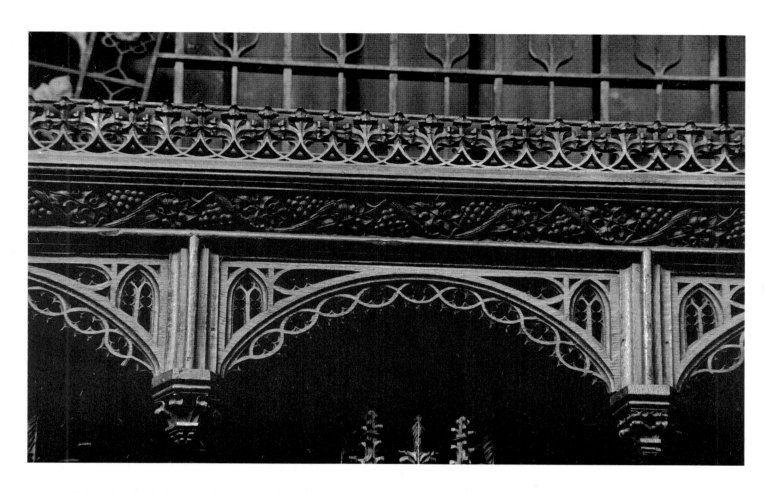

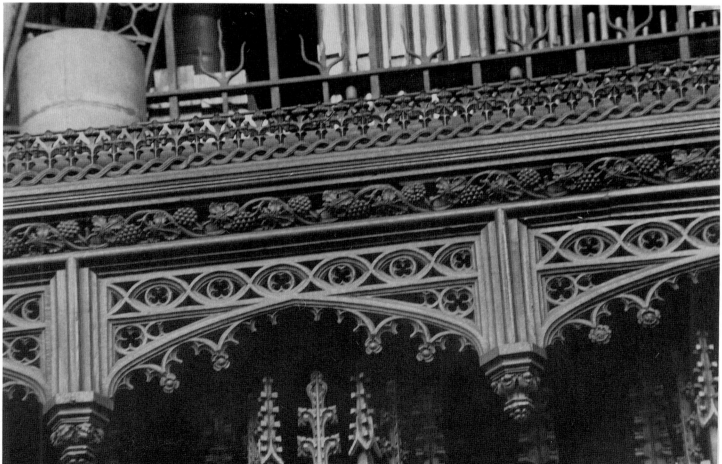

71a & b. Manchester Cathedral. Stall canopywork tester. N. and S. sides. Details.

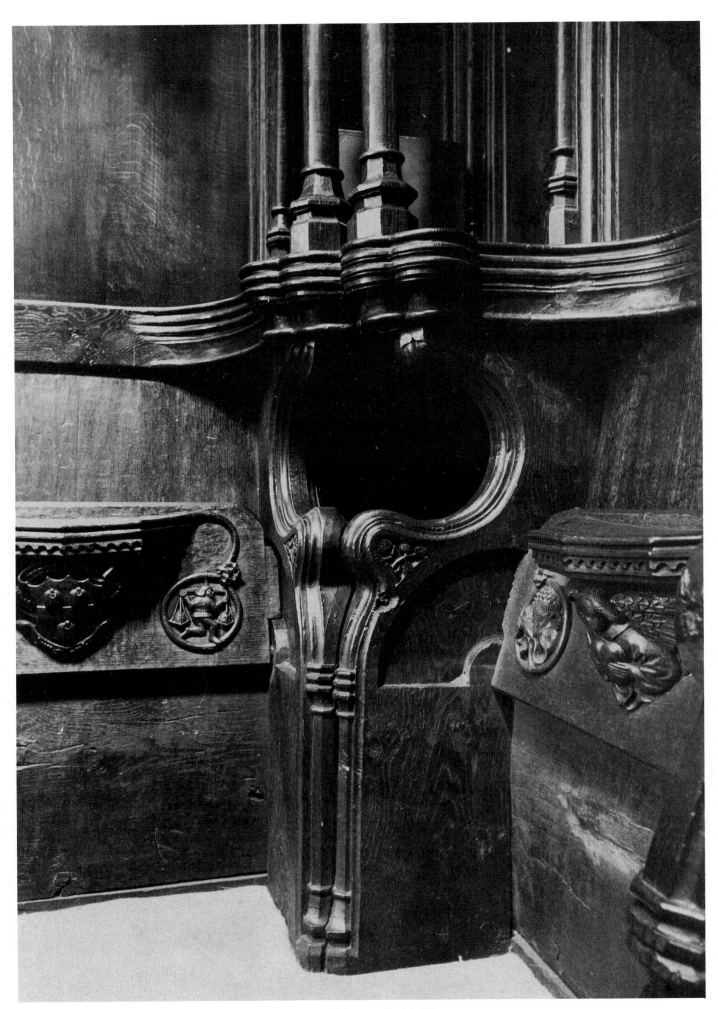

72. Beverley Minster. Choir-stalls. N.W. corner junction.

a

b

c

d

73a–d. Beverley Minster. Misericord supporters.

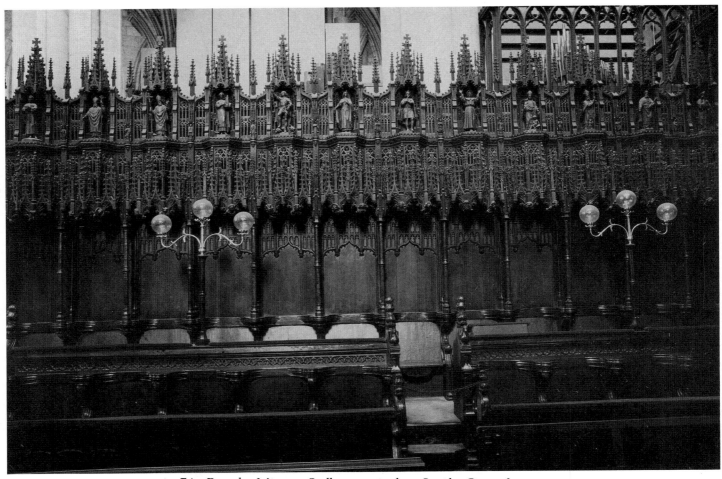

74. *Beverley Minster. Stall canopywork on S. side. General view.*

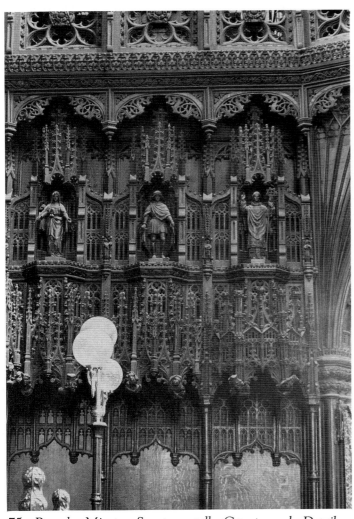

75. *Beverley Minster. S. return stalls. Canopywork. Detail.*

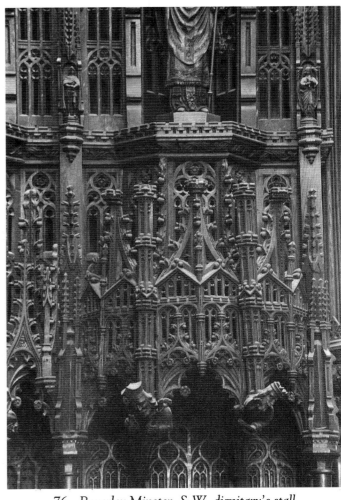

76. *Beverley Minster. S.W. dignitary's stall. Lower canopy. Detail.*

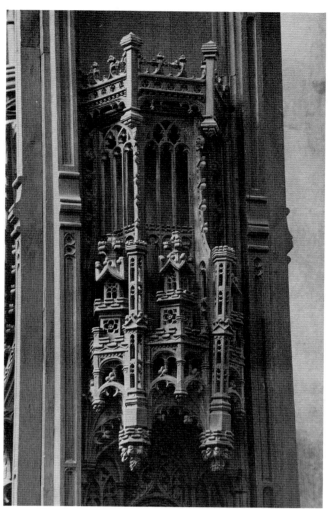

77. Ripon Minster. N.E. wing screen canopy.

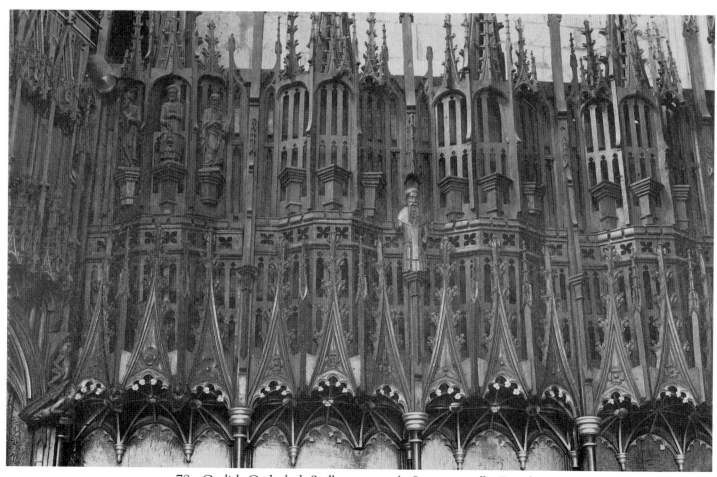

78. Carlisle Cathedral. Stall canopywork. S. return stalls. Detail.

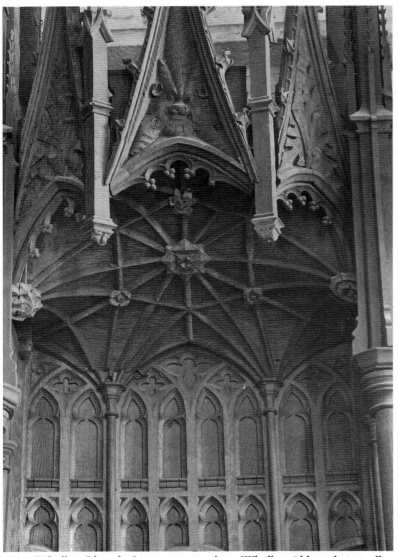

79. *Whalley Church. Lower canopy from Whalley Abbey choir-stalls.*

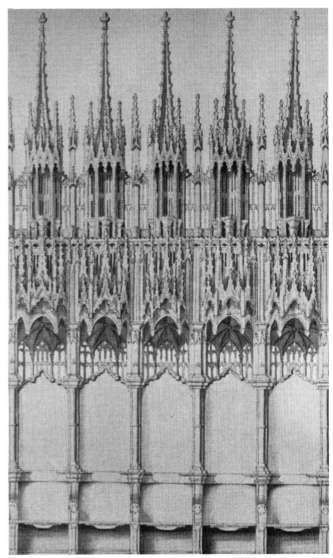

80. *York Minster. View of choir-stalls.*
Watercolour drawing by Joseph Halfpenny, 1796
(J. B. Morrel, Woodwork in York,
London: Batsford, 1950, Frontispiece.
Copyright Batsford).

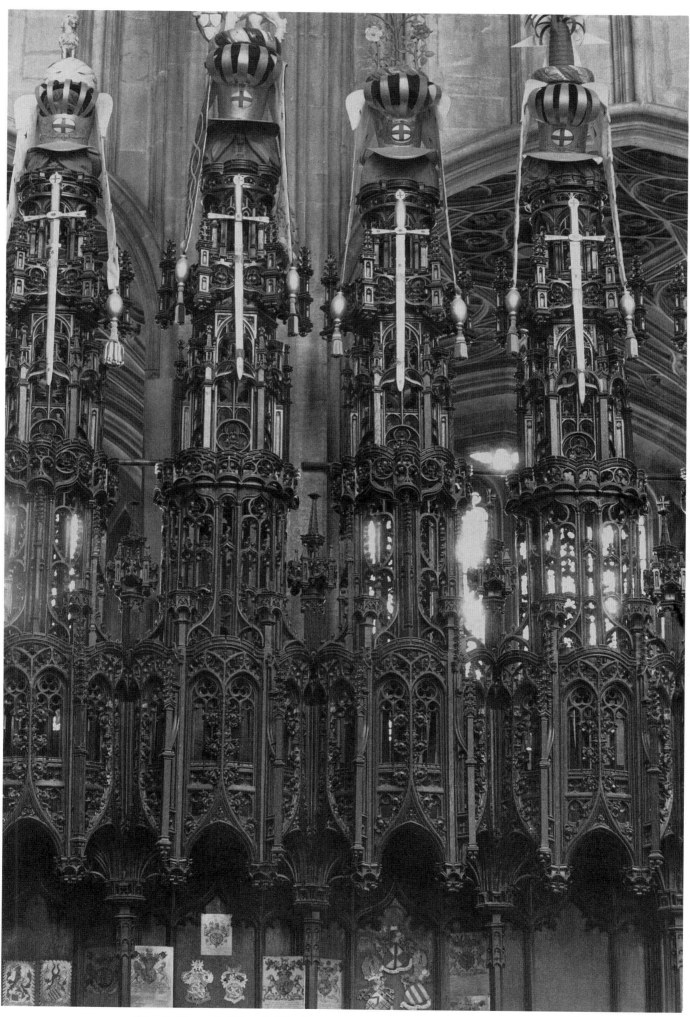

81. St George's Chapel, Windsor. Lateral choir-stall superstructure. Detail.

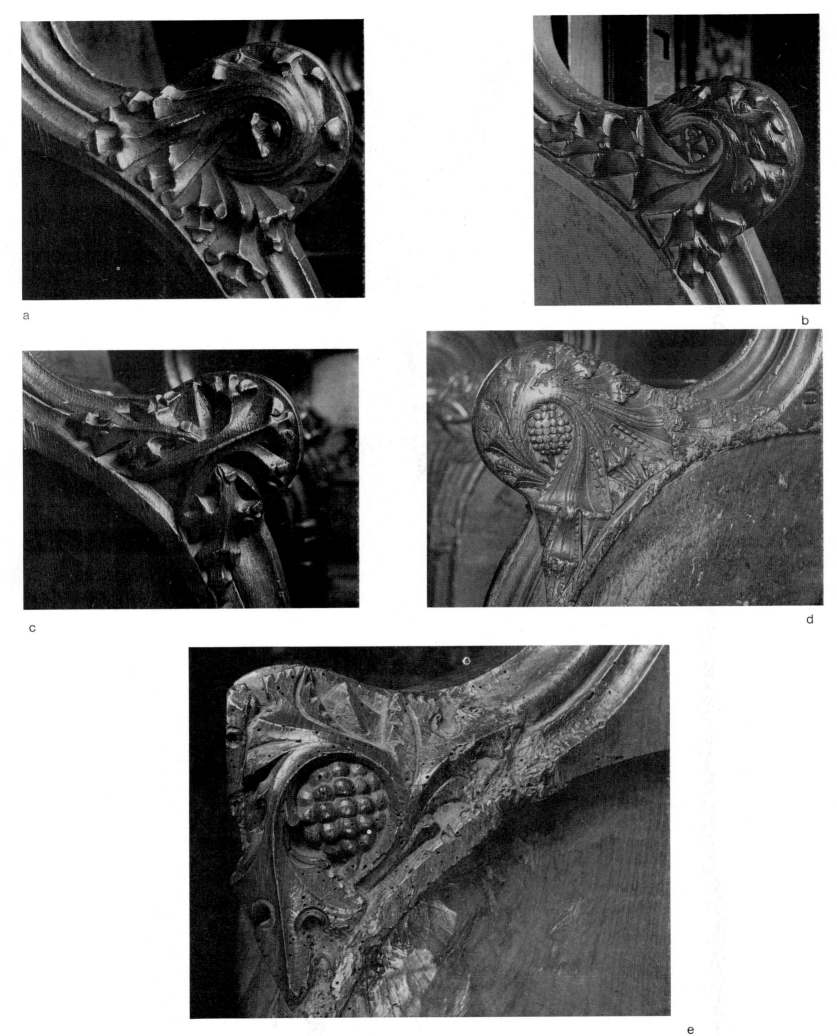

82a–c. *Carlisle, Cartmel and Ripon. (a)–(c) Hawthorn and (d)–(e) Cartmel and Ripon vine foliage seat elbows.*

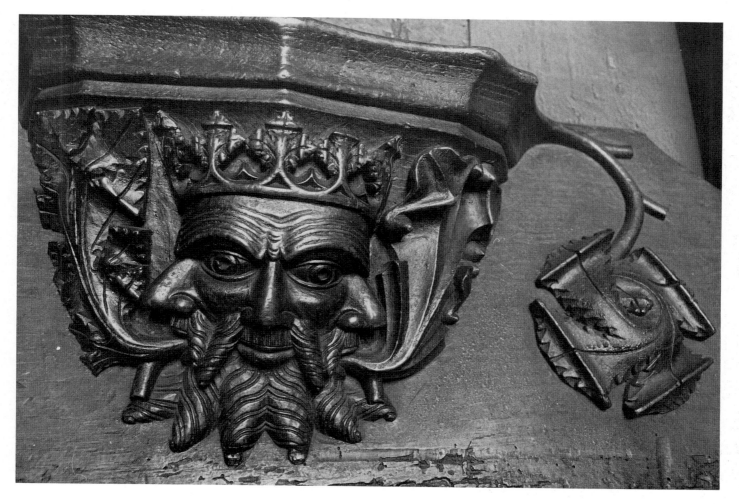

83. *Cartmel Priory. Triple-face misericord.*

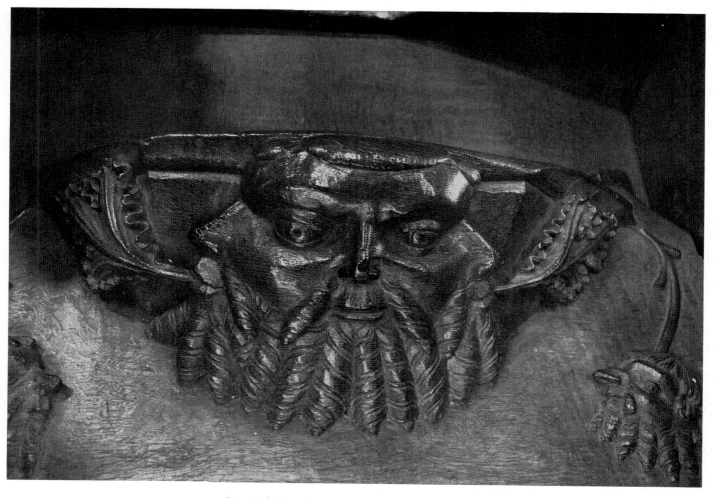

84. *Whalley Church. Triple-face misericord.*

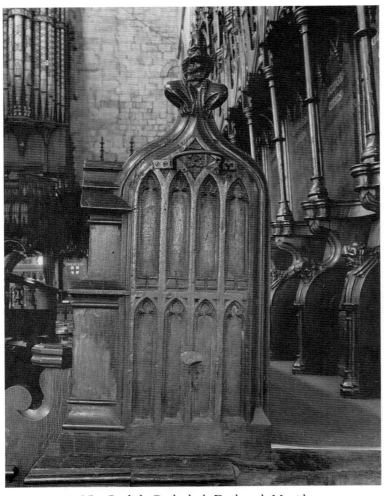

85. *Carlisle Cathedral. Desk end. N. side.*

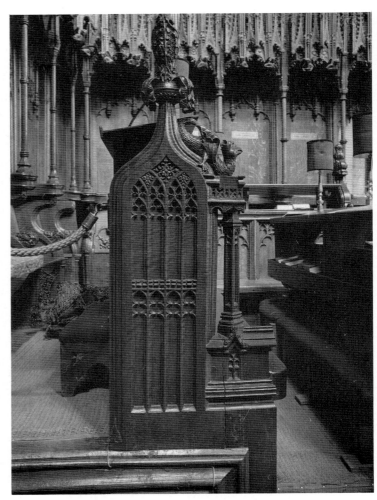

86. *Ripon Minster. Desk end of S.W. dignitary's stall.*

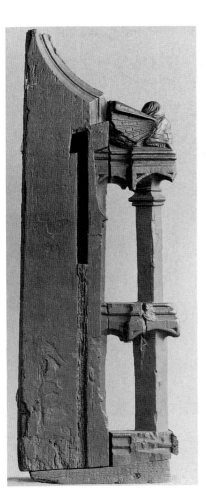

87. *V & A Museum.*
Bench end from St Nicholas, King's Lynn
(Copyright V & A Museum.
Acq. No. W. 9–1916).

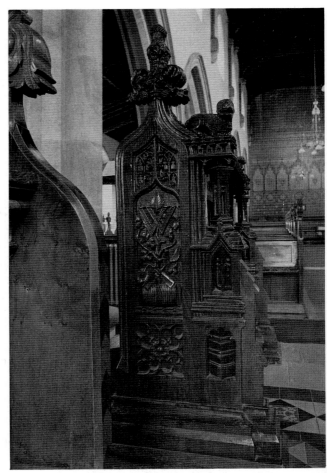

88. *Aysgarth Church, Yorks. Heslington desk end from*
Jervaulx Abbey.

a

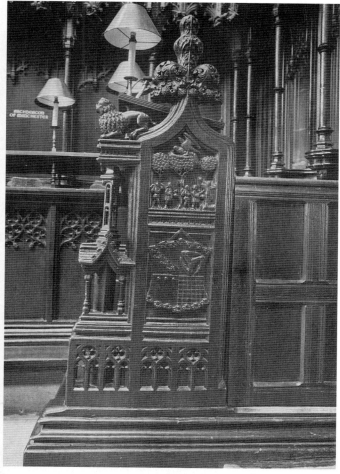

b

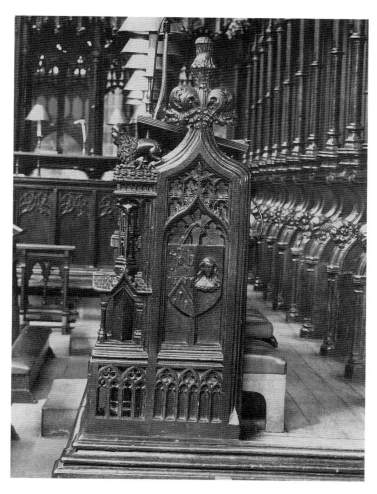

c

89a–c. Ripon Minster. (a) Hand C foliage misericord with leaf 'tie';
(b)–(c) Manchester Cathedral. Choir-stalls. Stanley and Beswicke desk ends.

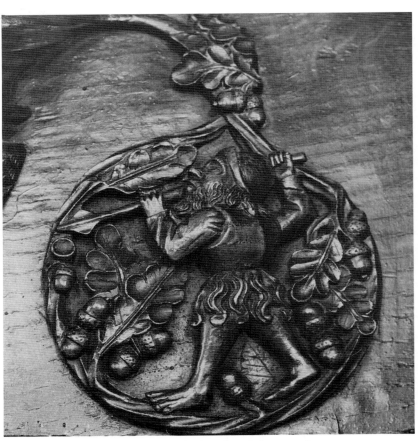

90. *St George's Chapel, Windsor. Misericord supporter.*

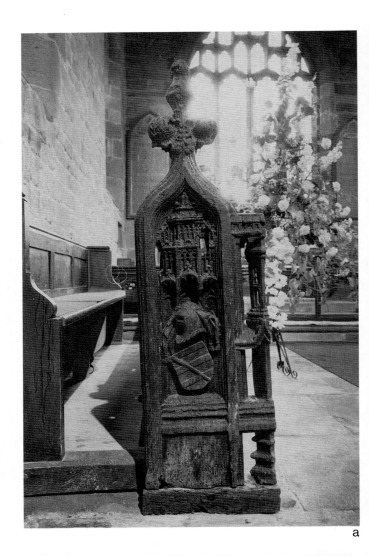

a

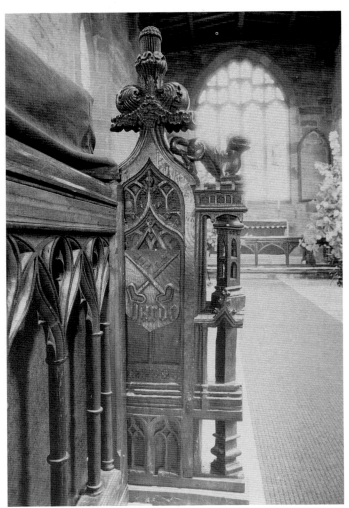

b

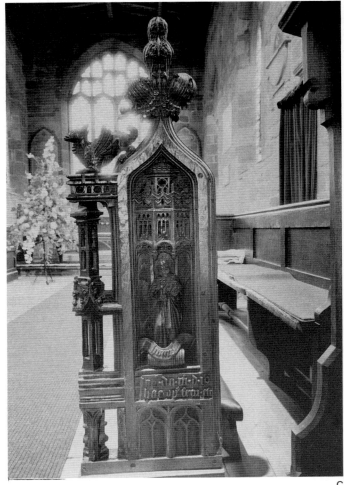

c

91a–c. Leake Church, Yorks. Gaunt, Hardy and Hompton desk ends.

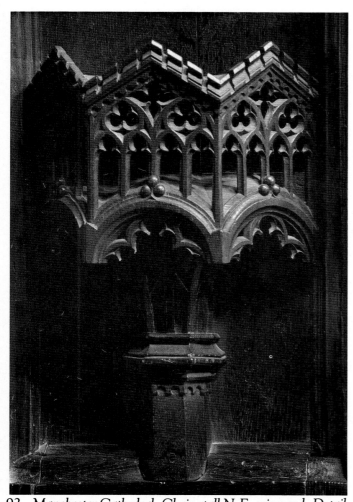

92. *Manchester Cathedral. Choir-stall N.E. wing end. Detail.*

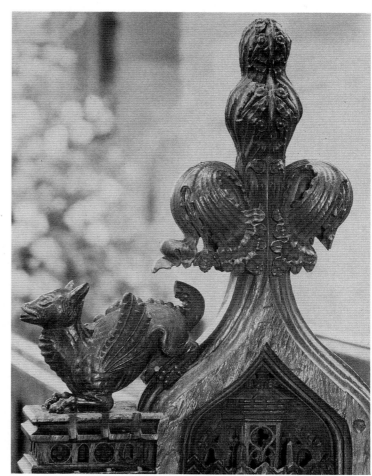

93. *Leake Church, Yorks. Hompton desk end.*
Poppy head and cresting.

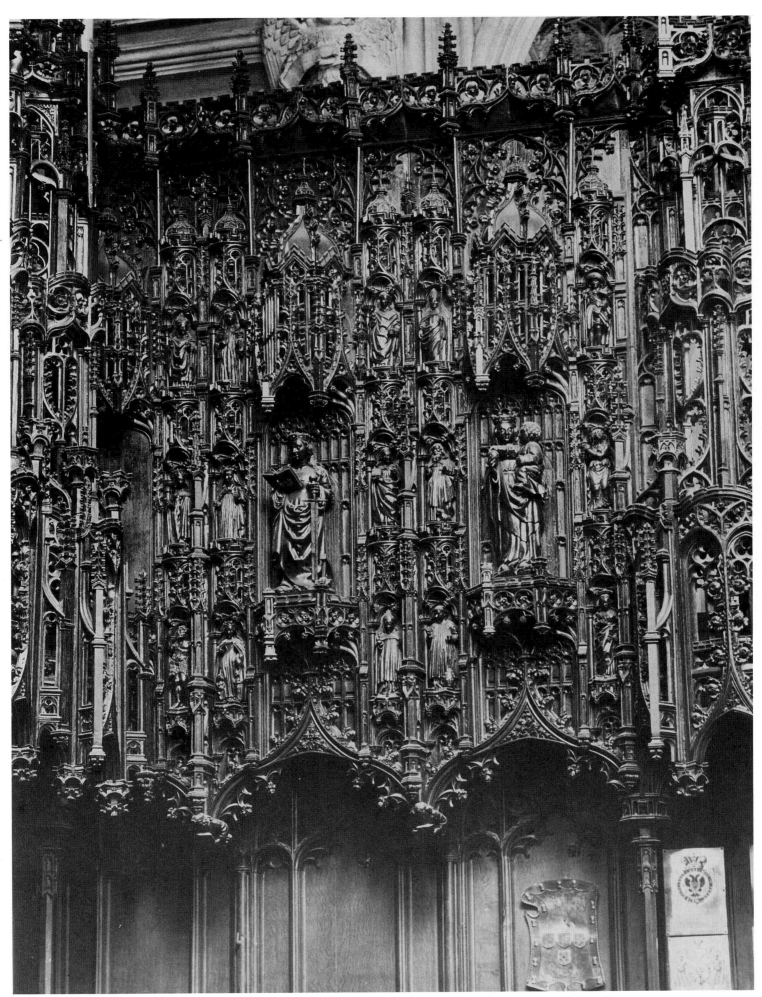

94. *St George's Chapel, Windsor. Choir-stall canopywork screen in N.W. corner.*

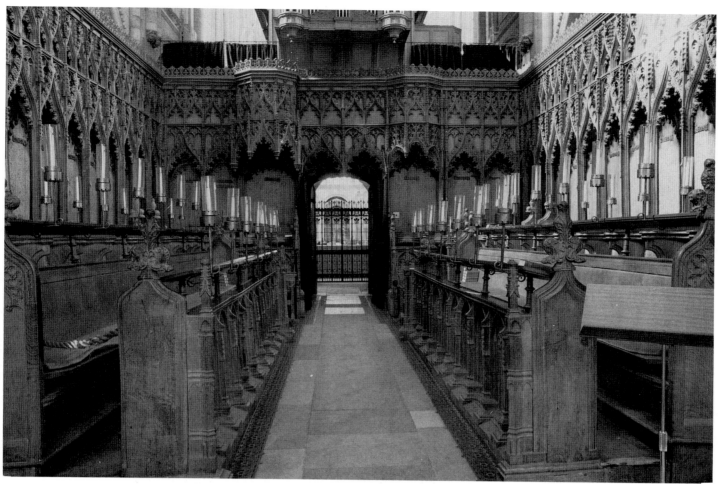

95. *Norwich Cathedral. General view of choir-stalls from E.*

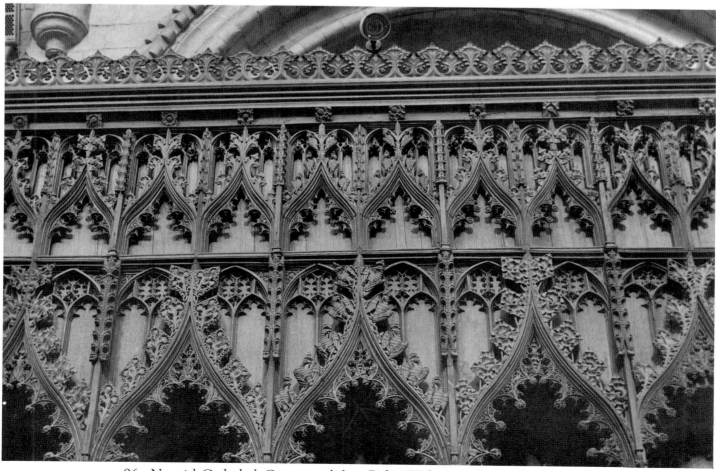

96. *Norwich Cathedral. Canopywork from Bishop Wakering's choir-stalls. Detail.*

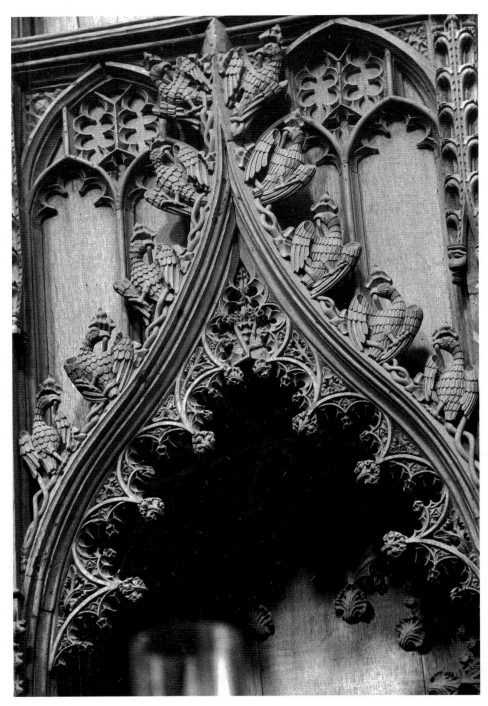

97. Norwich Cathedral. Choir-stall canopy with bird crockets.

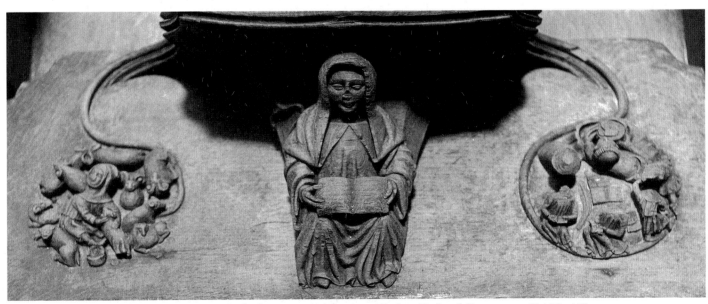

98. Norwich Cathedral. Misericord depicting Bishop Richard Courtenay (1413–15) (S.6) (Royal Commission on the Historical Monuments of England).

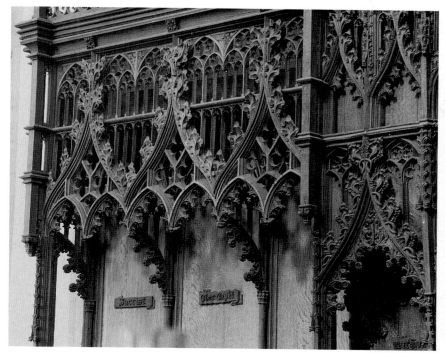

99. *Norwich Cathedral. E. end of S. lateral choir-stalls,
showing junction of canopywork of first two campaigns.*

100a & b. *Norwich Cathedral. S.W. junction of choir-stalls (first building
phase) and loose seating in presbytery (second phase).*

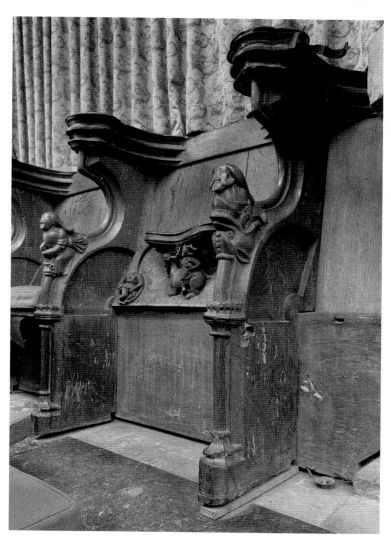

c

100c & d. Norwich Cathedral.
'Rose-bush' misericord from first and 'Green Man' misericord from second phase.

d

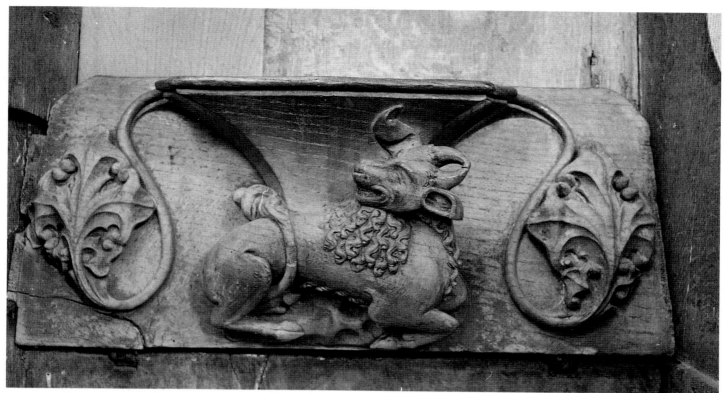

101. Norwich Cathedral. Choir-stall Taurus misericord (S.29) from post 1509 renovation, probably of early 15th c. date.

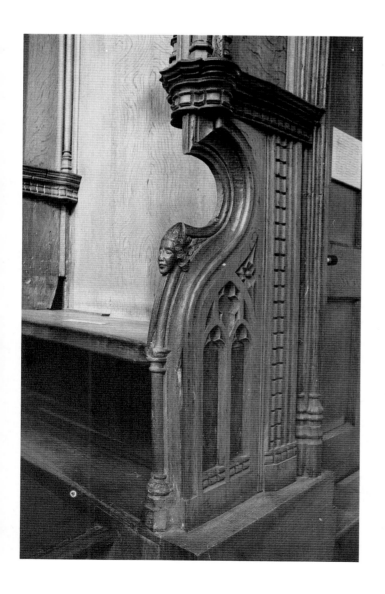

102a & b. Norwich Cathedral. Seat standard of dean's stall (tracery panel is modern) and misericord now in precentor's seat (N.19). Possibly from former Lady Chapel.

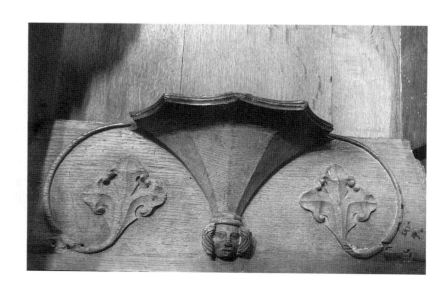

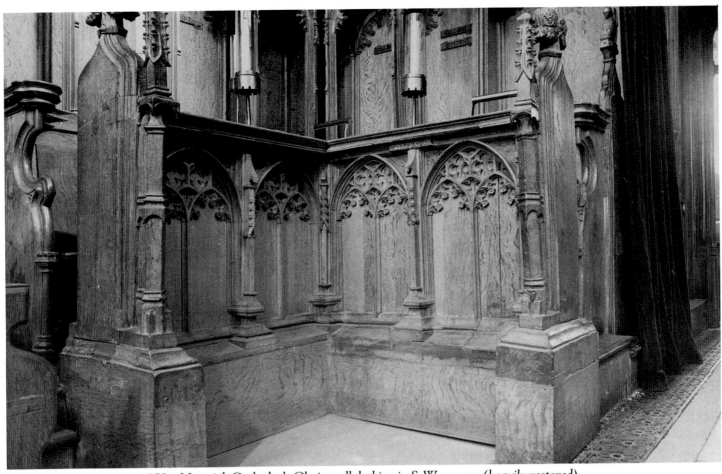

103. *Norwich Cathedral. Choir-stall desking in S.W. corner (heavily restored).*

104. *Norwich Cathedral. Drawing of the return choir-stalls. c. 1830. From a book in the Deanery* (Friends of
the Cathedral Church of Norwich. 9th Annual Report, 1938, *facing* 9).

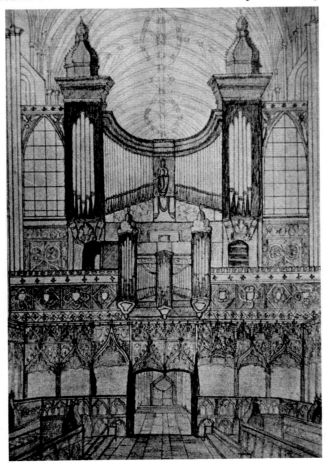

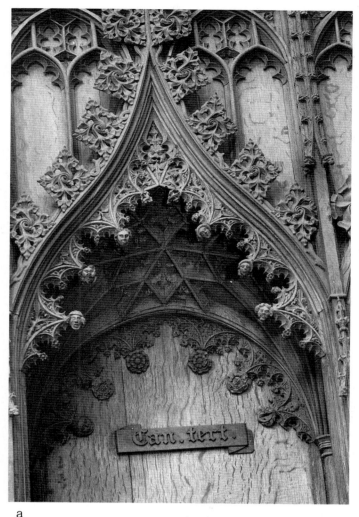

a

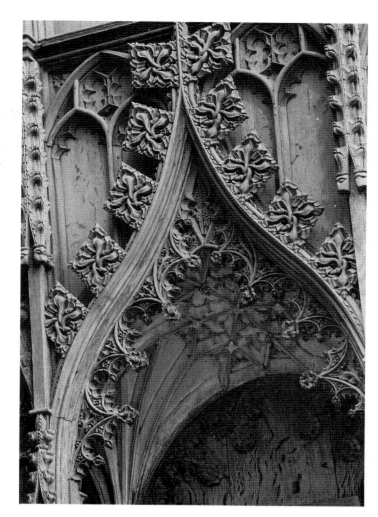

b

105a–d. Norwich Cathedral. Lower canopy gables from Bishop Wakering's choir-stalls.

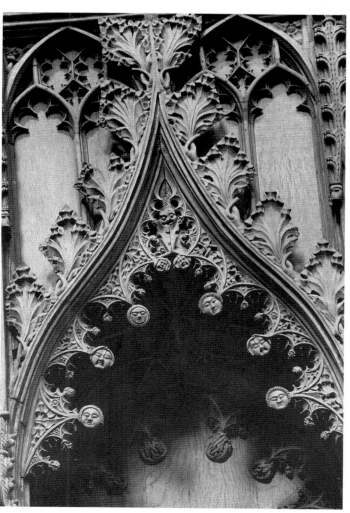

c

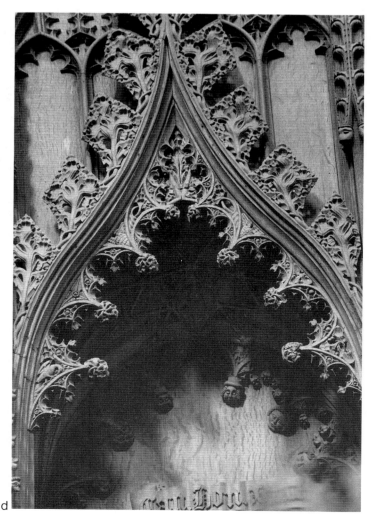

d

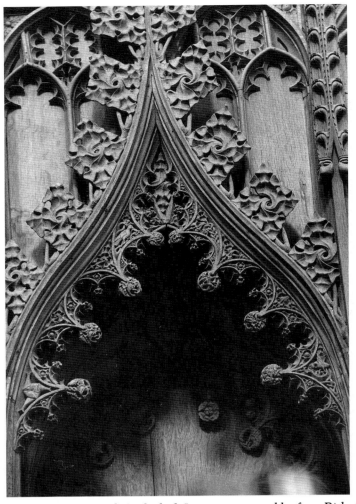
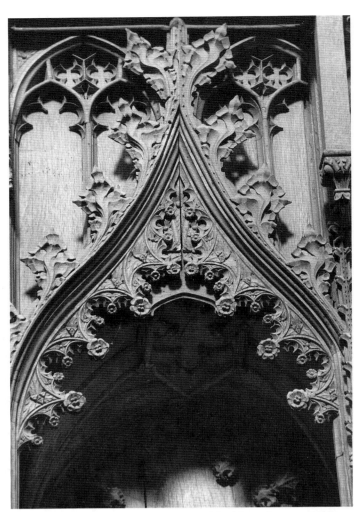

e f

105e–f. *Norwich Cathedral. Lower canopy gables from Bishop Wakering's choir-stalls. Note inserted vault from second building phase in 105f.*

106. *Norwich Cathedral. Gable from upper zone of Bishop Wakering's choir-stalls.*

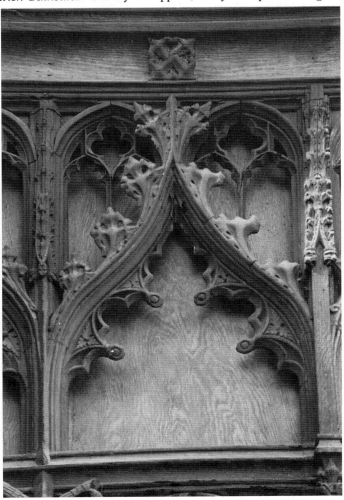

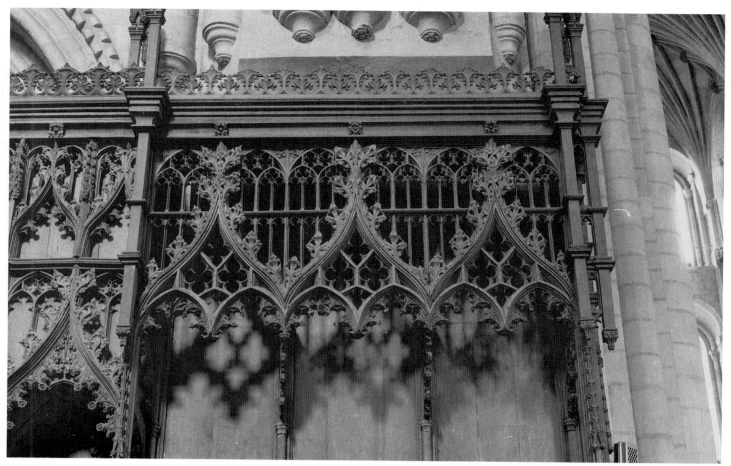

107. *Norwich Cathedral. Choir-stall canopywork from Bishop Goldwell phase.*

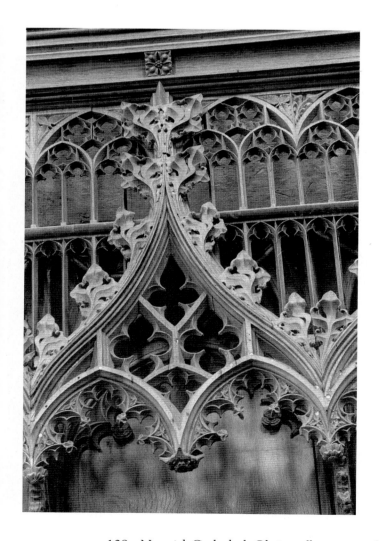

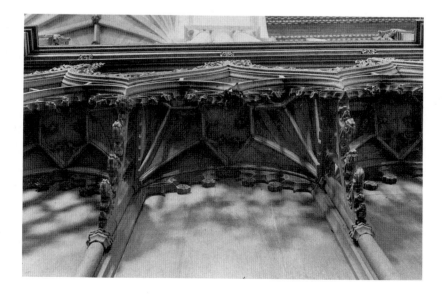

108. *Norwich Cathedral. Choir-stall canopywork from Bishop Goldwell phase. (a) Detail of gable; (b) Vaulting.*

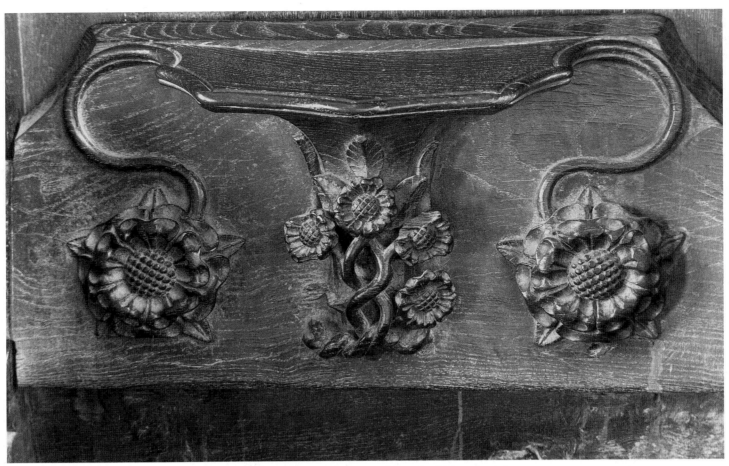

109. *St Margaret, King's Lynn. 'Rose-bush' misericord.*

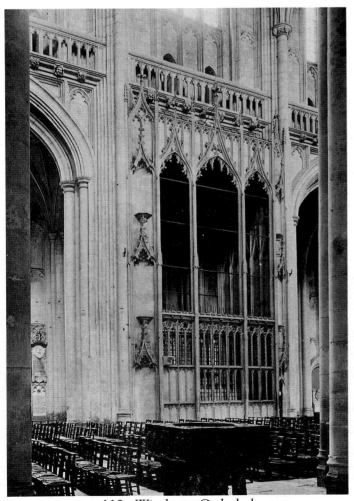

110. *Winchester Cathedral.*
William of Wykeham Chantry Chapel. Detail
(Royal Commission on the Historical Monuments of England).

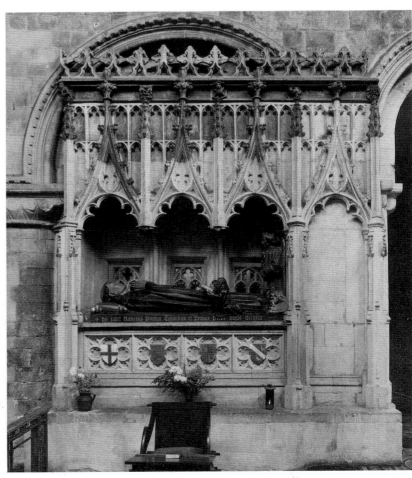

111. *St Bartholomew the Great, Smithfield. Prior Rahere tomb*
(Conway Library, Courtauld Institute of Art).

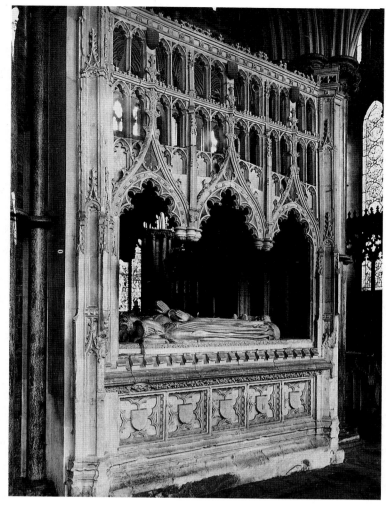

112. *Ely Cathedral.*
Tomb of John Tiptoft, Earl of Worcester
(Royal Commission on the Historical
Monuments of England).

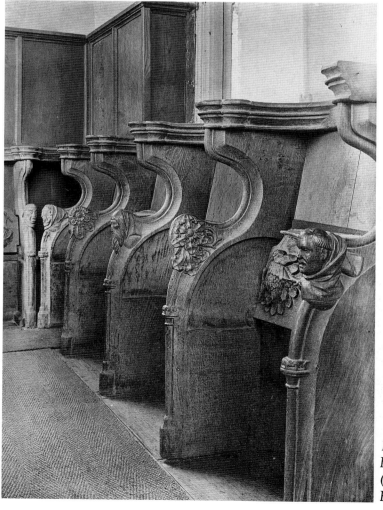

113. *Salle Church, Norfolk.*
Detail of choir-stall seating
(Royal Commission on the
Historical Monuments of England).

114a & b. Norwich Cathedral. Rose and hop foliage choir-stall desk poppy heads.

*116. St Mildred, Canterbury.
Desk end on S. side with
'pomegranate'-type poppy head.
Detail. Formerly in
St John le Poor Church, Canterbury.*

115a & b. Great Chart Church, Kent. Desk end poppy heads.

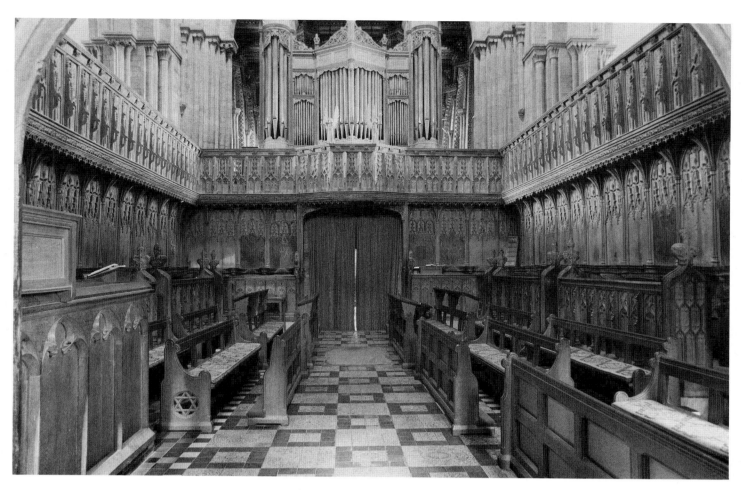

117. *St David's Cathedral. View of choir-stalls from E.*

118. *Bristol Cathedral. View of portion of S. lateral stalls.*

119. *St David's Cathedral. Choir-stall superstructure. Detail.*

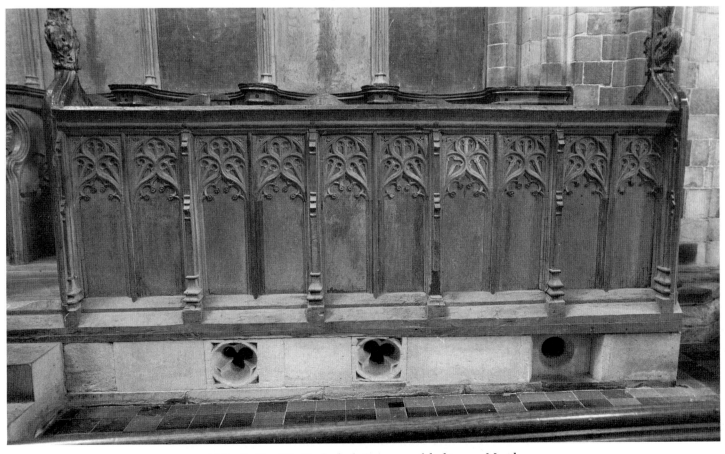

120. *St David's Cathedral. Segment of desking on N. side.*

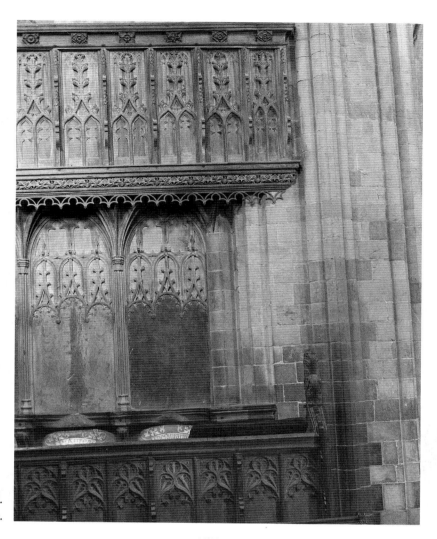

121. St David's Cathedral.
E. end of N. lateral stalls.

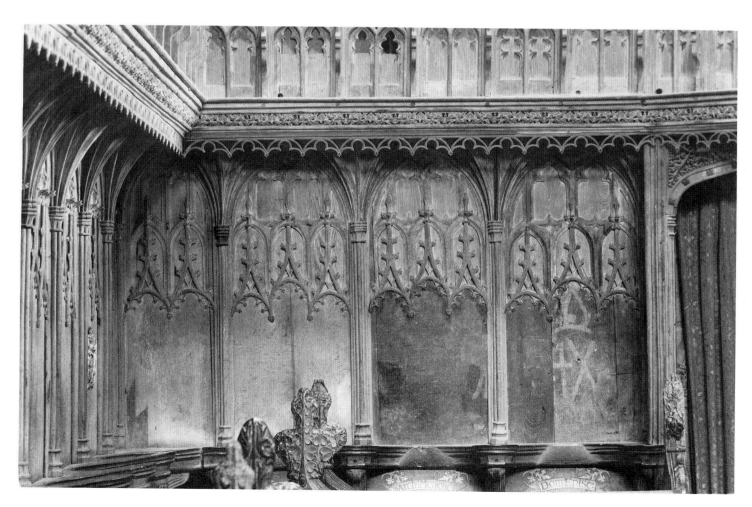

122. St David's Cathedral. S. return stalls. Detail.

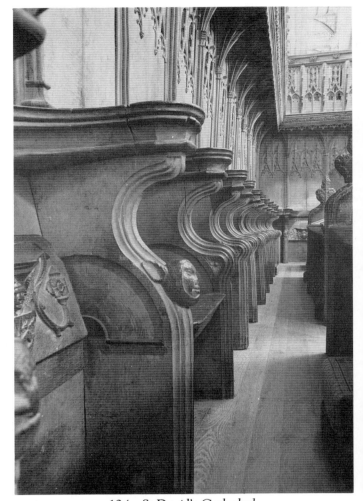

123. *St David's Cathedral. Choir-stall superstructure.*
Detail of upper zone above south return stalls.

124. *St David's Cathedral.*
S. lateral choir-stall seating. Detail.

125a & b. *Bristol Cathedral and St Mary, Olveston. Tracery heads from Bristol Abbey choir-stalls with shield and initials of Robert Elyot.*

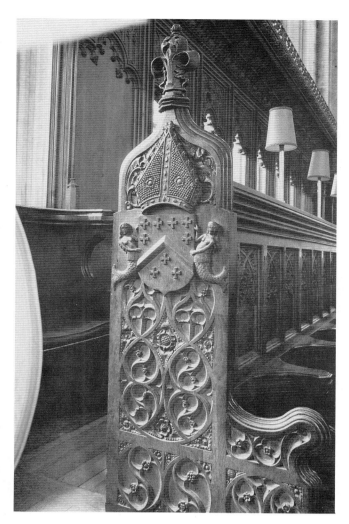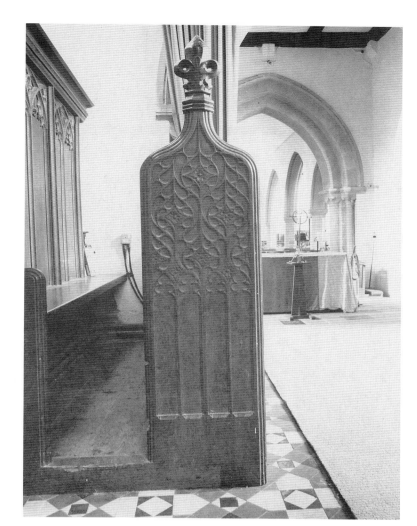

126a & b. Bristol Cathedral and St Mary, Olveston. Choir-stall desk ends.
One with Berkeley shield below a mitre, the other plain.
At Olveston, notice the parclose panelling at the back with later bench inserted.

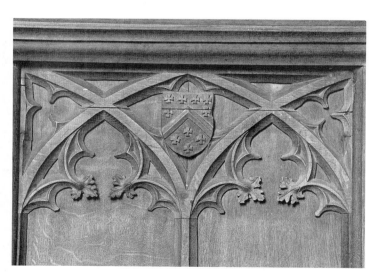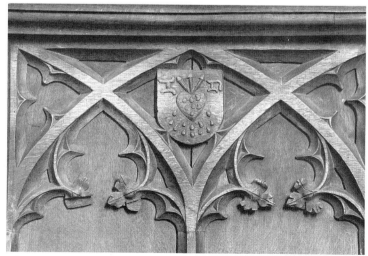

127a & b. St Mary, Olveston. Parclose panel tracery heads
from Bristol Abbey choir-stalls with the arms of the Berkeley family and Abbot Nailheart.

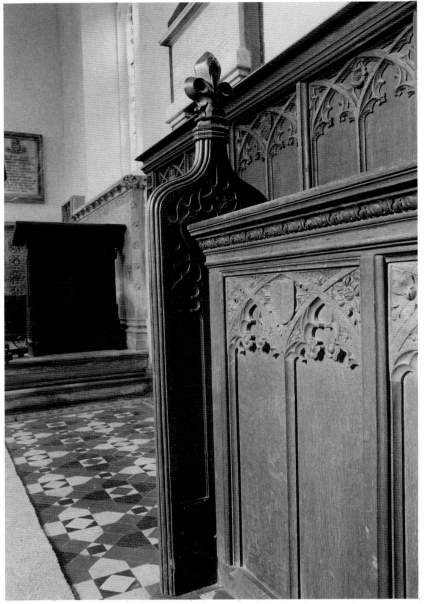

128. *St Mary, Olveston. Desking from Bristol Abbey choir-stalls. Detail. Reverse of Pl. 126b.*

129a & b. *Bristol Cathedral. Choir-stall superstructure. Coving and crowning architrave. Details.*

130a & b. Bristol Cathedral. Panelling probably from the abbey choir-stalls incorporated into pulpit.

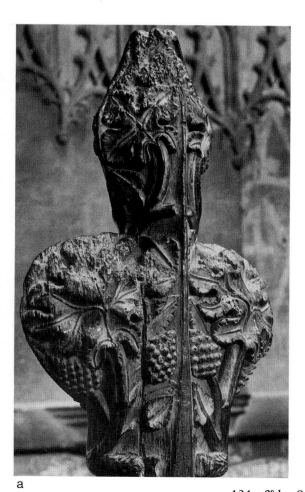

a

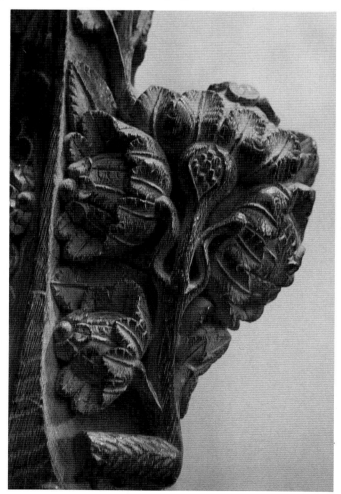

b

131a & b. St David's Cathedral. Choir-stall poppy carving
showing vine and 'pomegranate'-type foliage.

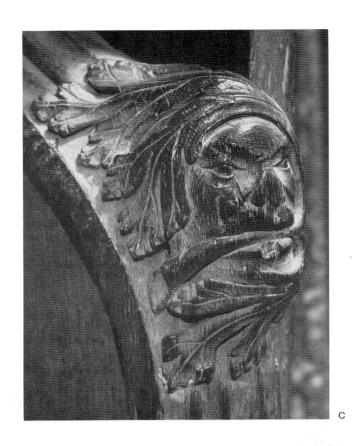

c

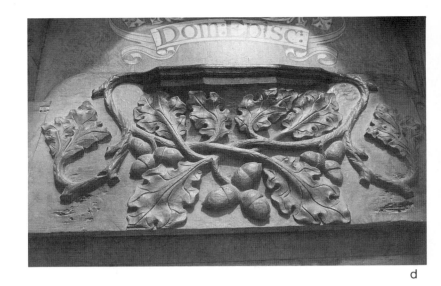

d

131c & d. St David's Cathedral. Choir-stall seat standard elbow
and misericord carving showing hawthorn and oak foliage.

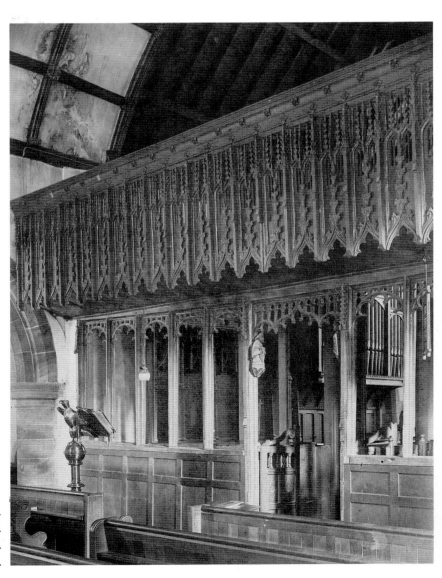

132. Montgomery Church.
Choir screen rood loft from W.
(Conway Library, Courtauld Institute of Art.
Copyright Canon M. H. Ridgway).

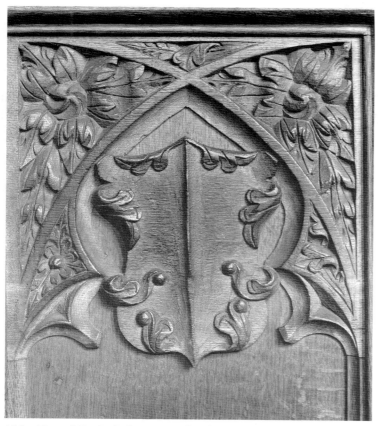

133. *Bristol Cathedral. Tracery head from desk front with shield.*

134. *Bristol Cathedral. Misericord supporter.*

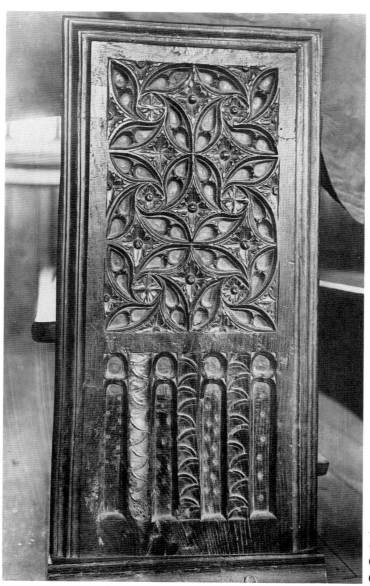

135. *Milverton Church, Somerset.*
Bench end
(Conway Library,
Courtauld Institute of Art.
Copyright Canon M. H. Ridgway).

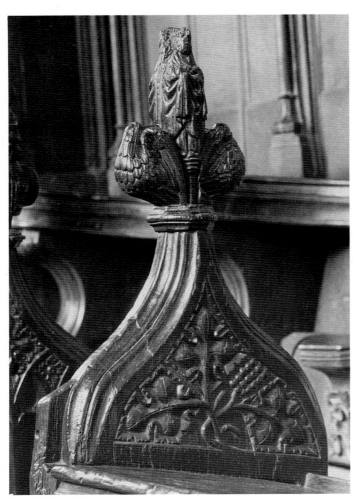

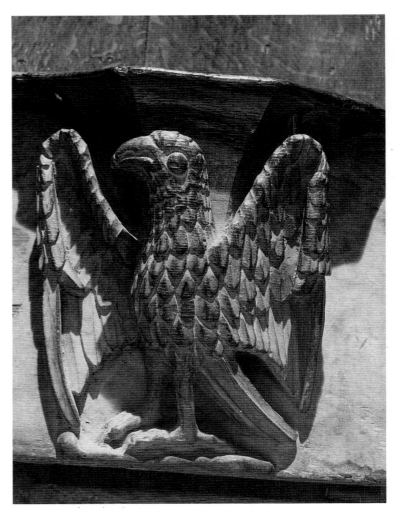

136. *Tong Church. Choir-stall desk end poppy head.*

137a. *Montgomery Church. Eagle misericord.*

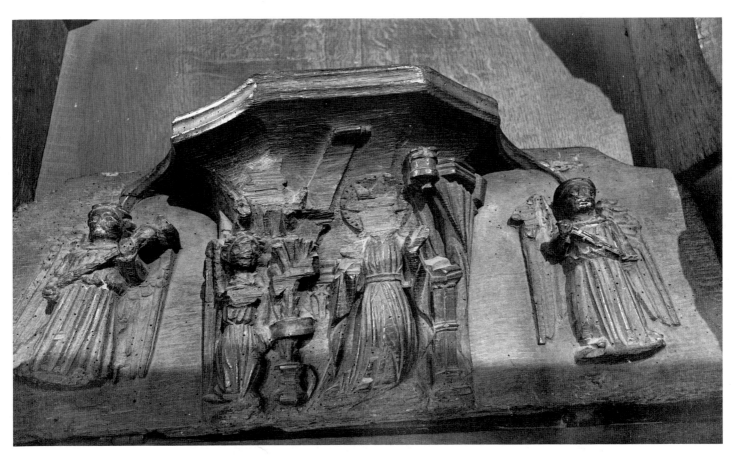

137b. *Leintwardine Church. Annunciation misericord.*

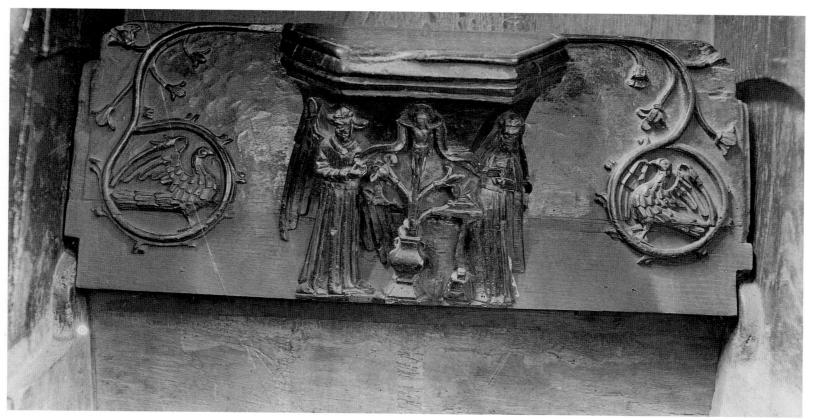

138. *Tong Church. Annunciation misericord*
(Conway Library, Courtauld Institute of Art. Copyright Canon M. H. Ridgway).

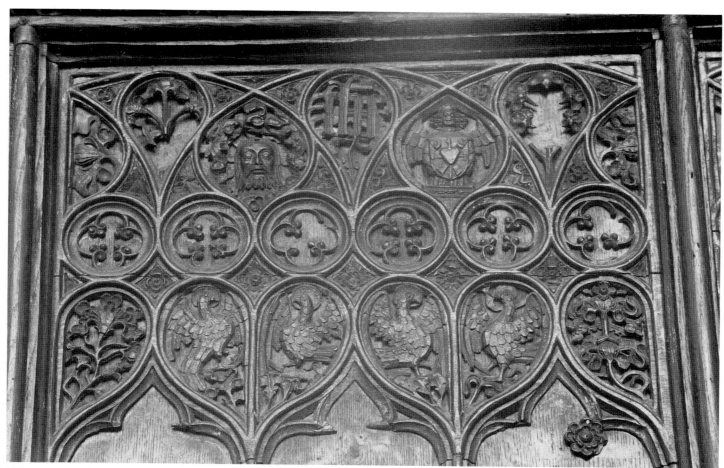

139a. Tong Church. Choir-stall backing screen on S. side, fourth panel from E., with face of Christ and Instruments of the Passion symbols.

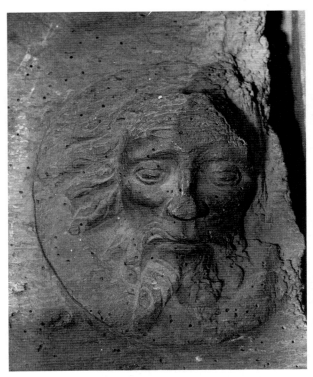

139b. Leintwardine Church.
Misericord supporter with the face of Christ.

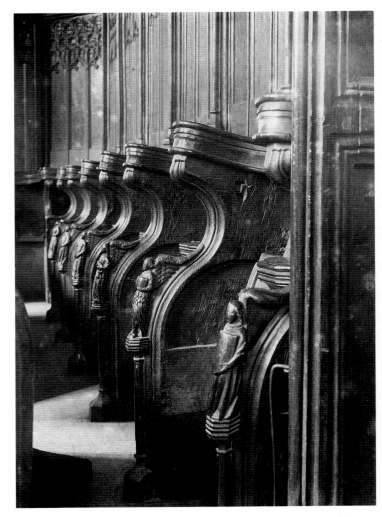

140. Tong Church. Choir-stall seating. N. side (Conway Library,
Courtauld Institute of Art. Copyright Canon M. H. Ridgway).

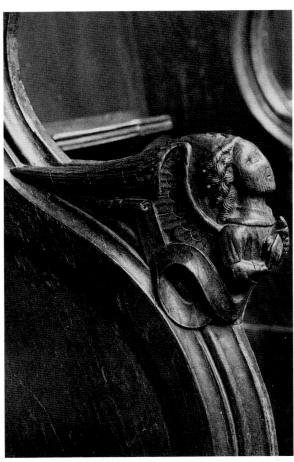

141. St Laurence, Ludlow.
Angel choir-stall seat standard elbow.

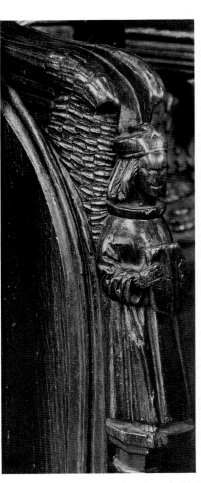
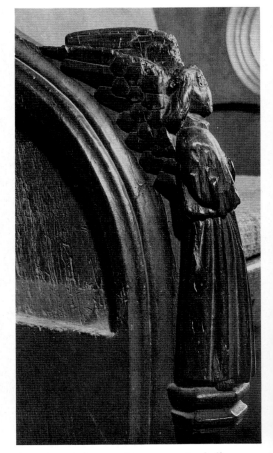

142a & b. Gresford and Halsall Churches. Angel choir-stall seat standard elbows.

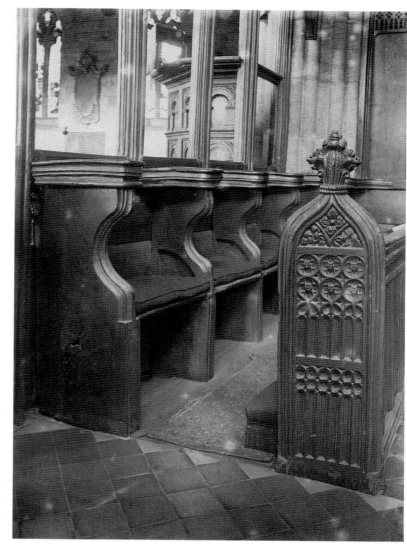

143. Astbury Church, Cheshire.
N. side of choir-stalls. Detail.
(Conway Library, Courtauld Institute of Art.
Copyright M. H. Ridgway).

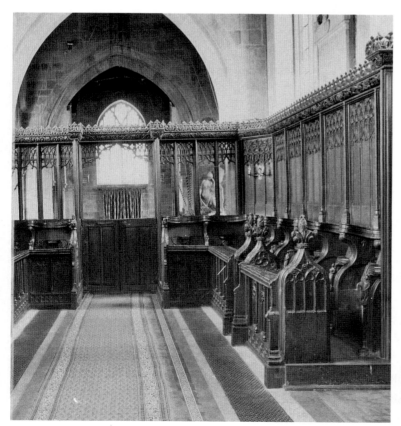

144. Tong Church. N. side of choir-stalls.
Choir screen and entranceway.

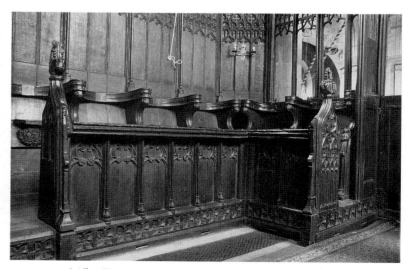

145. Tong Church. S.W. corner of choir-stalls.

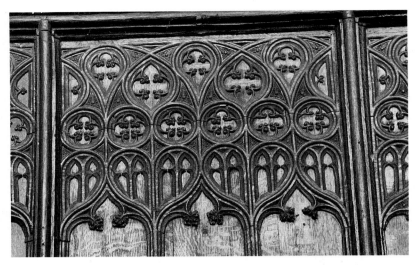

146. Tong Church. Choir-stall backing screen. Standard design.

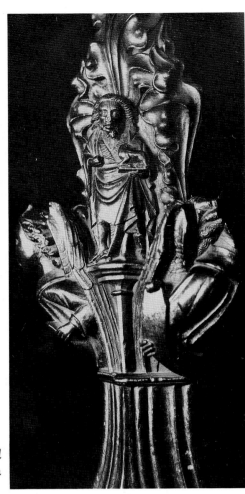

147. St Laurence, Ludlow. Choir-stall desk end poppy head with figure perched on column (Royal Commission on the Historical Monuments of England).

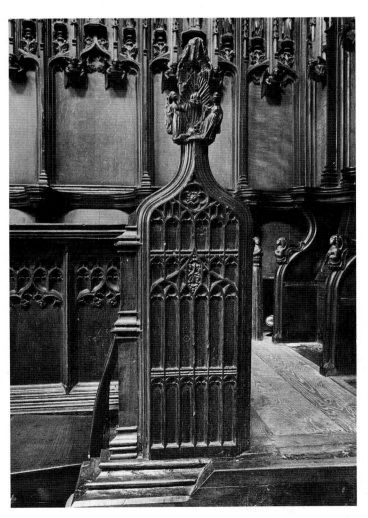

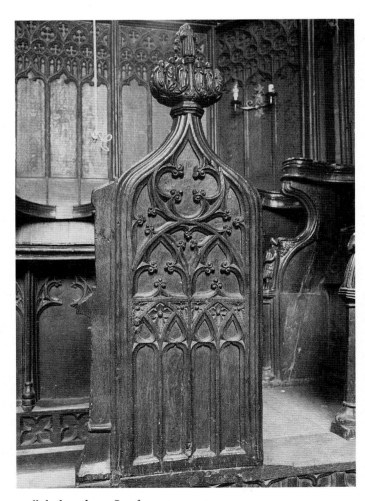

148a & b. St Laurence, Ludlow and Tong Church. Choir-stall desk ends on S. of entranceway.

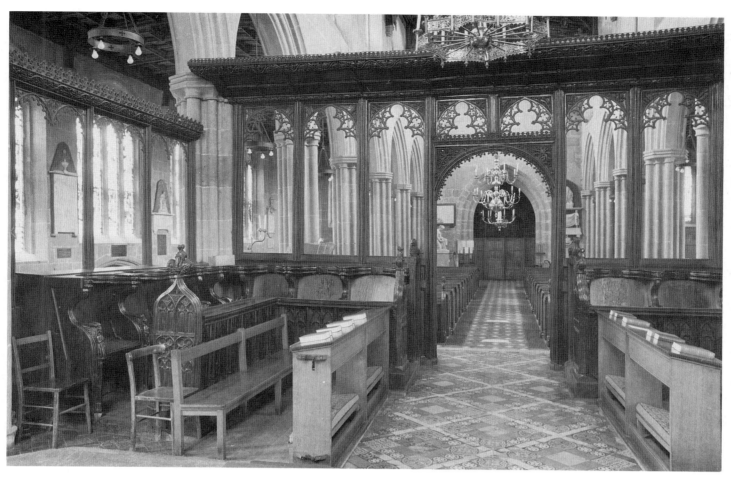

149. *Gresford Church. S.E. side of choir-stalls.*

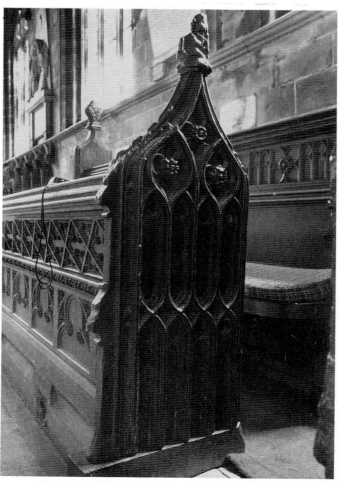

150. *Halsall Church. View of choir-stall desking.*

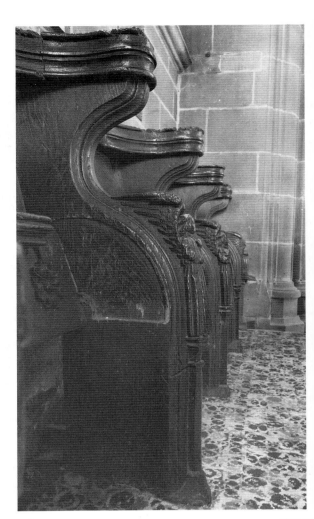

151a & b. Gresford and Halsall Churches. Choir-stall seating.

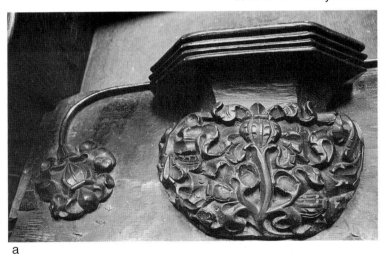

a

b

c

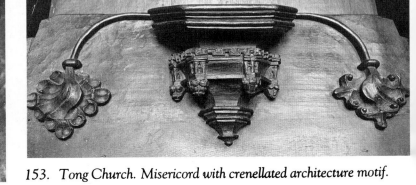

153. Tong Church. Misericord with crenellated architecture motif.

152. (a) Tong Church. 'Stylised' flower; (b) Gresford Church. Winged monster and unicorn; (c) Halsall Church. Eagle misericord. Details.

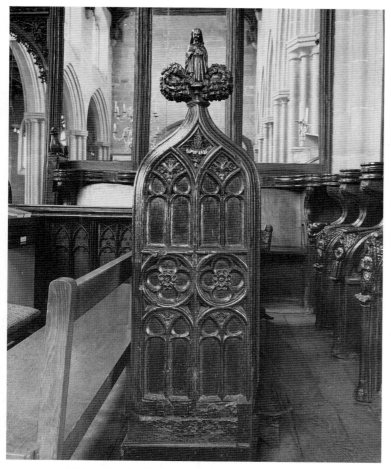

154. Gresford Church. Choir-stall desk end.

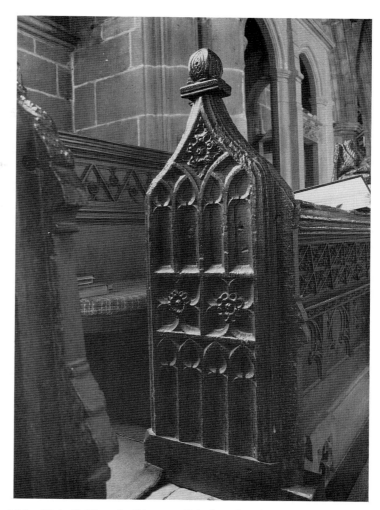

155. Halsall Church. Choir-stall desk end with attached buttress.

156. Halsall Church. Choir-stall desk end. Detail showing use of tracery lights in gable mouldings.

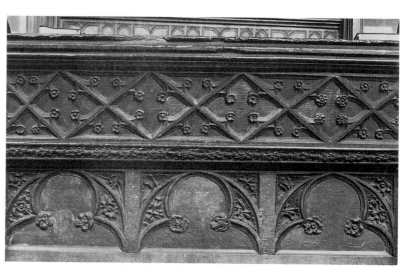

157. Halsall Church. Panelling on front of choir-stall desking. Detail.

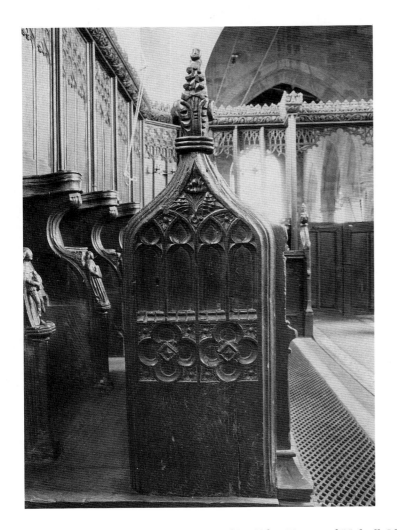
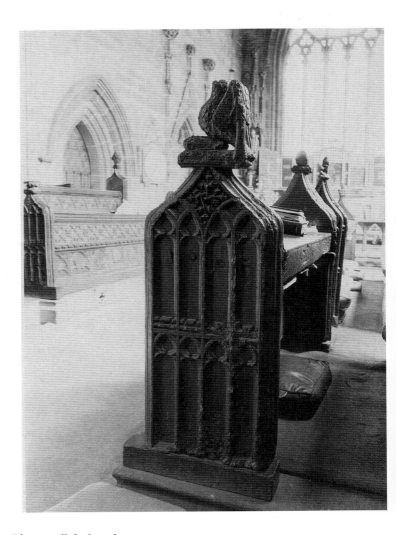

158a & b. Tong and Halsall Churches. Choir-stall desk end comparisons.

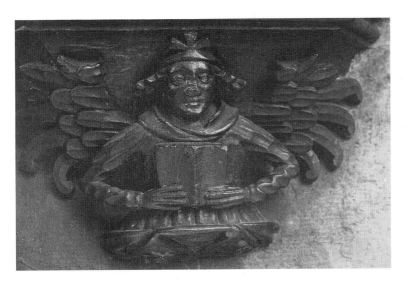

159a & b. Tong and Halsall Churches. Shield-bearing angel misericords.

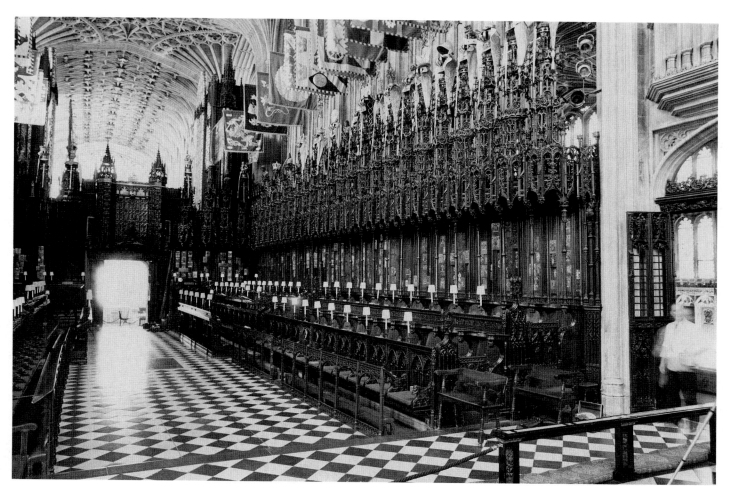

160. St George's Chapel, Windsor. N. side of choir-stalls from E.

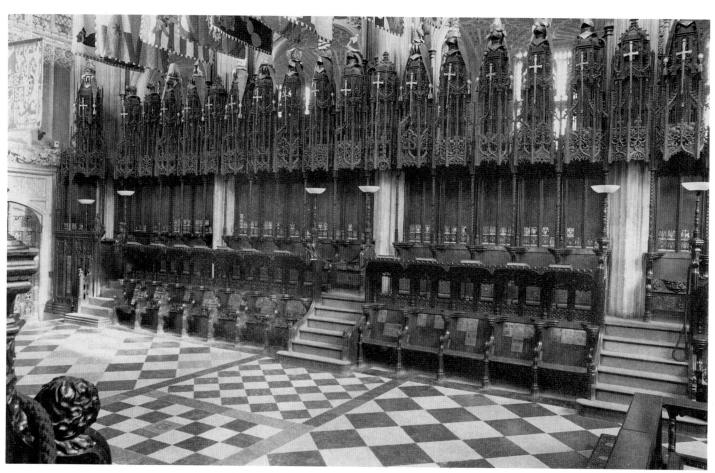

161. Henry VII Chapel, Westminster Abbey.
N. side of choir-stalls. The post-medieval furniture in the fourth bay to the E. is out of picture.
The substalls to the east of the second choir entranceway are post-medieval.

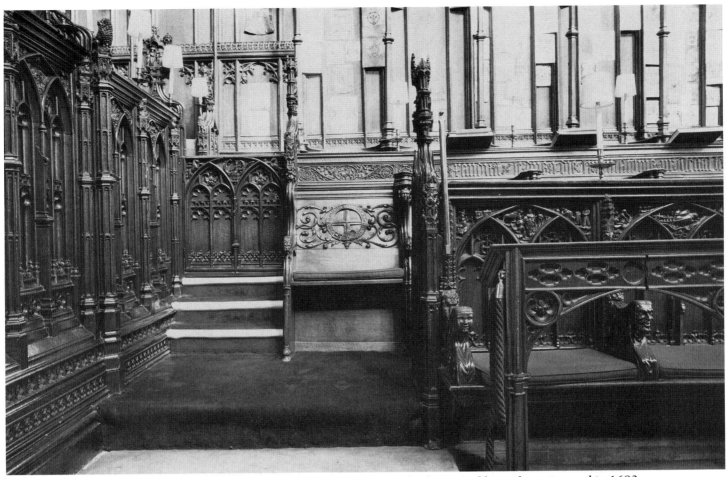

162. St George's Chapel, Windsor. Choir substalls on N. side showing additional seat inserted in 1683.

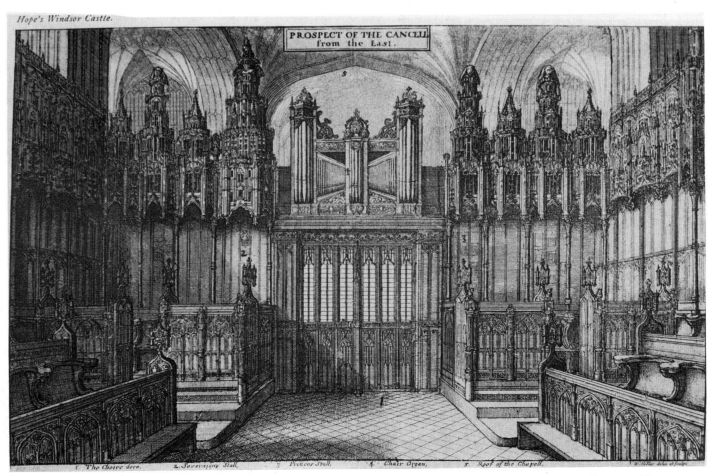

163. St George's Chapel, Windsor. 'Prospect of the Cancell from the east'. Engraving after W. Hollar, c. 1672.

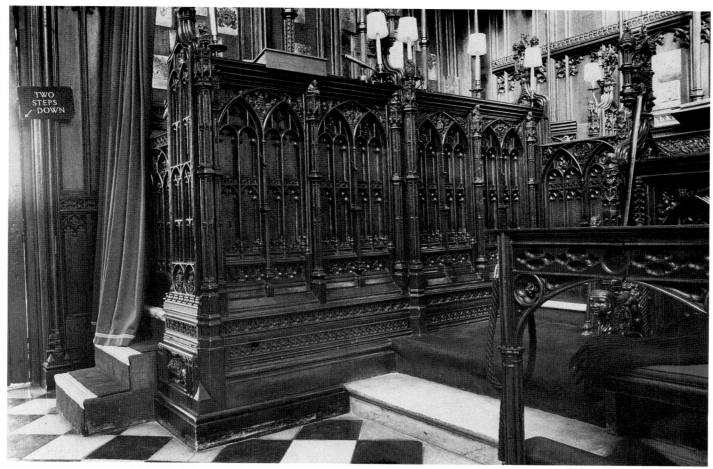

164. St George's Chapel, Windsor. N. return stalls desking showing base plinth.

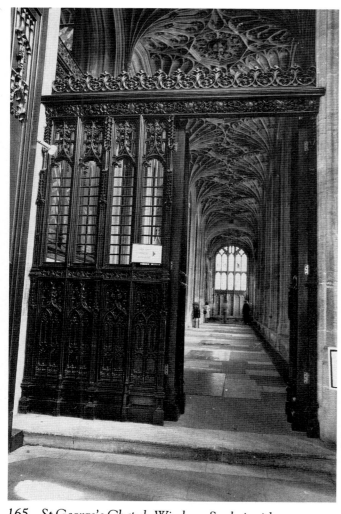

165. St George's Chapel, Windsor. S. choir aisle screen.

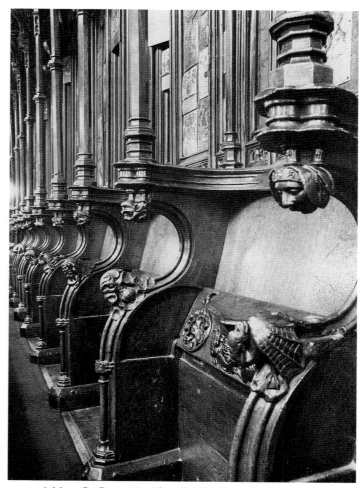

166a. St George's Chapel, Windsor. Back seating.
Note pomegranate fruit on elbow at left foreground.

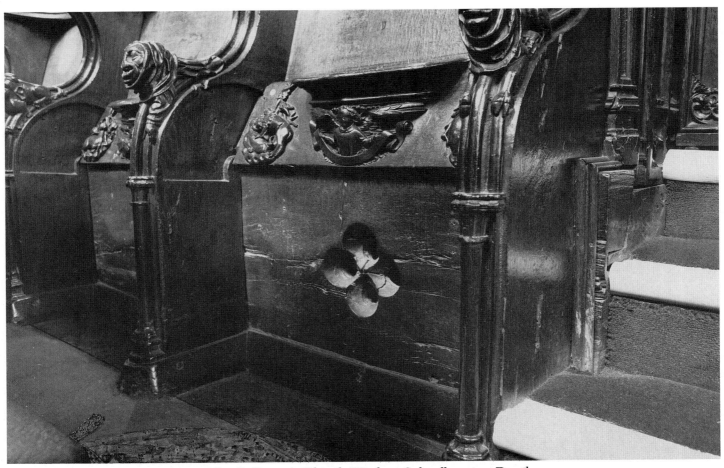

166b. St George's Chapel, Windsor. Substall seating. Details.

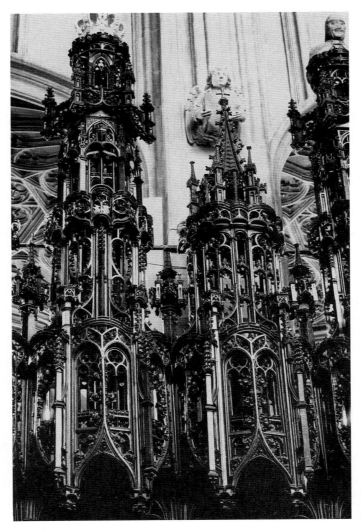

*167. St George's Chapel, Windsor.
Choir-stall superstructure showing
knight-companions' (left)
and canons' (right) canopies.*

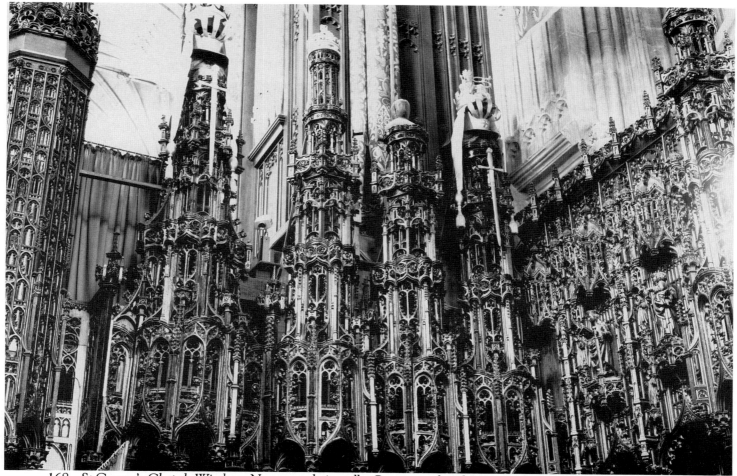

168. St George's Chapel, Windsor. N. return choir-stalls. Canopywork. The Prince of Wales' canopy is on the left.

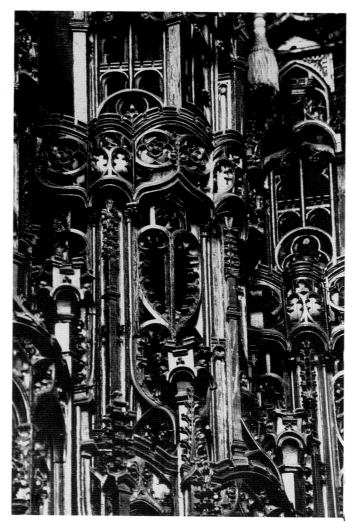

169. St George's Chapel, Windsor. Detail of choir-stall canopywork showing ornamental treatment including 'cusping' device.

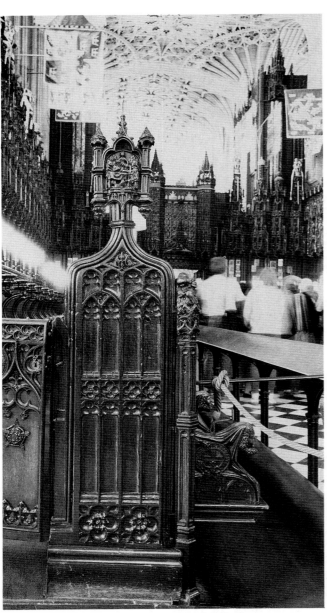

170. *St George's Chapel, Windsor.*
Choir-stall desk end on S. side.

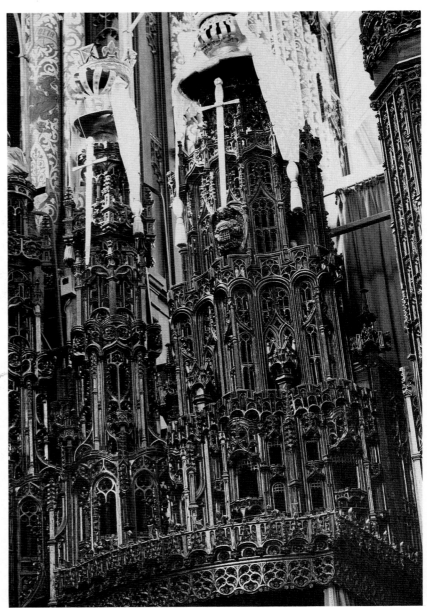

171. *St George's Chapel, Windsor. Canopy of monarch's choir-stall*
on S. side of entranceway (the tester below is by Emlyn).

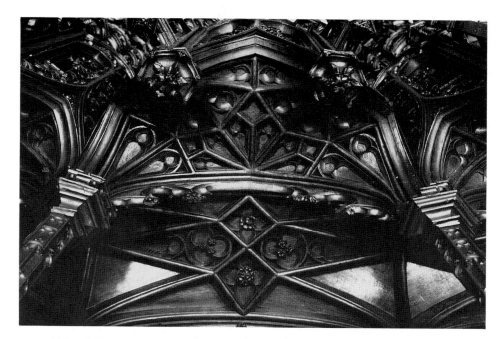

172. *St George's Chapel, Windsor. Standard canopy choir-stall vaulting.*

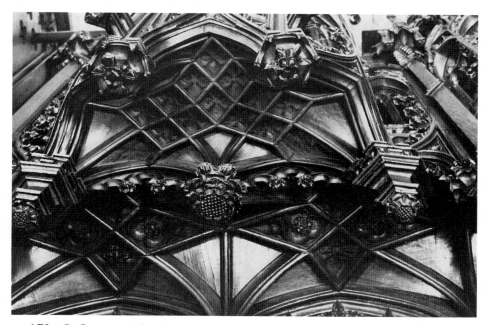

173. *St George's Chapel, Windsor. Canopy vaulting. Prince of Wales' stall.*

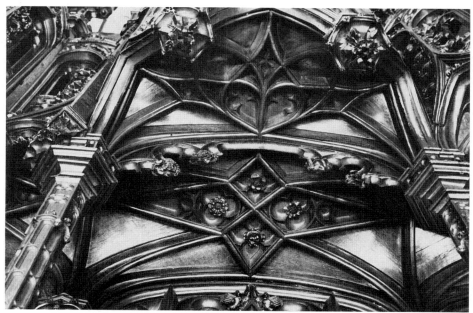

174. *St George's Chapel, Windsor. N. return stalls.*
Seat adjacent to Prince of Wales' stall. Canopy vaulting.

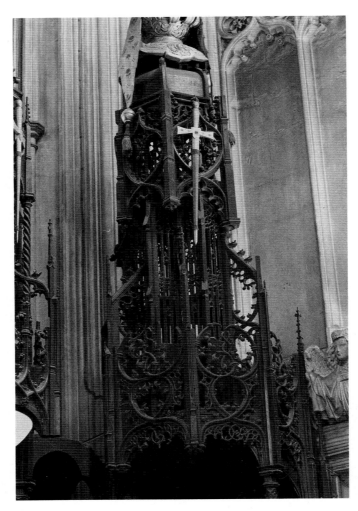

175. Henry VII Chapel, Westminster Abbey. Royal choir-stall canopy on S. side.

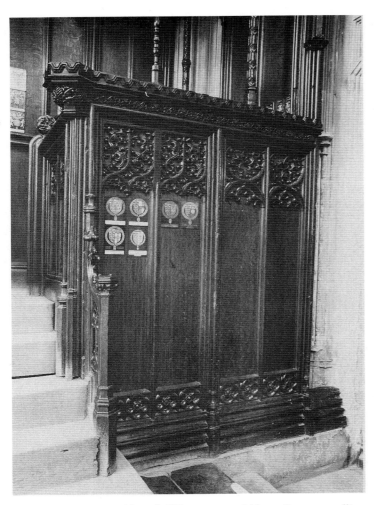

176. Henry VII Chapel, Westminster Abbey. Front panelling of monarch's stall on S. side.

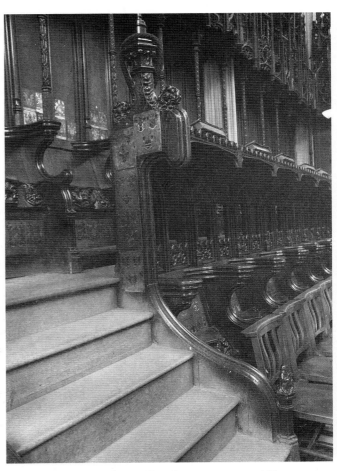

177. Henry VII Chapel, Westminster Abbey. N.W. entranceway to choir-stalls showing back and substalls, and 18th century desk end.

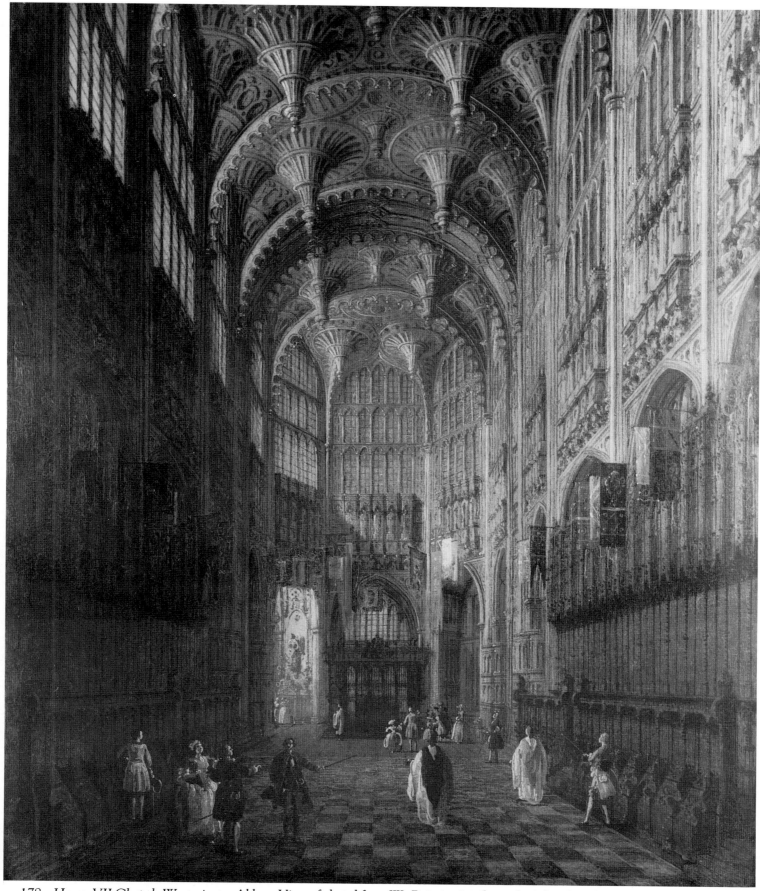

178. *Henry VII Chapel, Westminster Abbey. View of chapel from W. Painting in oils attributed to Canaletto (Museum of London Acq. No. 20964).*

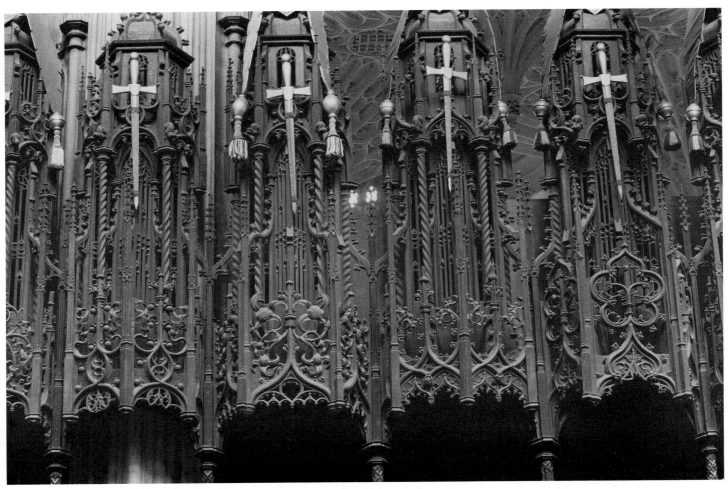

179. *Henry VII Chapel, Westminster Abbey. Choir-stall canopywork. Detail.*

180. *Henry VII Chapel, Westminster Abbey. Foliage misericord.*

181. *Henry VII Chapel, Westminster Abbey.*
Pomegranate fruit and foliage misericord supporter.

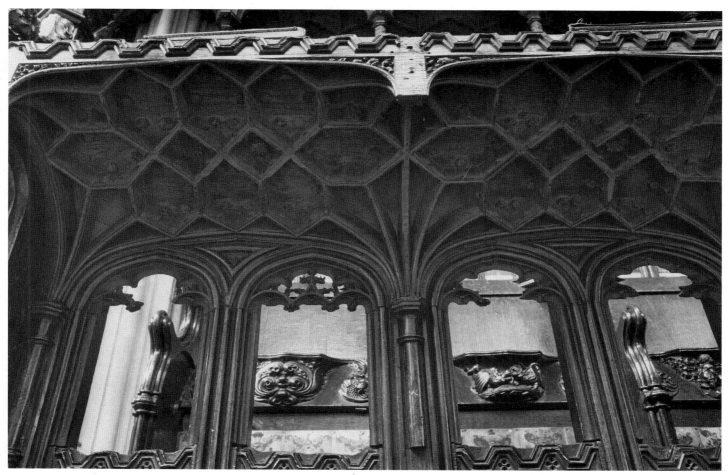

182. Henry VII Chapel, Westminster Abbey. View of underside of choir-stall desk tops. Detail.

183. Henry VII Chapel, Westminster Abbey.
Front edge of choir-stall desking. Detail.

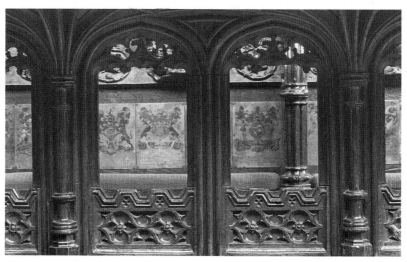

184. Henry VII Chapel, Westminster Abbey. Backing of substalls. Detail.

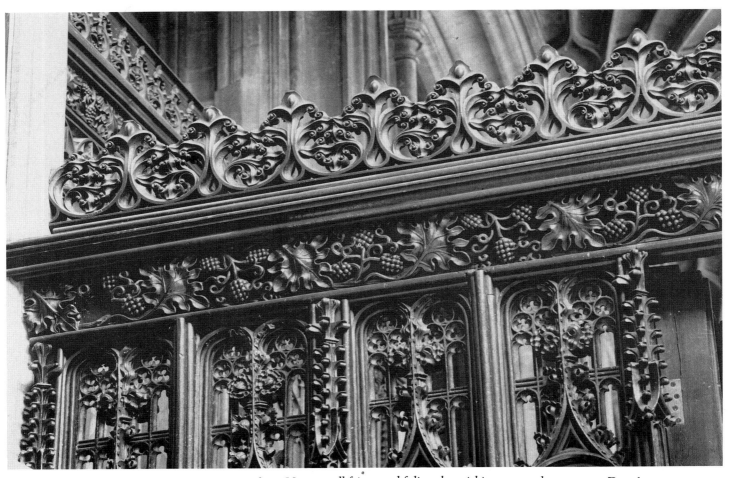

185. *St George's Chapel, Windsor. Vine-scroll frieze and foliage brattishing on parclose screen. Detail.*

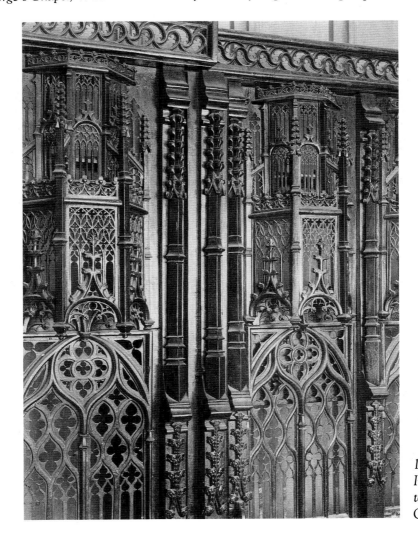

186. *St George's Chapel, Windsor. Iron gates in front of Edward IV tomb. Detail (Conway Library, Courtauld Institute of Art).*

187. *St George's Chapel, Windsor. Hawthorn foliage misericord. Detail.*

188a & b. *St George's Chapel, Windsor. Rose and 'pomegranate'-type foliage misericords. Details.*

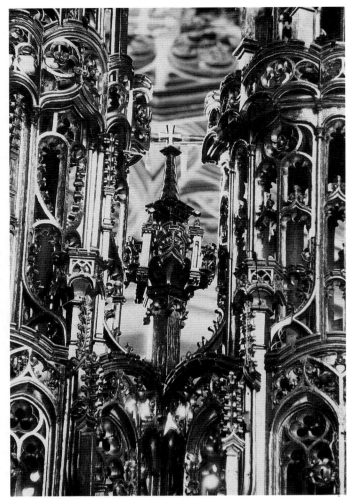

189. *St George's Chapel, Windsor.*
Miniature free-standing bracket
device between stall canopies.

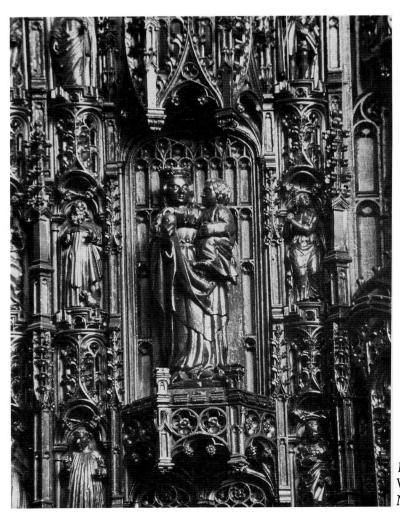

190. *St George's Chapel, Windsor.*
Virgin and Child sculpture on
N. choir-stall wing screen.

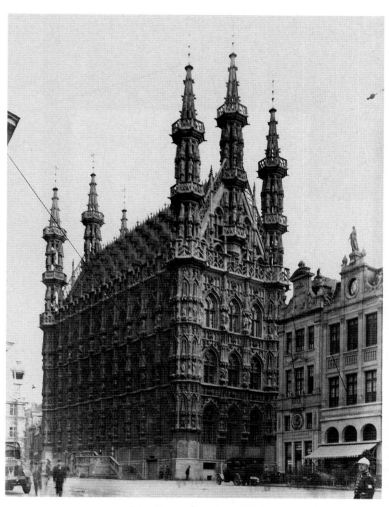

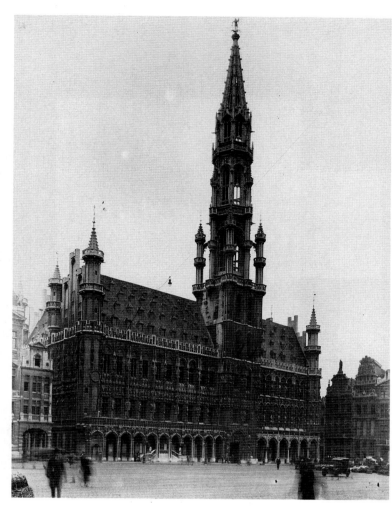

191. *Brussels. Town Hall*
(*Conway Library, Courtauld Institute of Art*).

192. *Leuven. Town Hall*
(*Conway Library, Courtauld Institute of Art*).

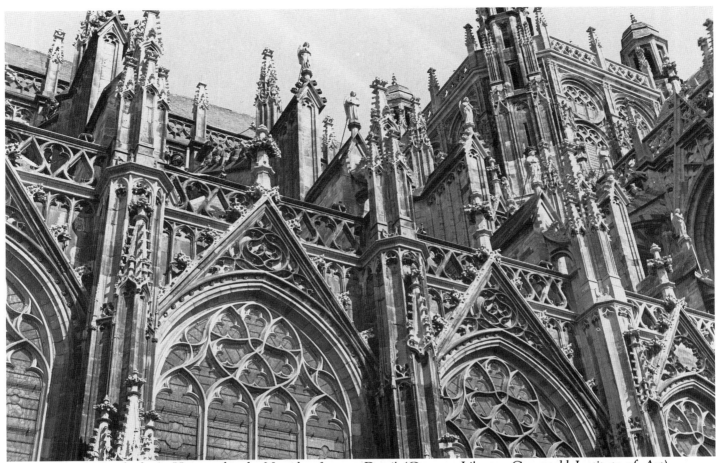

193. St Janskerk, 's Hertogenbosch. N. side of nave. Detail (Conway Library, Courtauld Institute of Art).

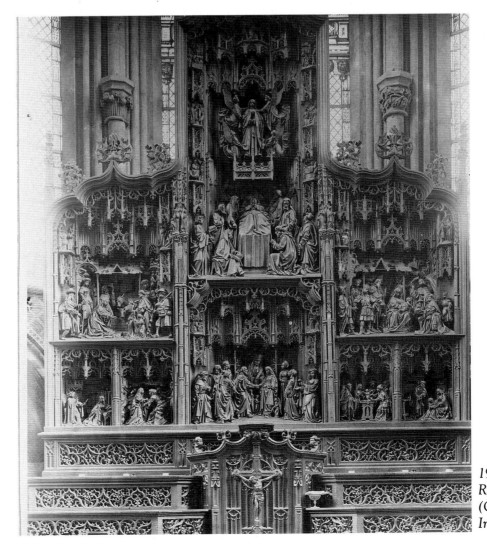

194. Nôtre Dame, Tongres. Retable with Life of the Virgin (Conway Library, Courtauld Institute of Art).

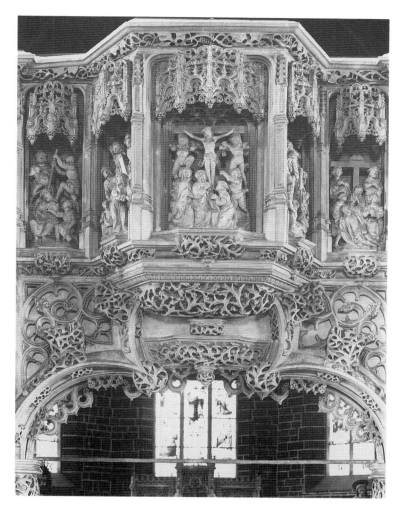

195. *St Martin, Tessenderloo.*
Pulpitum (Conway Library,
Courtauld Institute of Art).

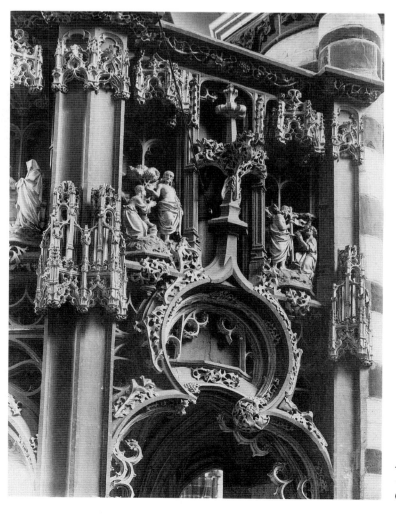

196. *Onze Lieve Vrouwkerk,*
Aerschot. Pulpitum
(Conway Library,
Courtauld Institute of Art).

197. *Winchester Cathedral. Lady Chapel stalls. Decorative carving, incorporating 'pomegranate'-type on desk front. Detail.*

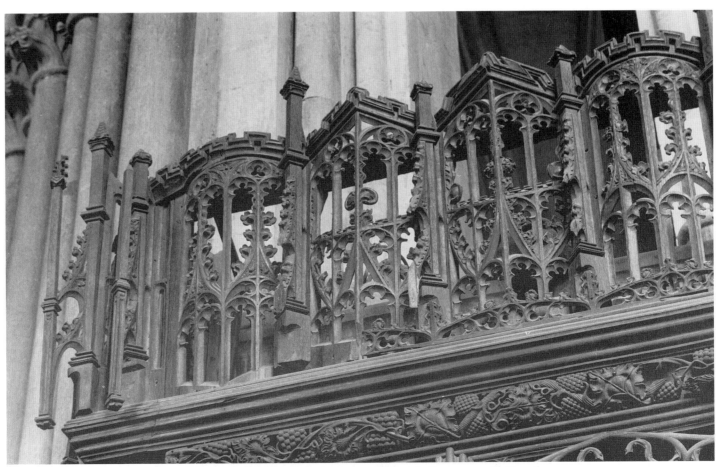

198. *Winchester Cathedral. Langton Chapel. Canopywork. Detail.*

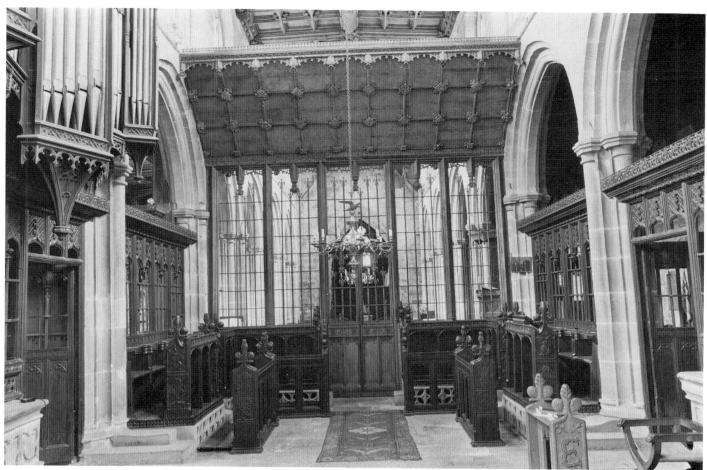

199. *Sefton Church. Choir-stalls and rood screen from E.*

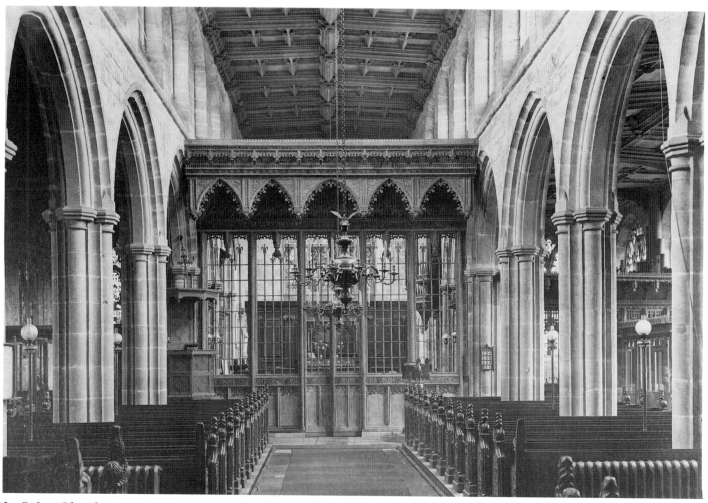

200. *Sefton Church. View from nave looking E. (Conway Library, Courtauld Institute of Art. Copyright Canon M. H. Ridgway).*

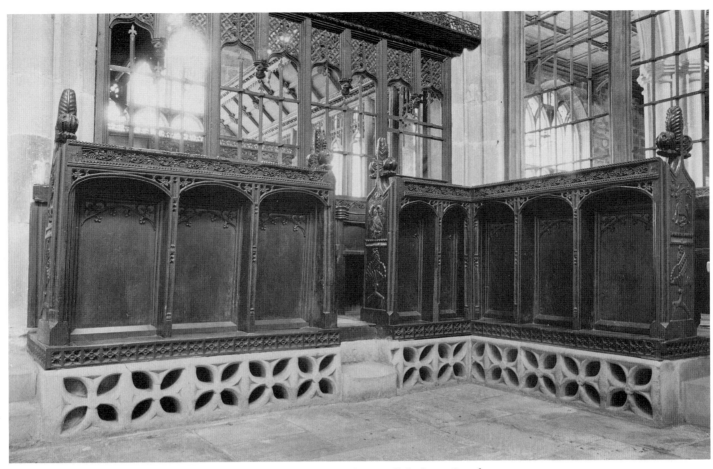

201. *Sefton Church. Choir-stall desking. S. side.*

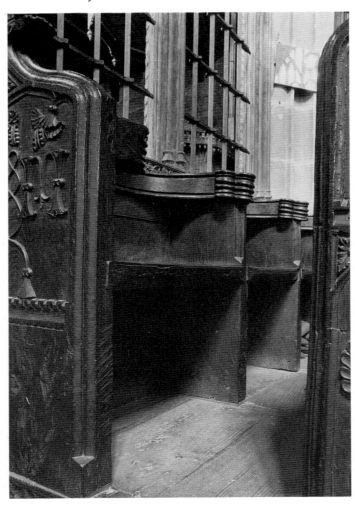

202. *Sefton Church. Seating of return stalls on N. side.*

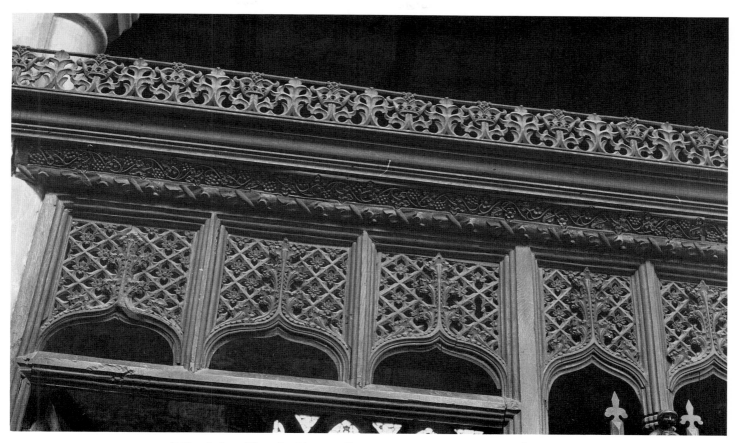

203. *Sefton Church. Choir-stall tracery backing and cornice. Detail.*

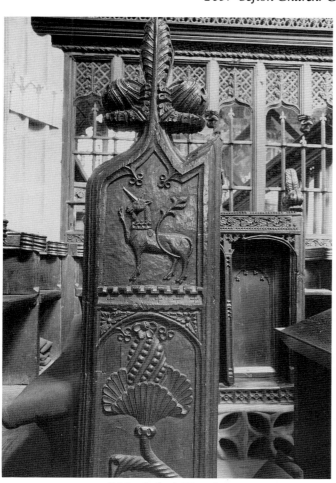

204. *Sefton Church.*
Choir-stall desk end on N. side of entranceway.

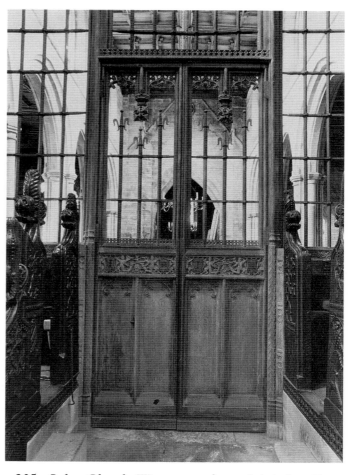

205. *Sefton Church. W. entrance doors of choir from E.*

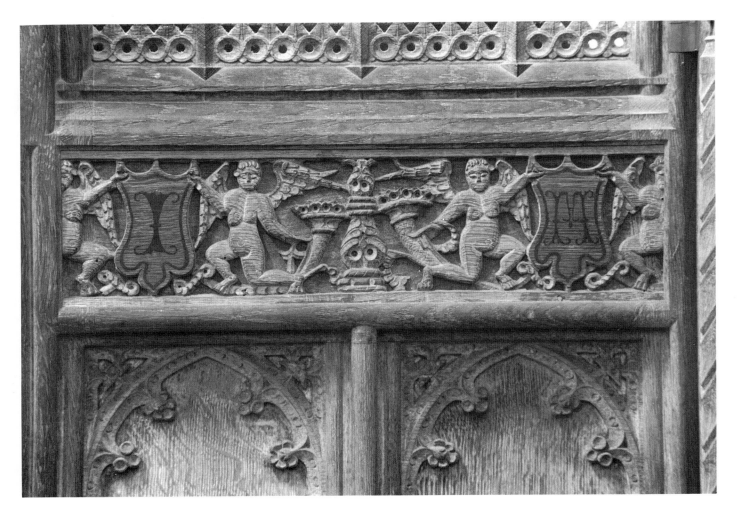

206a & b. Sefton Church. Dado rail of choir entrance door and architrave of choir screen. Details showing Renaissance decoration

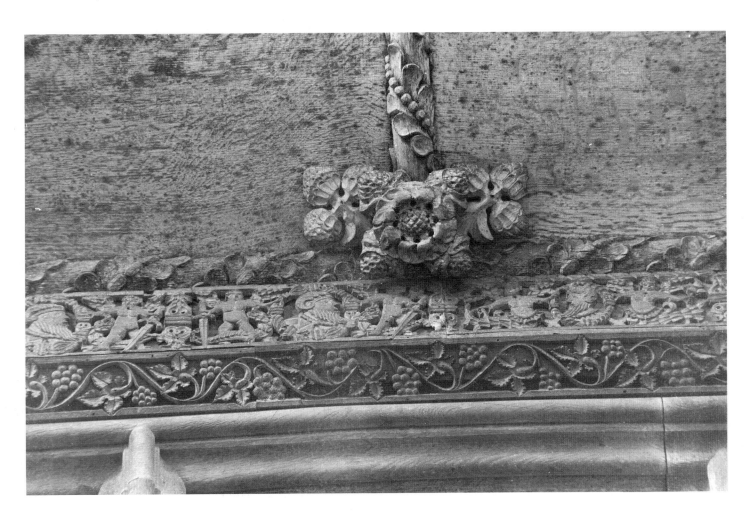

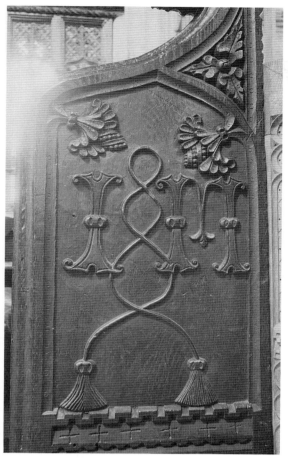

207. *Sefton Church. Choir-stall end on S. of W. entranceway with 'I.M.' initials.*

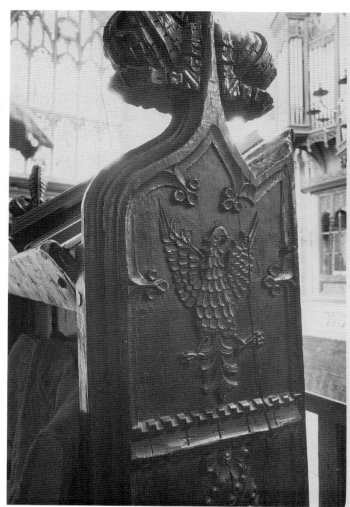

208. *Sefton Church. Choir-stall desk end with displayed eagle.*

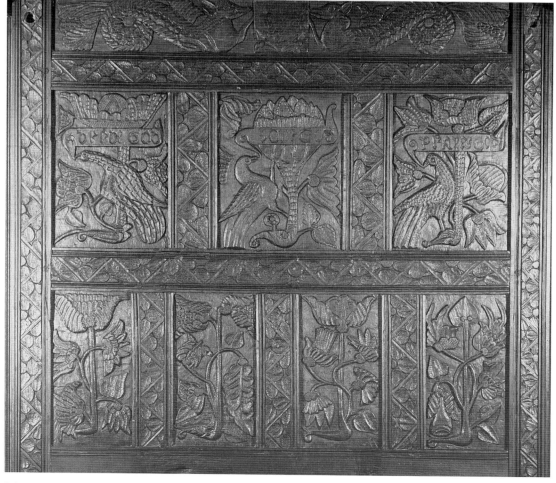

209. *V & A Museum. 'Crackenthorpe Bed' (Copyright V & A Museum. Acq. No. W.12–1943).*

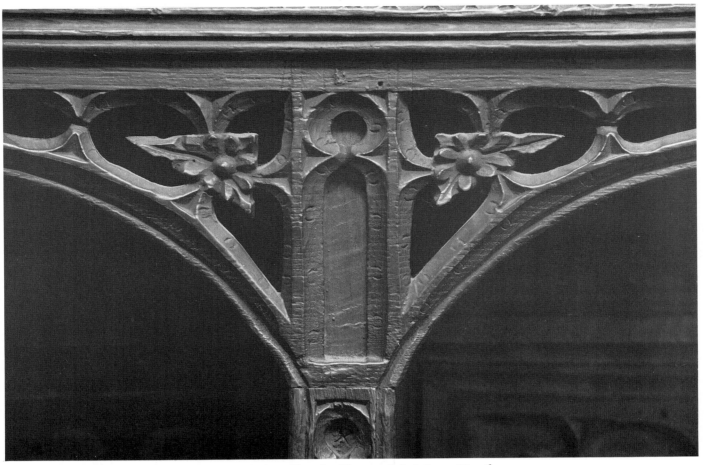

210. Sefton Church. Choir-stall desk front. Detail.

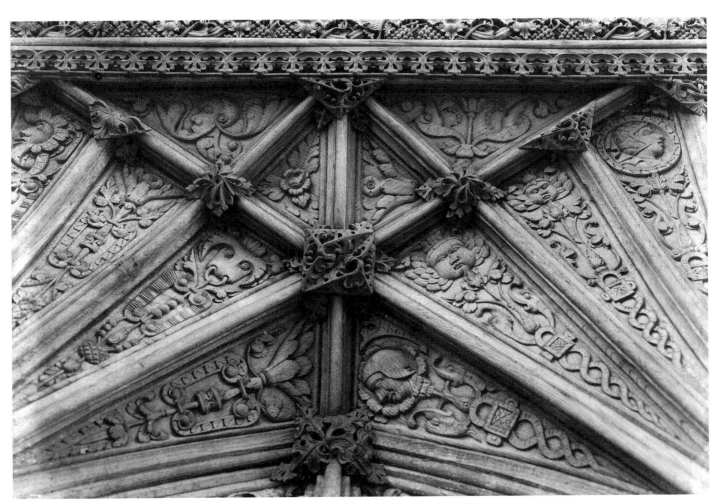

211. Atherington Church, Devon. Rood loft vaulting. Detail
(Conway Library, Courtauld Institute of Art. Copyright Canon M. H. Ridgway).

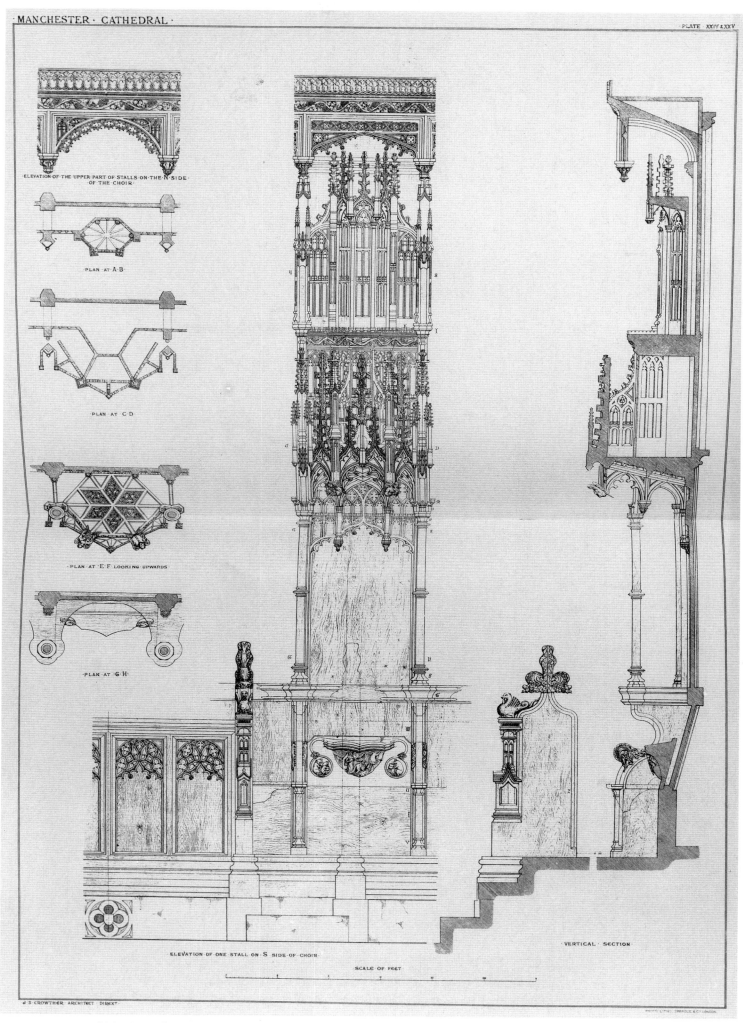

MANCHESTER · CATHEDRAL ·

PLATE · XXIV & XXV

ELEVATION · OF · THE · UPPER · PART · OF · STALLS · ON · THE · N · SIDE · OF · THE · CHOIR

PLAN · AT · A · B

PLAN · AT · C · D

PLAN · AT · E · F · LOOKING · UPWARDS

PLAN · AT · G · H

ELEVATION · OF · ONE · STALL · ON · S · SIDE · OF · CHOIR

SCALE · OF · FEET

VERTICAL · SECTION

212. Manchester Cathedral. Elevation drawing of one stall on south side of choir by J. S. Crowther.
See Crowther (1893), Pls XXIV & XXV (Copyright British Architectural Library/RIBA).

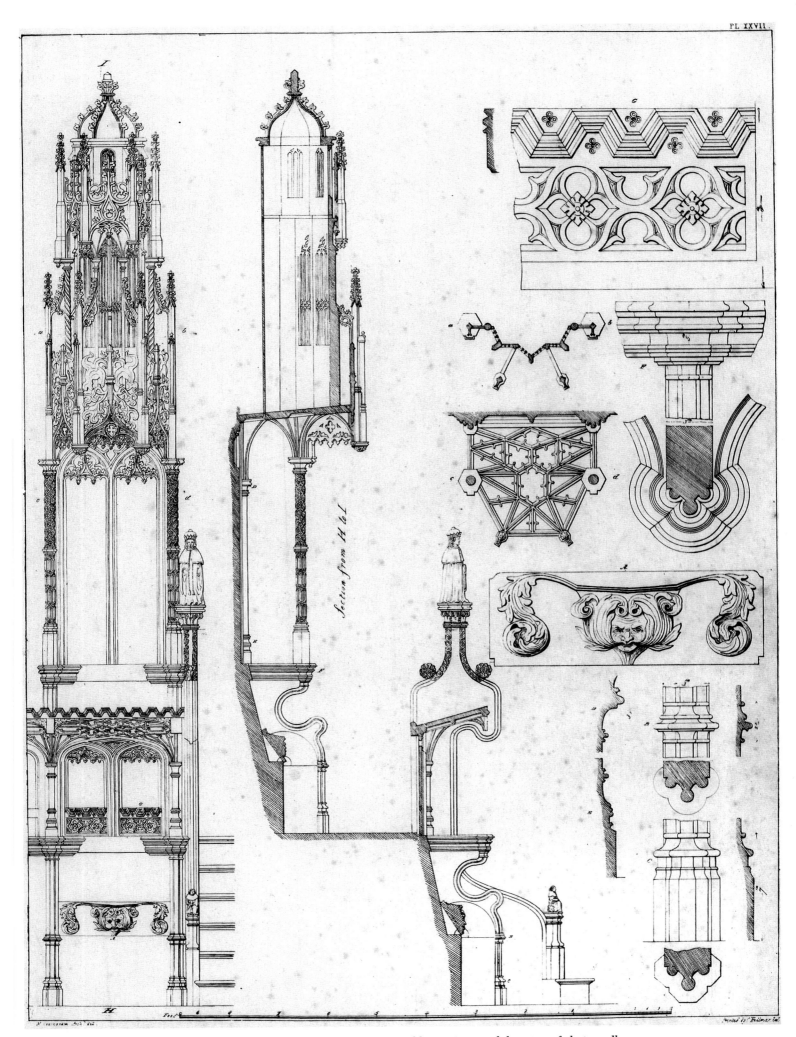

Section from H to I

213. Henry VII Chapel, Westminster Abbey. Measured drawing of choir-stalls.
From L. N. Cottingham, Plans, Elevations, Sections and Details of the Interior of Henry VII Chapel, Westminster,
vol. II, London, 1829, Pl. XXVII (Copyright British Architectural Library/RIBA).

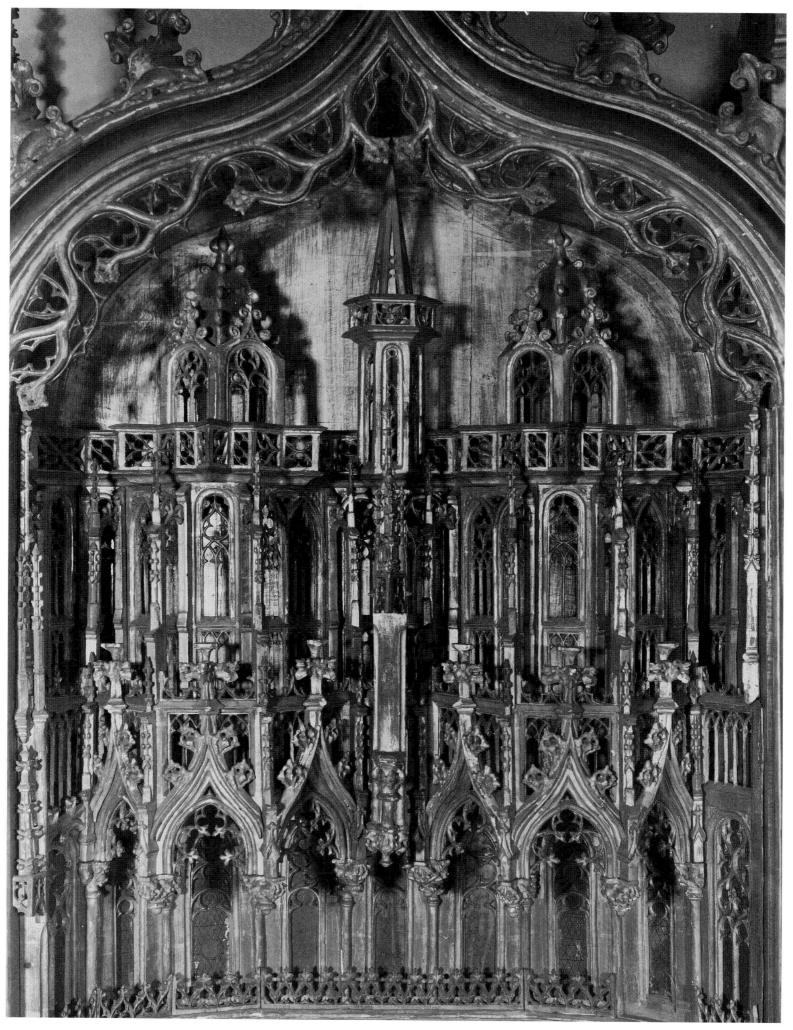

214. Retable de Villa. Detail of left-hand panel (Copyright Musées Royaux D'Art et D'Histoire, Brussels).